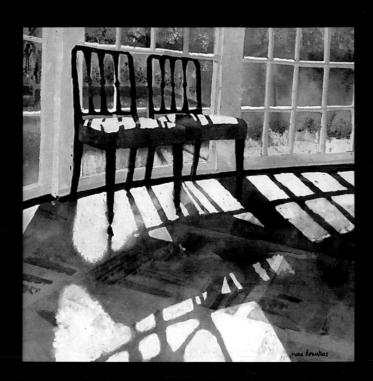

PAINTING LIGHT
AND SHADE

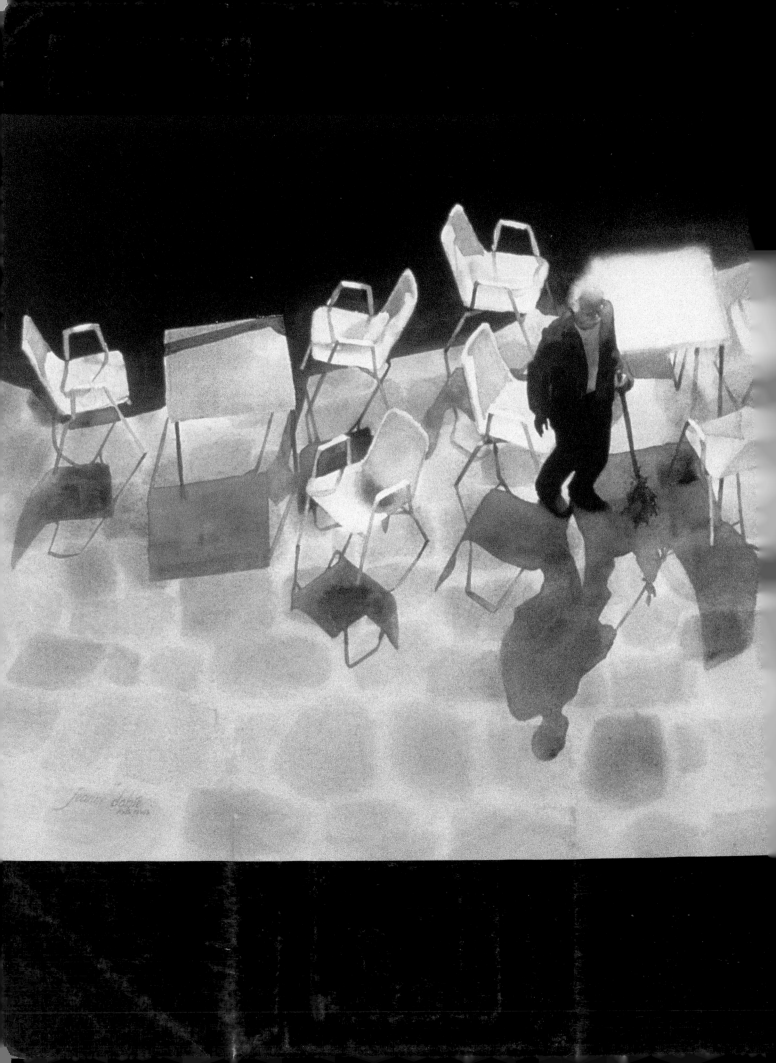

PAINTING LIGHT AND SHADE

How to achieve
precise tonal variation
in your watercolors

Patricia Seligman

North Light Books
Cincinnati, Ohio

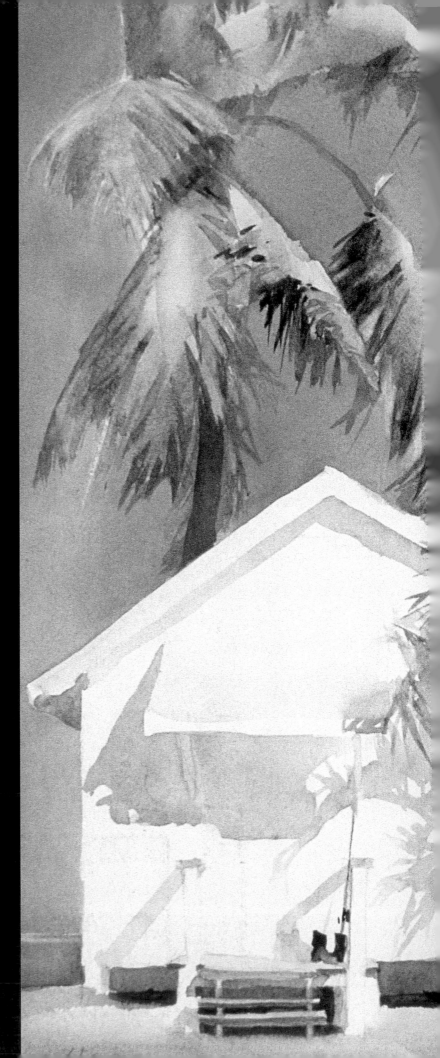

A QUARTO BOOK

Distributed to the trade and
art markets in North America by
North Light Books,
an imprint of F&W Publications, Inc.
4700 East Galbraith Road
Cincinnati, OH 45236
(800) 289-0963

ISBN 1-58180-448-2

Conceived, designed, and produced by
Quarto Publishing plc
The Old Brewery
6 Blundell Street
London N7 9BH

Senior project editor: Nadia Naqib
Senior art editor: Penny Cobb
Designer: Tanya Devonshire-Jones
Text editors: Jean Coppendale, Amy Corzine
Photographers: Colin Bowling, Paul Forrester
Illustrator: Jane Hughes

Art director: Moira Clinch
Publisher: Piers Spence

QUAR.PLAS

Manufactured by Pro-Vision Pte Ltd, Singapore
Printed by Star Standard Industries (PTE) Ltd,
Singapore

Page 1
Houston Chairs *JULIA ROWNTREE*

Pages 2 and 3
Piazza Patterns *JEAN DOBIÉ*

Pages 4 and 5
detail from **V.I.P. Cottage** *JEAN DOBIÉ*

CONTENTS

Introduction

A painting without light is a painting without life: somehow it lacks spirit and vitality. And yet you will see such paintings everywhere, often in museums and galleries. You will not quite be able to put your finger on what it is they lack, nor why they fail to grab your attention, but it is because they do not have the hidden energy that light brings to a painting. This doesn't mean that your pictures must be dominated by bright colors and thrumming optical gymnastics, although light can be added to create an atmosphere that is loud and attention grabbing. A painting may be bathed in a soft light that glimmers and glitters, or a light that is ethereal and utterly still and peaceful, yet hold a sense of movement and energy.

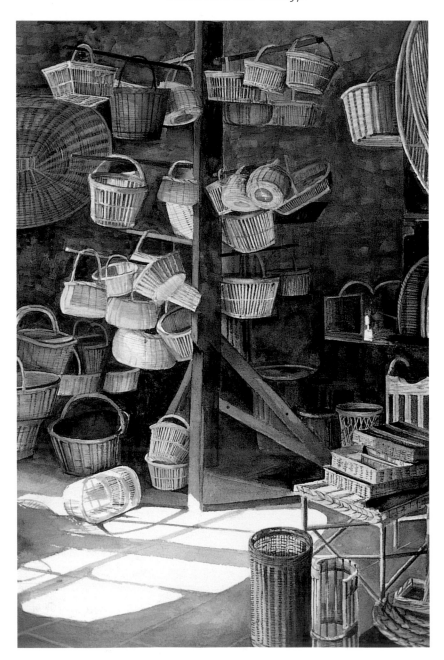

But this book, you might say, is about light *and* shade. Indeed, in painting, there can be no light without contrasts. A sense of light comes from contrasting it with its opposite—and this often takes the form of shadows. Bright light creates dark, sharp-edged shadows; soft light creates more subtle, indistinct shadows in a wide range of neutral tones. Shadows are often regarded as negative areas of a painting. Yet a sense of light in a painting comes through the subtle—and even unsubtle—colors found in shadows not always immediately noticed by the eye. These colors must be identified, or even created, to project a sense of light.

Watercolor is the perfect medium for capturing the illusive nature of light. When you apply a stroke of watercolor, you immediately create a range of tones—with white paper showing through the irregular

Baskets for Sale
ARLENE CORNELL
Sunlight steals into this basket store, casting golden rays on the floor and giving a resonance to the painting's earth colors—ochers, siennas, and umbers—of the baskets and of the deep shadows.

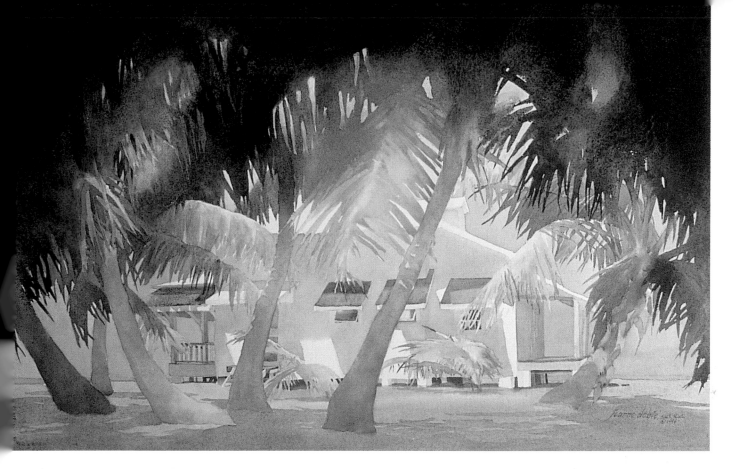

application of the transparent medium. But you can add another brushstroke of color to the first to create subtleties of color and tone, or superimpose a second wash after the first one is dry. Stroke in color, wet-in-wet, and it will bleed into the first color, feeding on it to make new combinations, before finally drying out in a pattern of color and texture. Yet, just in this one action of feeding one color into another there are so many choices to make—what brush, what mix of color, how much water—and predictions of the outcome are precarious. Watercolor is unpredictable by nature, which to most artists is one of its attractions. But you will get to know its foibles, although any experienced artist will tell you that, even after years of experience, you can still be surprised.

This book will show you how you can use watercolor to create and describe all aspects of light and shade, and so bring life to your paintings. We will explore how you can edit what you see in the physical world around you, simplify tonal ranges of light and shadow, and manipulate the physical structure of your composition to achieve this goal. As your confidence grows, we investigate specific techniques for capturing light and shade—how to paint light from the sky, capture isolated highlights, and bring interest and subtle variation to your shadows. Included throughout, to give you inspiration, are examples of artists' works, which say more than words ever can.

I hope that this book will give you the impetus and know-how to try out new ideas and bring the expressive power of light and shade to all of your watercolors.

Patricia Seligman

Keys to painting light and shade

Painting light and shade in watercolor is not simple, as anyone who has tried it will testify. There is valuable advice to bear in mind when you are painting, however, that will help you achieve your objectives. These pages set out the basic tenets of painting light and shade. They are covered more thoroughly at various stages throughout this book, but have been condensed here for quick reference. This is not the whole story, but if you can master these basic rules of thumb, you will bring light into your paintings. The artists on these pages have, through experience or instinct (or a combination of the two), mastered the basic principles, and their paintings demonstrate just how.

CONSERVE YOUR HIGHLIGHTS

With watercolor, it is the highlights—the white of the paper—which will bring light into your painting. Conserving these with masking fluid, or by painting around them is of the utmost importance and needs some thought before you start.

MIX PAINTS AS LITTLE AS POSSIBLE

Keep colors pure, and mix your colors minimally, if possible, on the paper itself. By doing so, the white of the paper can be seen through the transparent layer and will bring luminosity to your colors.

PIT CONTRASTS AGAINST EACH OTHER

Highlights need shadows or contrasting dark tones to pit themselves against in order to shine out.

Sun in the Street *HAZEL SOAN*
There is a tremendous feeling of energy and movement in this painting which comes from the bright sunlight blazing through the figures from the back. **1** You can see the important areas of white paper highlights around the figures, which are conserved with masking fluid during the painting process. **2** The highly saturated color of the figures has been mixed on the paper so that it remains pure and transparent, allowing the white of the paper to add luminosity. **3** Reflected light in the shadows provides added interest.

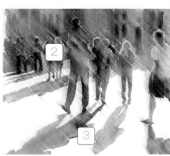

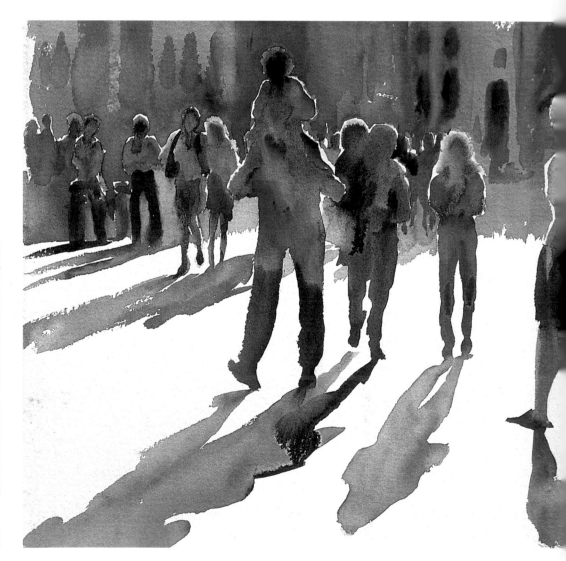

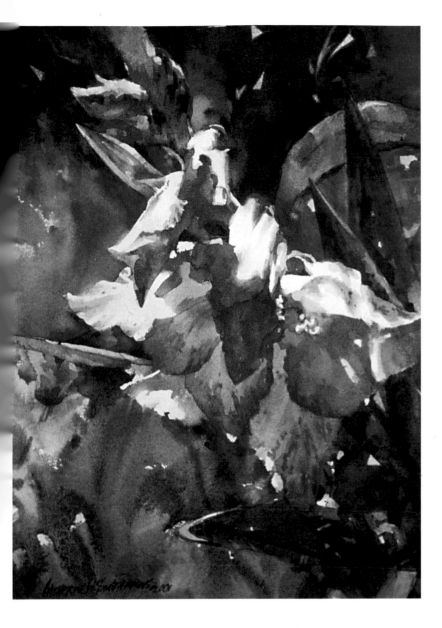

Gladiolus II *CATHERINE WILSON SMITH*
The sense of sunlight in this painting, conveyed by the glow of the flowers with their tangible luminosity, has been expressed through contrasts. **1** The luminous highlights have been conserved, and are shown up with good dark shadow contrasts. Warm and cool colors have been placed next to each other—contrasts which again serve to intensify a sense of energy and light. **2** There are warm and cool pinks and mauves in the flowers, and (**3**) warm and cool greens in the background. **4** Suggestions of complementaries, opposites in the color wheel, energize the background too—greens and reds, mauves and yellows.

Catching Rays *DIANE MAXEY*
Color does not have to be saturated and bright to convey a sense of light. **1** Here, subtle complementary yellows and mauves in the shadows give a warm glow to the painting, which is bathed in soft evening light. **2** Areas of duller opaque greens in the background provide a contrast to the transparent glazes used to describe the flowers and the shadows on the floor.

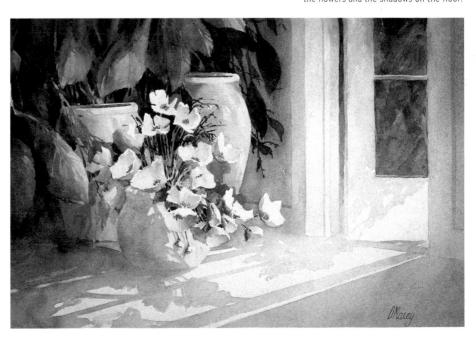

KEEP SHADOWS COLORFUL

Shadows are made of all the colors of the rainbow and are never dull. Look for reflected color from the object casting the shadow or from the sky. Mix these shadow colors on paper for the best effects.

BE AWARE OF EDGES

Include hard and soft edges, in order to describe the texture of objects and to place them in the picture space. The way the light falls on an object describes that object, but it also describes the light. Find and lose edges to keep the viewer's eye moving around your painting.

USE COLOR THEORY

Complementary colors and the juxtaposition of warm and cool colors can be used to bring light and energy into your painting.

DON'T FORGET MOVEMENT

Light is never still; it twinkles, shimmers, and flashes. Use pathways of light to bring movement into your painting.

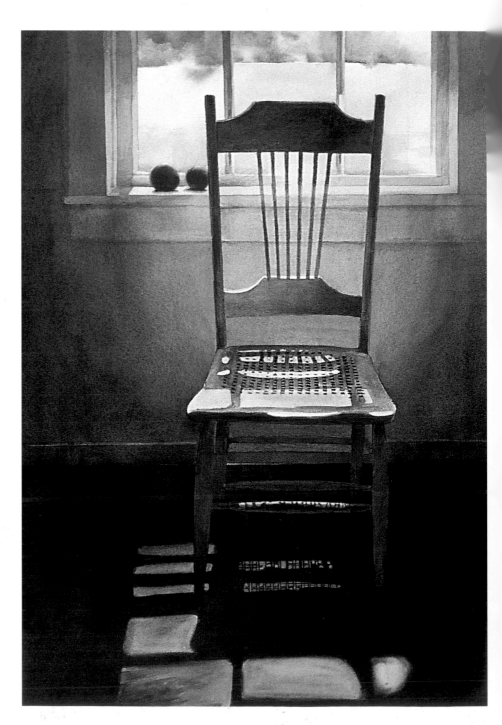

Summer *JOAN ROTHEL*
This painting features the simplest of subjects—a wooden chair and apples, both evocative of summertime. But of course it is the light which tells you what season it is. **1** A warm yellow light falls on the chair, varying its color and tone throughout to produce golden yellows, reddish browns, and deep umbers. **2** The falling light also varies the edge of the chair, losing it sometimes against the background shadows, only for the edge to reappear; starkly pale against the purple darkness.

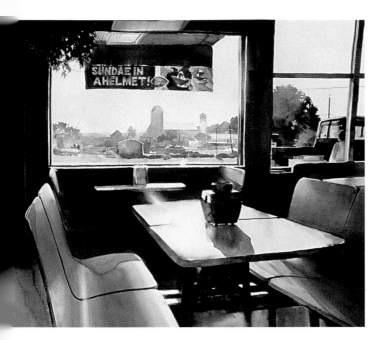

American Icons
JAMES MCFARLANE
This is a beautifully controlled watercolor, one where you can almost feel the light pouring in through the windows onto the polished surfaces of the diner. The painting projects energy by virtue of a studied route of light. **1** The eye enters the painting from the left, where there is a vertical highlight illuminating this area. **2** In the central part, the highlights beneath the table invite the viewer to explore this area. **3** On the near right-hand corner of the table, a touch of light shines out of the darkness. **4** The eye follows the lit-up surface of the table through the window to the view beyond.

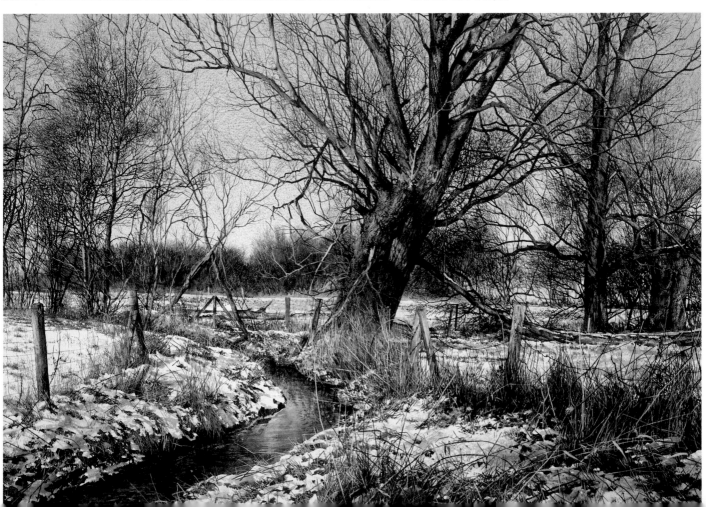

Homage to a Willow *MARTIN TAYLOR*
Combinations of transparent watercolor and opaque gouache give this painting an impressive sense of three-dimensionality. **1** The patches of snow are kept as white paper, with shadow glazes over the top. **2** Tree bark textures are worked up with drybrush techniques. **3** The light comes from the translucent blue sky, which has been allowed to granulate for an added sense of depth.

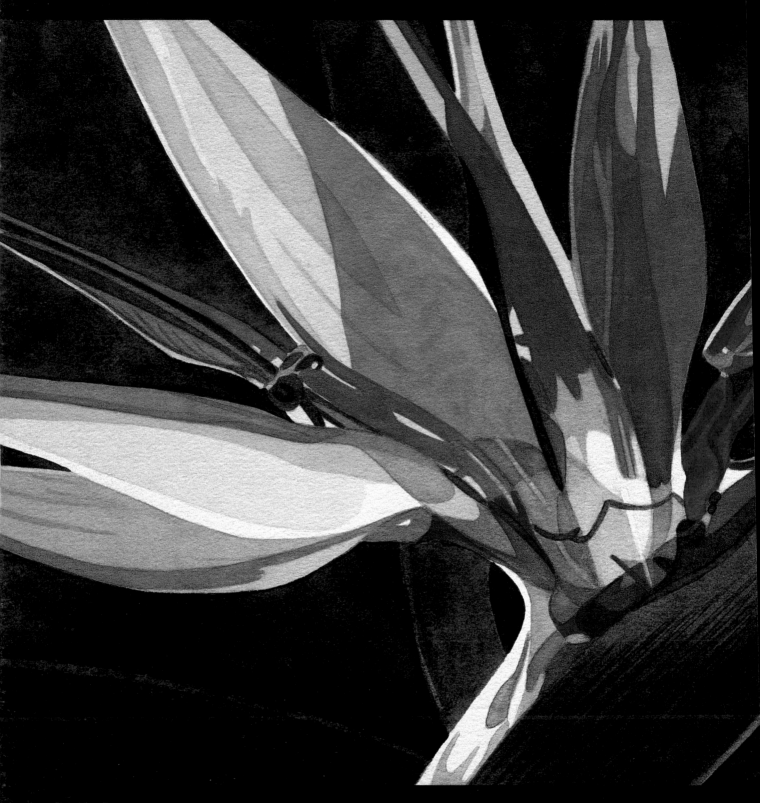

Bird of Paradise *MARJORIE COLLINS*
Seen against a dramatic dark background, the primary colors of
this showy flower appear bathed in sunlight. Closer inspection
reveals the simplification of the range of tones of these colors.
The white of the paper has been left for the brightest highlights,
which are balanced by the inky darks behind.

START AT THE BEGINNING

In this chapter, we will explore ideas on how to observe light and shade: from choosing the subject, simplifying it into something approachable, and arranging it into a composition using the subtle structures offered by patterns of light and shade, to exploring all these options in the preparatory work for a number of watercolors.

Learning to see a scene in terms of contrasts of tone is the first step toward the successful painting of light and shade in watercolor. Observation is the key, but an editing facility—the ability to make good decisions about what to put in and what to leave out—is always crucial. Simplification is essential, so that the artist may be be bold and free, and guards against too much detail.

Choosing a subject

Light is a huge subject and, as such, can be quite daunting. The best way to make a start is to paint what is around you. Don't go out searching for that life-changing vision, as you may come back empty-handed. Instead, begin with a still life at the kitchen table, a view out of the window, the street, your backyard, and beyond.

Nothing is too humble to be considered a subject for painting. After all, it's your interpretation of a subject that makes you an artist. Drawing people's attention to the perfection of unimportant elements may persuade them to look at things differently.

A vital part of seeing things as an artist does involves imagining how a person will view your painting when it is finished. How will they "read" it? You want the person looking at your painting to focus on something that you find especially beautiful, which has touched you. Your work is making a comment on life.

The Window Se...
BRYN CRAI...
A view from a windo... is available to most of u... Such a subject will chang... dramatically throughout th... day as the sun follows it... overhead path, changin... the direction, as well as th... strength and temperature... of the light that's cas... Observe here how th... sunlight creates a pattern o... shadows in the room and als... the patch of azure blue o... the window seat, whic... dominates the painting...

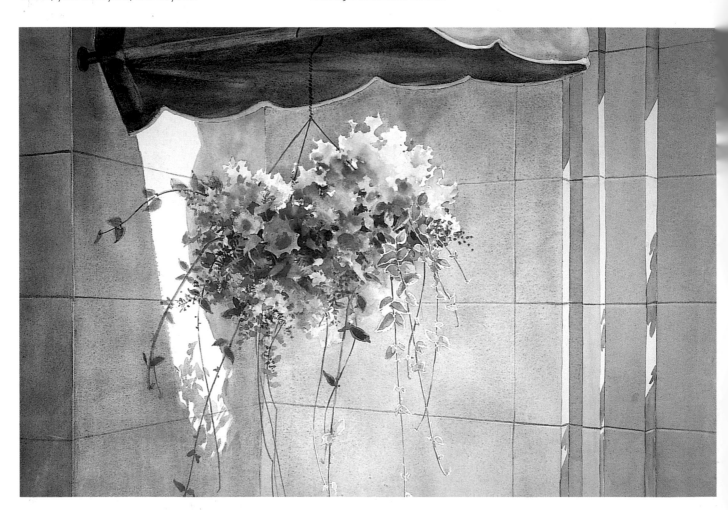

City Garden *RUTH BADERIAN*
You need not go far to find a subject to paint. In this case, a hanging basket in a city corner presents a pretty but not uncomplicated subject. A mysterious patch of sunlight dances on the flowers, casting shadows on the warm stone of the building. Choosing to bring in bright sunlight, even if only a patch of it, adds greatly to the dimension of the subject.

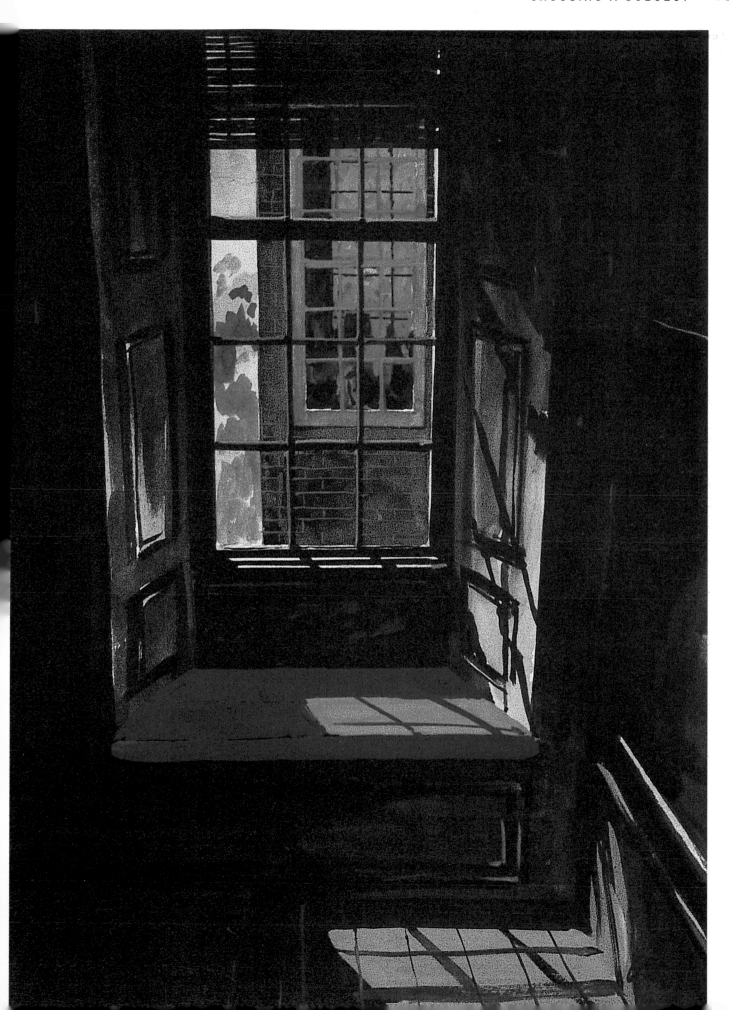

To gain confidence, try arranging anything and everything around you into small compositions of simple shapes, capturing them with a few lines. Keep things simple and record what you see. Study your subject in different kinds of light— both the changing light of day and the particular season outside affect the countryside, and this filters through if you are working indoors. Precisely how changes in the quality and direction of light can affect a chosen composition will be discussed in more detail later (see page 54).

Pictures of any sort—in magazines, in holiday destination sites on the internet, at art exhibitions—are sources of inspiration. But look at them from the point of view of a light-painting artist. Note where the light is coming from and how it affects the painting's mood—are the light and color upbeat with stark contrasts, or are they gentle with lots of subtle mid-tones?

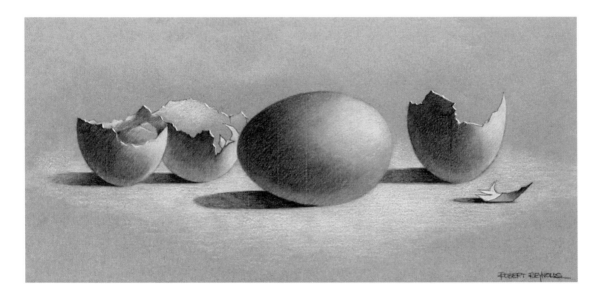

Egg Shells *ROBERT REYNOLDS*
If you are looking for a subject to paint at home, an egg and broken shells make simple, yet challenging, subjects. Exploring these here in charcoal, with white Conté pencil highlights, the artist produces a tonal sketch that will help to prepare for a watercolor painting.

The Pear-Tender
SUSANNA SPANN
This still life can hardly be described as comprising objects commonly found around the home. The artist has purposefully gathered a small collection of diverse objects of different shapes and textures within a narrow color range. Seen in the warm sunlight with strongly cast shadows, the result is captivating.

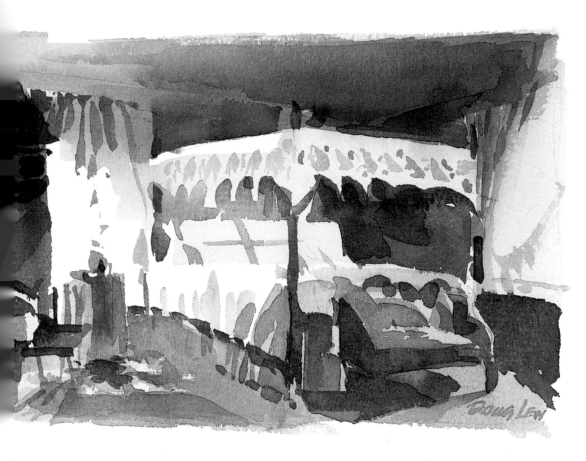

Guest Room
DOUG LEW
For this light-filled interior, the artist has produced an exquisite watercolor sketch, simply executed with a few carefully chosen brushstrokes.

Sketch Book
Fill your sketchbook with views from your everyday life. But remember, you are a light-painting artist, and so must always be aware of what the light is doing. Use arrows to note the direction of light and the time of day. Swatches will remind you of the colors you want to aim for. If you restrict yourself to a gray crayon for the mid-tones and a black one for the darker areas, you will find it easier to simplify the range of tones.

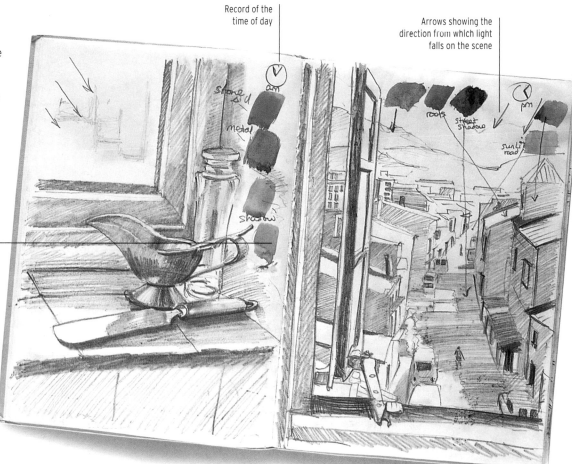

Record of the time of day

Arrows showing the direction from which light falls on the scene

Swatches of color to aim for and notes to link them into the sketch

Editing what you see

When artists look at a scene, they cannot transfer every detail of that scene into their paintings. An editing process has to take place, not only to make a painting possible but also because including every tiny detail is simply unnecessary. For example, if you were to outline a couple of bricks on an expanse of color, the eye would see a wall. Not every brick must be included.

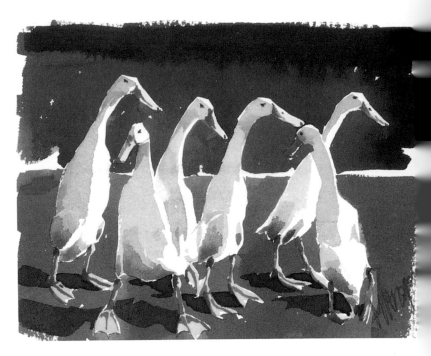

Indian Runners *MARY ANN ROGERS*

These ducks come to life with very few colors and tones. The artist has edited down the infinite gradations of tone to just a few, so that the imagination of the viewer can "see" the details of their feathers, even though they are not explicitly described.

Simplifying the tonal range

The same editing process should be applied to light and shade. Not every infinite subtlety of color and tone can be—or indeed needs to be—included in your watercolor. Artists only need to create "a plot," with a few clues, for the imagination of the viewer to do the rest of their work for them. What you have to do is suggest what is there so that the eye can read it. With light and shade, this means you have to simplify what exists by painting a scene's lightest and darkest tones, with a few tonal values in between. The eye will do the rest.

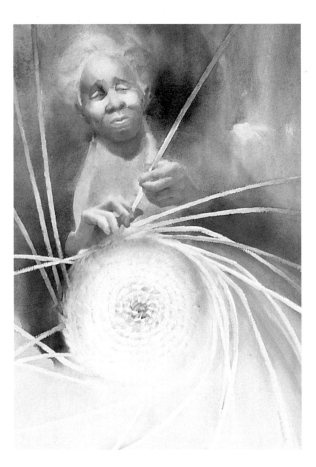

Lady Gullah *JEANNE DOBIE*

The focus of this painting is on the face and hands of the basket weaver. Consequently, everything else merges into the background. This is achieved through a misty cast of light, which comes from behind the viewer, emphasizing the frontal planes and producing soft colors in a mid-tonal range.

Editing the Tonal Range

It may seem like a simple red pepper, but don't let it fool you. First, the artist explored the tonal possibilities in a soft pencil sketch, simplifying the areas of tone. Next, he made a simple line-underdrawing, which mapped out those areas of tone. Then, using three tones of black watercolor, leaving the white for highlights, he brought the pepper to life.

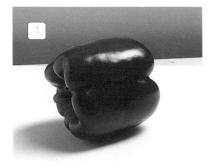

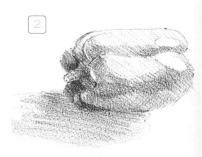

The best way to practice this is with photographs where the tonal range is already simplified to white and black. Make it even simpler by referring to black-and-white photocopies of photographs. Copy these by using paints, simplifying the tonal range with light gray, dark gray, and black, and using the white of the page as white. Isolate any highlights and progress with washes of pale gray, then add dark gray, and then black.

Making sense of the light and shadows

You will find that it takes quite a strong light for a visible cast shadow to appear. For example, if you paint a cup on a table without a shadow, it will lack conviction. Shadows give a painting three-dimensionality, add compositional interest, and also create contrasts for the highlights. Artists often must invent shadows that are not there—editing in rather then editing out. In due course, this will become second nature to you, but if you don't want to be too inventive at the start, make sure you paint a subject cast in a light that exaggerates the shadows.

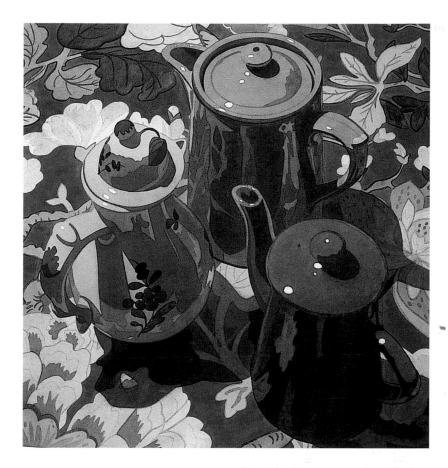

Three Coffee Pots *MARJORIE COLLINS*
Sometimes shadows do not show up because the light in a scene is too weak, so the artist needs to add them to make sense of the painting. The strong, clear direction of the light in this still life creates shadows that help model the coffee pots. These dark shadows add compositional interest and balance the highlights.

1 The artificial light shines strongly from the top right, casting a good strong shadow. Note how the shadow grows weaker and softer, the farther it is from the pepper.

2 A tonal sketch made with a soft pencil edits the information on light and shade, reducing it to a few simple steps from light to dark. However, the image itself is also altered to fit the artist's personal interpretation of a pepper: the shape has changed and some of the pepper's flaws have been edited out.

3 A simple line underdrawing maps out areas of tone. Next, the first wash is added—a pale mid-tone over the whole pepper except for the areas of highlight. The area to be painted is wetted with water first, and then the gray mix dropped in.

4 Allow the first wash to dry, then add the second tone of gray over the darker areas. Finally, seek out the darkest shadows with the black mix. The essence of the pepper is captured in simple, superimposed washes. The viewer can gain much information from this image without trying too hard.

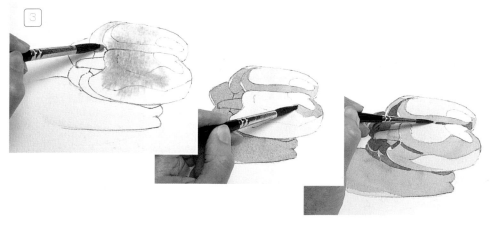

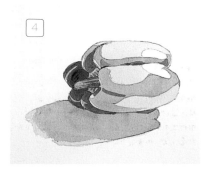

Texture and highlights

It is areas of light and dark that describe, or model, the three-dimensional shapes that make up a scene. The way that light is absorbed or reflected by the surface it lands on helps us learn more about that surface—it is a clue that artists can give a viewer to describe what they are painting. For example, if light falls on a person riding a horse, it will reflect off hard, shiny surfaces like the leather of the saddle and the metal stirrups, and be absorbed by the soft coat of the horse and the rider's matte clothing. So there will be bright, hard-edged highlights on shiny surfaces, and softer-edged highlights on soft, matte surfaces.

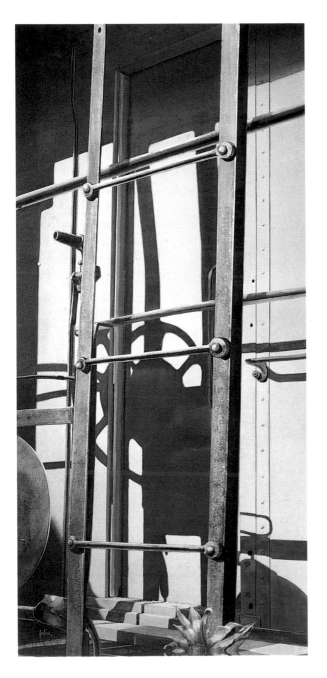

Describing Texture

Here we have three objects of varying texture: a soft, fuzzy-skinned peach; a pomegranate, the skin of which is tough and smooth, reflective but not shiny; and, lastly, a piece of smooth, but intricately patterned, driftwood. It is the light shining on these objects that describes the subtleties of their textures, and each texture requires a different technique to describe it.

1 Flood in the color of the peach; the paper's texture breaks up the edges. Then a semi-opaque wash of white gouache adds the downy fuzz of the skin.

2 The shape and texture of the pomegranate suggest a block-like treatment for the fruit's color and tone. This is best expressed with a square brush. The cool blue of the background cuts in around the hard edge of the fruit.

3 For the driftwood, lay down the shadows first and then add a color wash for the wood itself. But keep the brush dry for the final layer of darker blue-gray to describe the variations in the driftwood's texture.

The Caboose
MARY LOU FERBERT

The hard edges of the ironwork combine with shadows cast from within and without the picture space to form an almost abstract arrangement. By cropping the picture in this way, the artist has created a puzzle for the viewer, encouraging the eye to travel backward and forward along the compositional lines in an attempt to solve the riddle of the subject matter.

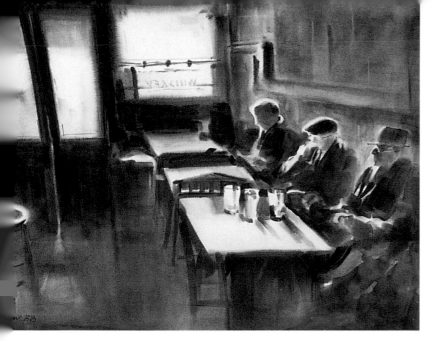

Beer for Three *DOUG LEW*

Seated in the murky depths of a room lit by artificial light, these three men would disappear into the background were it not for the light coming through the window behind them. Note how the details of the drinkers' faces and clothes are lost, but their outline is preserved in a halo of light–in this case, the white of the paper.

Drawing with light

Light falling on a scene has no respect for the fine detail of individual components with their neat outlines. In poor light, outlines disappear and figures merge into the background. Bright light can be equally confusing. It can light up a scene so fiercely that it bleaches out any color and obscures detail in highlights and deep shadow. For example, a white horse will show up against a background of trees, whereas a dark horse will merge into a background of similar value.

That artists have to make sense of all this is part of the editing process. A dark horse will disappear into a shadowy background, and its viewer won't notice it much. To rectify this, the instinct is to draw an outline around the dark horse, but this will give too much information to the viewer so that the result will seem labored. But you can use light to show a subject's outline. In the case of a dark horse, there may not be a curve of reflected light along its rump, but you can create one so that the horse does not disappear into the background. All that is needed is a sliver of white paper showing through between washes. Now the viewer has been given enough information to read the picture and you, the artist, did not have to resort to outlining.

Tonal Adjustment

Here below, the artist has used a photograph as the starting point for her painting. Her sketches explore different lighting options–there are many details to consider, such as how to make sense of the guitarist's head, which is "lost" against the dark background, and how to deal with the harsh light.

1 In the photograph, the light is coming from the flash of the camera to the front of the guitarist and bouncing off his forehead.

2 With the light shining from the top left, the back of the head can be seen against the background darks. However, this means that the guitar and shirt are now equal in tone, so a strip of light–the paler side of the guitar–is introduced to separate them.

3 Now we observe the same guitarist but with the light coming through the window behind him. This again "finds" enough of the head to allow the viewer to make sense of the composition. In tonal terms, it divides the composition into three areas, creating an energized central section containing a vital outline–of the head, profile, curve of the guitar, and separated fingers–which are all seen against the light.

Lighting should be softer for a "romantic" subject and the edges less stark

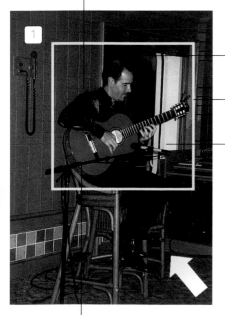

Head "'lost" against dark background

Crop to interesting part of photo

Background too busy–so energy of outline is lost

Clutter must be edited out

Light from front

Light from behind

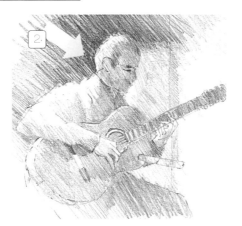

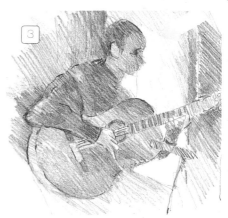

Composing with light and shade

Before they lift a brush to paper, artists spend almost as much time thinking and doodling as they do completing the painting. A lot of this time will be spent investigating the full potential of the composition.

What should be considered by a painter of light and shade? First, there is the physical structure of the composition, which can be manipulated through linking, or unifying, the various elements with areas of light and shade, to form rhythms and patterns in the painting. This may be a case of moving around apples and pears for a still life, so that the shadows and patches of light are an integral part of the composition. If you are painting outdoors, then you have to move around until your viewpoint of the subject offers what you are seeking, together with the right light. The mood of a painting can also be altered by the effects of light and shade. Your choice of colors and their strengths can create the bright colors and clear light of a spring day or the opposite strident colors and angry darkening light that may be associated with morbid thoughts about the state of our planet.

Hunstanton Beach *ALAN OLIVER*
This watercolor sketch looks almost unconsidered, yet the artist will have thought hard about compositional aspects before he put brush to paper. The eye is drawn into the golden, light-filled heart of the painting and then, enticed by warm pinks and reds, led off into the distance. Framing this central focus of light are cooler colors. This device is repeated, in a very subtle way, in the colors and patterns of the clouds in the sky above.

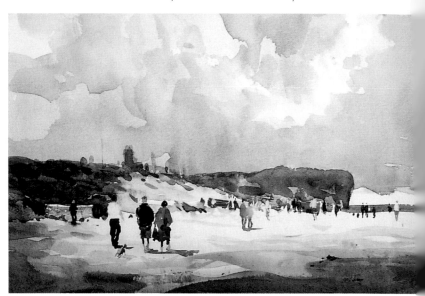

Light and Shade in your Composition

By changing the position of the source of light, you can manipulate the structure and mood of your painting. You can see here how shadows can be used to link disparate elements, thereby forming rhythms and patterns in the painting. In addition, the strength and quality of that light can affect the dynamics of the painting.

1 Under low, flat lighting, the objects in the arrangement are thrown forward to the surface of the composition, creating a decorative, almost two-dimensional pattern.

2 With light coming from the bottom left, the jug and the knife cast intriguing shadows, while the shadows from the vase and jug link to create a focal point.

3 Here, a bright light shines from low down, at the back of the vase, on the right. The resulting patterns of light and shadow create movement and energy.

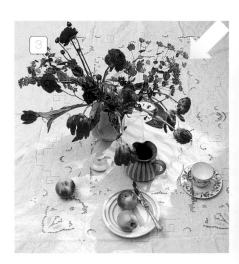

omposing ith shadows

Shadows can be used to great effect in a composition to link various disparate elements. few objects on a table can be linked with their ast shadows, leading the eye from one object to nother. In addition, light can transform what could e a dull group of objects by creating intricate hadows, which invite the eye to dance from one ighlight to another around the picture. In this way, ne eye of the viewer can be controlled in a journey round the painting. Try lighting a still life with ifferent strengths and qualities of artificial light; lso try changing the angle of the light and its istance from the subject. Take photographs or ketch the results, and make a note of different ghting arrangements so that you can compare hem. You will see how the direction and source of ght can alter the focus of a composition by hanging the directional lines found in the hapes of the shadows cast.

Outside, you can't move the sun, but you can hange your viewpoint and choose the time of day when you paint. A screen of trees will look dramatic f painted with a low, strong, summer light from

the back of your composition. This will show the shadows bursting forward into the foreground, providing lines down which the eye will obediently travel into the depths of the composition.

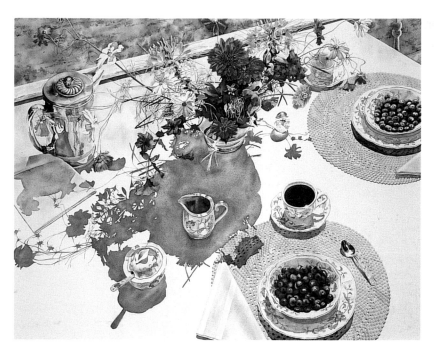

Blueberries, Dahlias, and Cleonie WILLIAM C. WRIGHT
There are so many choices open to the artist when composing a painting. For this late summer feast of blueberries and coffee, a high viewpoint has been chosen, which has the impact of isolating the individual elements of the composition—the cups, bowls, and so on. These disparate elements are linked together visually by the cast shadows and patches of highlight.

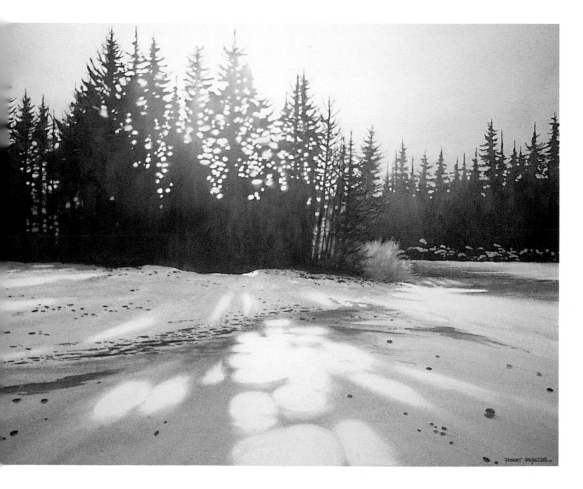

Winter Light ROBERT REYNOLDS
A screen of fir trees, backlit by the dying winter sun, throws long unexpected shadows across the snow, which are broken by patches of light. These directional patches of dark and light lead the eye into the picture space.

Unifying through light

The color of the light source—for example, the golden yellow of a summer's evening—can help to unify a composition, pulling the individual parts together. The easiest way to do this is to lay down a pale wash of color over the whole area of the painting at the start, thereby qualifying both the shadows and the palest highlights. Usually this unifying light takes its cue from the sky, but an underlying colored wash can be applied in an interior scene for the same effect.

Creating movement with light

When planning your painting, think about using light to bring a sense of movement into it. A planned route, made up of touches of light making its way through the picture, will invite the eye to explore the picture space and create a feeling of movement within it. Start from the left edge, where the western eye will enter the picture space, and take it on through the center in a wide arc, finishing with another arc to the top right, and then come back to the center.

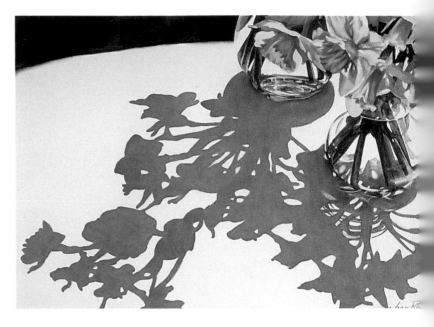

Tabletop *JOAN ROTHELL*
Here the shadows have become the subject of the painting. The vases of flowers, used to having the viewer's full attention, have been cropped and relegated to a secondary role in the background.

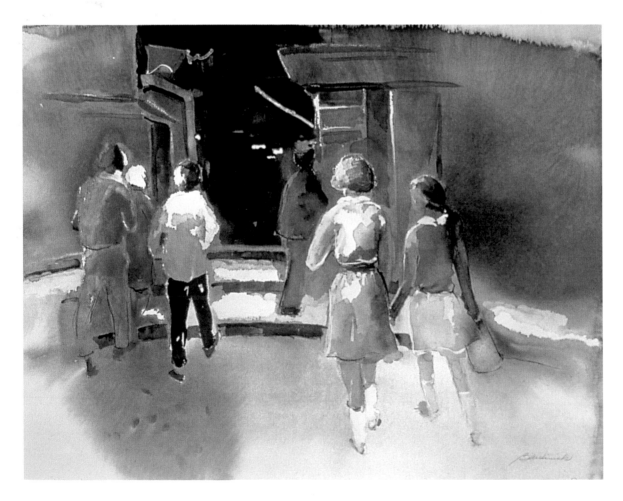

Concénto VII *BERNYCE ALBERT WINICK*
Well-placed touches of light lead the eye from the sides of this painting into the void beyond, linking the figures in the process. In this way, the composition is fully explored, bringing with it a sense of movement.

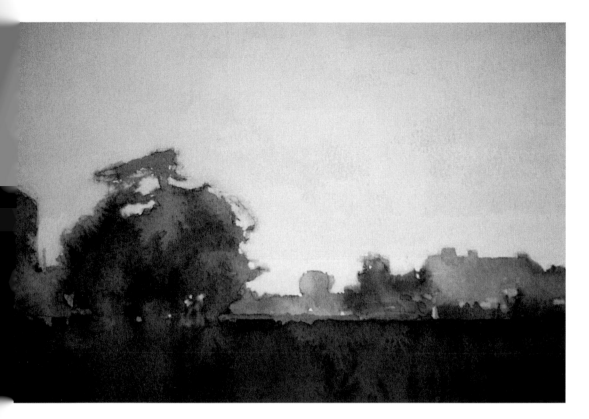

Evening, Stock Lane
PETER KELLY
The last vestiges of a hazy summer sun disappear below the horizon. To integrate the pale sky and dark landscape below, try taking the color of the sky down below the landscape as an initial wash. Touches of this wash will show through subsequent washes, and have the effect of unifying the painting.

Creating a focus

Create a focus in a painting by manipulating the eye to travel toward it through various artifices: directional lines, patches of color, bright light, or dark shadow. The careful distribution of highlights, or patches of shadow, throughout a painting makes the eye dance from one area to another around the picture, inevitably drawing it toward a contrived focus.

Controlling the mood

The quality of the light—its strength and color—will help you control a painting's mood. Look at Edward Hopper's disturbing paintings of everyday life, such as *The House by the Railroad*, painted in 1925. Like so many of his paintings, it is lit by a strong, cool, clear, and unnatural yellow light. This light, as though before a storm, suggests a sense of disquiet that sets the scene for a painting filled with nervous tension. You will notice that the quality of light changes with the weather and from season to season—compare the cool, pale lemon yellow light of a winter's day with the warm cadmium yellow of a hot day in summer. Take advantage of what nature provides to express mood in your paintings.

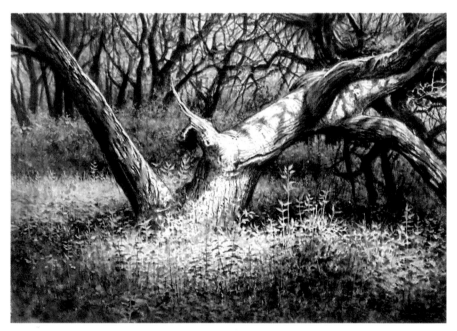

Light in Elfin Forest *ROBERT REYNOLDS*
When you stand looking at a scene, your eye will naturally explore it, resting on a feature that intrigues it, and hurrying over other aspects. This is what you want the viewer to do with your painting. Here, a patch of sunlight filtering through the trees creates a focus of light on the tree trunk, which draws in the viewer. Then, as if in a maze, the eye tries every exit along the various branches, returning to the center along broken lines of light, or through dark shapes acting as directional lines.

Reducing a scene to its basic components

Establishing the value of local color

Seeing light and shade

Tonal values

The most important step toward becoming an artist of light-filled watercolors is learning to look like one. This doesn't mean that you have to start wearing a beret and smock, and ride a bicycle! It means learning to see the world around you in terms of tonal values—as a patchwork of lights and darks—and not as made up of individual objects with an outline, each with their own local color. Looking out of the window you might indeed be able to see a wall, a tree, a fence, and a road—all of which can be drawn in outline. However, the painter of light-filled watercolors sees intricate, interlocking shapes of light and dark—highlights, shadows, and tones in-between—spreading over such a view, without respect for the boundaries of individual objects within his composition.

Local Color

The local color of an object is the color it actually is—a red tomato or a brown fox. This color has a tonal value when placed against other local colors. Here we have a mid-tone brown fox prowling through mid-tone brownish-green grasses, with a darker-toned green tree in the background. Establishing these local values is the first step to working out the complexities of relative tonal values in a painting.

1 It's difficult to judge the value of local colors when they behave so idiosyncratically. The warm, reddish brown of the fox comes forward, and appears to be higher in value than the coolish greens among the grasses.

2 A black-and-white photocopy solves this problem. From this you can see how the brown part of the fox is equal to the overall tone of the grasses. Blurring the image by looking at it through half-closed eyes allows you to see this more easily.

3 Establish the outline of the fox and its background.

4 Now with a graphite pencil, and ignoring patches of light and dark, add the tonal value of the local colors.

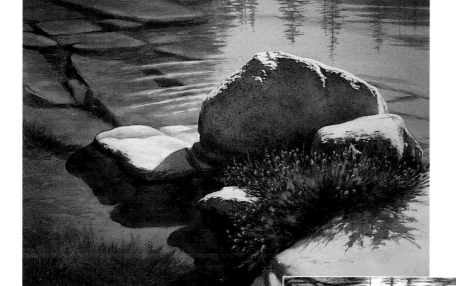

Summer Blossoms *ROBERT REYNOLDS*
Before painting, the artist explored the pattern of light and shade in a careful tonal sketch, right. The tricky part is the highlight at the top of the main rock, which appears against a patch of bright reflection on the water behind it. As you can see in the painting above, the reflection behind the rock is tonally darker and, when cut in around the reserved white paper, creates the bright highlight at the top of the rock.

Local color Learn how to view the world this way. Take a photograph from a magazine or one you have taken yourself—preferably one with clear, simple shapes shown in a strong light. Now copy it, reducing it to an outline of its individual components. Next, use a graphite pencil to shade in its local colors—the mid-tone of the red-bricked house, the slightly darker tone of the green leaves of the tree, and the even darker tone of the trunk.

Tonal Values

Now start again. This time, look at the same photograph with your artist-of-light-filled-watercolors hat on, that is, reduce the scene to a jigsaw of tonal shapes—areas of darkest shadow, highlights, and the tones in-between. Some painters find it easier to turn the photograph upside down, at first, so that objects' outlines do not interfere with their objectivity. Start with the darkest shape—such as patches of shadow under eaves, or beneath a tree. Add a mid-tone. Leave lighter tones as the white of the paper. Don't get bogged down in detail. Keep your work as simple as possible.

Tip: Half-close your eyes or squint. This helps to polarize color values and removes detail. If you're near-sighted, taking off your spectacles helps in the same way.

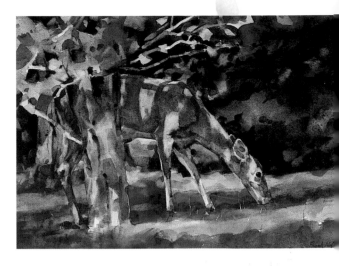

Noon-Day Snack *FRANK NOFER*
It is the deer's ability to melt into the background that saves it from danger, and the artist wants to convey this to the viewer. Seen in the dappled sunlight, the composition becomes a jigsaw of color and tone, making it difficult to see outlines clearly. The local color of the deer becomes striated with light and shade, so that its outline is sometimes clear against the background, and sometimes lost.

Seeing Light and Shade
Making sense of the pattern of light and shade in a scene requires you to look at it with total objectivity. With a photograph or photocopy, this can be engineered easily by turning the photo upside down. This way, you can see the areas of light and dark without being influenced by the dramatis personae—in this case, a fox.

1 Turn the photocopy of the fox upside down and study the areas of light and shade.

2 Without an outline, feel for those shapes through tone. Here, the dark background describes the ear of the fox. This comes close to how you would create the ear in watercolor. The subtle difference is that, instead of painting the ear and then the background, you describe the fox using the background and contrasts of tone.

3 The fox emerges in all its glory. Note that the artist has used her experience to edit the image further—by varying the tone of the background to produce a more interesting, inconsistent edge along the back of the fox.

4 Now you can create an underdrawing that can be used as a guide for the proposed painting. This is a distillation of all the thought that has gone into the above preparatory drawings, but is nevertheless kept simple. It comprises an outline, specifically of the fox (which could be erased before or after the painting), and also an outline of the areas of highlight and shadow.

Underdrawing
What we are working toward is an underdrawing for your painting. Now look at all of your sketches. Your painting will be a combination of information from these approaches. You will be aware of the outlines of individual components, and the tone of their local color, but you will also be painting blocks of light and shade. Armed with the information from your preparatory drawings, a useful underdrawing would outline the elements in the composition and then add outlines for highlights and shadows.

Most watercolor artists lay down some sort of underdrawing, usually with a pale graphite pencil that will not damage the surface of the paper or show through the superimposed washes of color. An underdrawing can be very intricate and the product of a great deal of preparatory work or, conversely, it can be a quick sketch from life, meant purely as a rough guide.

Tip: Photocopying simplifies further the tonal range, and extremes become more obvious. It might help you to see these extremes.

Approaches to preparation

Capturing light and shade in your watercolors requires a certain amount of planning. All artists have their own methods for doing this. For some, planning involves a few moments' thought before the business of painting begins. For others, the pleasure of picture-making could be said to derive more from the intellectual preparation of the work than from the painting itself. Here, you can see, first-hand, how different approaches to preparatory work can be—we look at the preparatory work of four different artists.

Permutations and combinations

Marjorie Collins' style is very precise, leading to paintings that are real to the point that you want to touch them. You can see the techniques used to achieve this on pages 106–109. She considers her options carefully before she begins to paint. Here we join her in her efforts to choose the best arrangement possible from the point of view of painting a still life, whimsically entitled *Life is a Bowl of Cherries*.

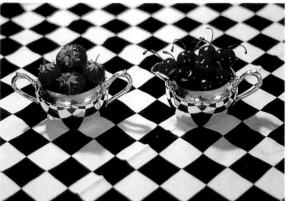

Simplifying the Composition
There are so many options here—whether to feature both the strawberries and cherries, or just one fruit, for a start. However, it is the reflections in the silver creamers that are of primary interest in a composition like this. The arrangement shown here is interesting, but there is too much going on.

Optical Illusions
The artist added a backdrop of polka dots in an attempt to break up the checkers and the scattered fruit. The fruit in the silver bowls is lost against this background.

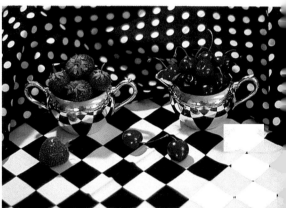

Distorted Reflections
Here is another compositional idea, with the berries cocooned in the checkered material. The concentric circles of the tablecloth are distorted in the reflections of the silver bowls to attractive effect. This composition doesn't work as a single piece though.

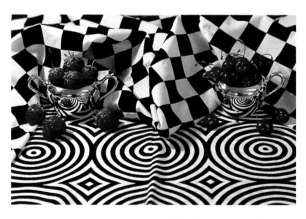

Final Decisions
The cherry-filled creamer in solitary state makes the most dramatic set-piece, with the eye drawn to the cherries and then compelled to linger on the reflections in the silver. The folds of the checkered backcloth are disturbing, though; the calmer effect of the flatter version above is preferable, as it does not detract from the still life. The artist's final choice of composition was a combination of both these versions. It was worked up into a very careful underdrawing and underpainting, as you can see on page 106.

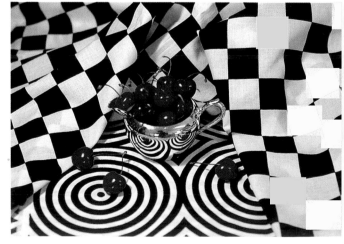

Manipulating the tone

It is early evening, with cool sunlight from the top left throwing up the contrasts in the foreground dry-stone wall, and casting dark shadows along it. The first step is to look at the scene's tonal distribution, using a black-and-white photocopy of the color photograph of the scene. The artist, Julia Rowntree, then tries out some color swatches and a small color sketch. This is followed by a few doodles to help make decisions about techniques and brushes, and a more detailed color sketch to explore the possibilties of keying up the work. The final painting is simply called *Dry Stone-Wall*.

The Color Photograph

This is the artist's starting point—the color photograph. The overall impression is of an expanse of green. The artist remembers the purples of the grasses in the field and the yellow flowers. You have to look hard, but they are there and will need to be brought out. The landscape is easily divided into three parts—foreground wall and grass; middleground fields and farm; and background hills.

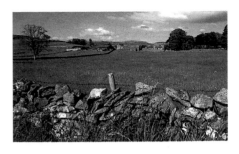

Tonal Adjustment

The black-and-white photocopy shows that some tonal doctoring is needed to bring light and energy into the scene and create a sense of recession into the far distance. This occurs in the tonal sketch, with muted tones in the background; mid-tones in the middleground; and more extreme darks and lights in the foreground. A plan for conserving the highlights evolves in the form of masking fluid for the distant walls, applied with a pen.

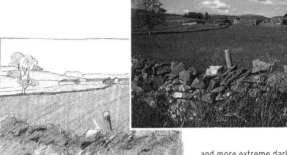

Color Swatches

Some ideas for colors are tried out—different combinations of Cerulean, Sepia, Aureolin, and Raw Umber. The artist uses a tiny color sketch to see how these colors react together.

Technique Options

Various techniques are explored for the different effects they produce—a fine brush for the pattern of light and shade on the foreground stones; a pen and watercolor for more graphic strokes; spattering with a toothbrush for foreground texture; and broken lines created with the edge of a credit card dipped in paint for the grasses.

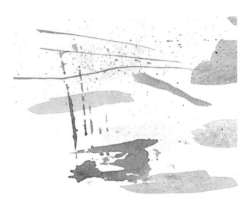

High-Key Version

A more detailed color sketch attempts a high-key version of the same scene, meaning more saturated colors and stronger contrasts. It departs too much from the original memory of the view, and the artist decides to abandon this idea.

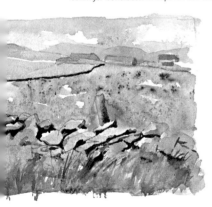

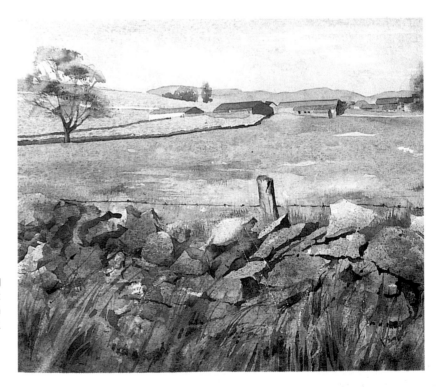

The Painting

The soft tones of the countryside shine through, but with higher contrasts and more saturated color in the foreground to bring in a sense of light.

The editing process

Here, the artist, Glynis Barnes-Mellish, takes two color printouts of a young girl as her starting point; she likes the sitter's pose in one and the lighting effects in the other. Having a few slightly different views of your subject allows you to pick and choose in this way. This experienced artist has painted many portraits in a similar way, and her approach to preparation is quick and intuitive. Having studied the views, she goes straight into an underdrawing, and quickly on to a tonal underpainting. See pages 74-77 for another portrait of the same sitter by the same artist.

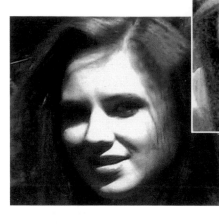

Gathering Information

The chosen pose (center) must be combined with the light effects of the sunny photo (left), where a strong natural light is coming from above and to the sitter's left. The lack of focus in the photograph of the chosen pose provides a useful general impression of the girl's features, whereas details, such as the color of her lips, can be obtained from the other photograph. Note, however, how the pixilation of the unfocused photo (right) can also suggest color mixes, particularly for shadow areas.

Underdrawing

An underdrawing is important in a watercolor portrait: you must get the proportions right, as watercolor does not allow one to feel for a likeness as some other mediums do. The drawing needs to be visible but not so black as to interfere with lighter parts of the painting. Keep your hand relaxed or the pencil line will score into the paper, which will interfere with the paint surface.

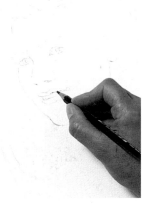

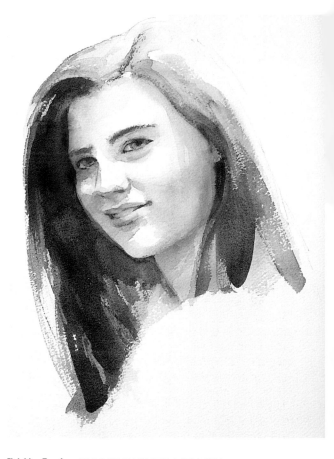

Underpainting

This first underpainting of Alizarin Crimson and Yellow Ochre, which models the form, is not strictly part of the preparatory work, but it is the equivalent of a tonal sketch. Most important of all, it maps out the areas of highlight which must be conserved as white paper.

Finishing Touches GLYNIS BARNES-MELLISH

The effects of the sunlight on the young girl's face, including the shadows of the hair across her cheek, have been taken from the rejected pose and skilfully combined with the chosen pose, as seen here.

Thought and Preparation

Adelene Fletcher's talent for evoking light in her paintings is not the result of chance but of a great deal of thought and preparation. For this painting of a peony (entitled *Pretty in Pink*), which you can see in full on pages 98-101, she starts with two photographs, taking the form from one and the color from the other. She wants the flower petals to radiate light, so she changes the tonal layout, exploring balance and contrasts with a black-and-white sketch. Next she considers manipulating energy and movement through patterns of light. Finally, she makes a temperature map, planning the areas of warm and cool color to add even more energy to the painting.

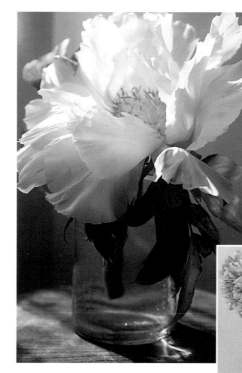

Starting Point
The basics come from these photographs—the form from the white peony and the color from the pink one. As you will see, the information contained in these photographs can suggest ways of developing the composition.

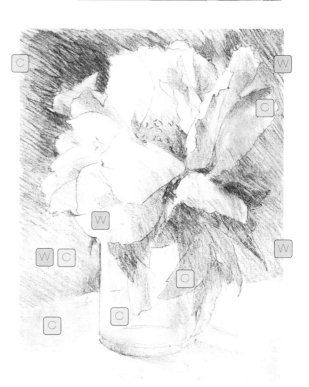

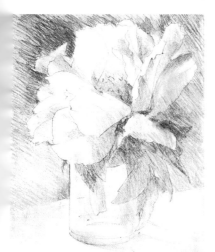

Contrasts for Light
The background is worked up in deepest darks to show up the purity of light on the flower's petals. To balance these darks, and to keep up the main tensions within the flower, the lower half is lightened. Contrasts within the flower head must also bring out the highlights, but this will be done more with saturation of color than with tonal variations.

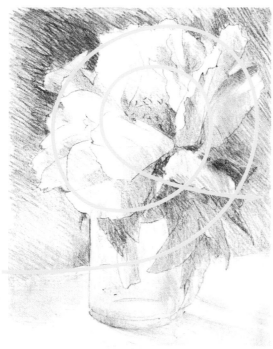

Light and Movement
To make the light travel around in the picture, the artist plots a pathway of light through the painting. The eye is compelled to follow this preordained route, jumping from one patch of highlight to another. These highlights are already evident in the photograph, but they have been adjusted slightly to make the pathway more evident.

Color Temperature
Alternating areas of cool color with areas of warm will help to bring energy to your painting. You will see that there are warm and cool colors within the flower, and these in turn will be next to warm or cool parts of the background. This plan is worked out on the sketch (W=warm; C=cool) and used as a reference as the painting evolves. Now turn to pages 98-101 to see how the painting works out.

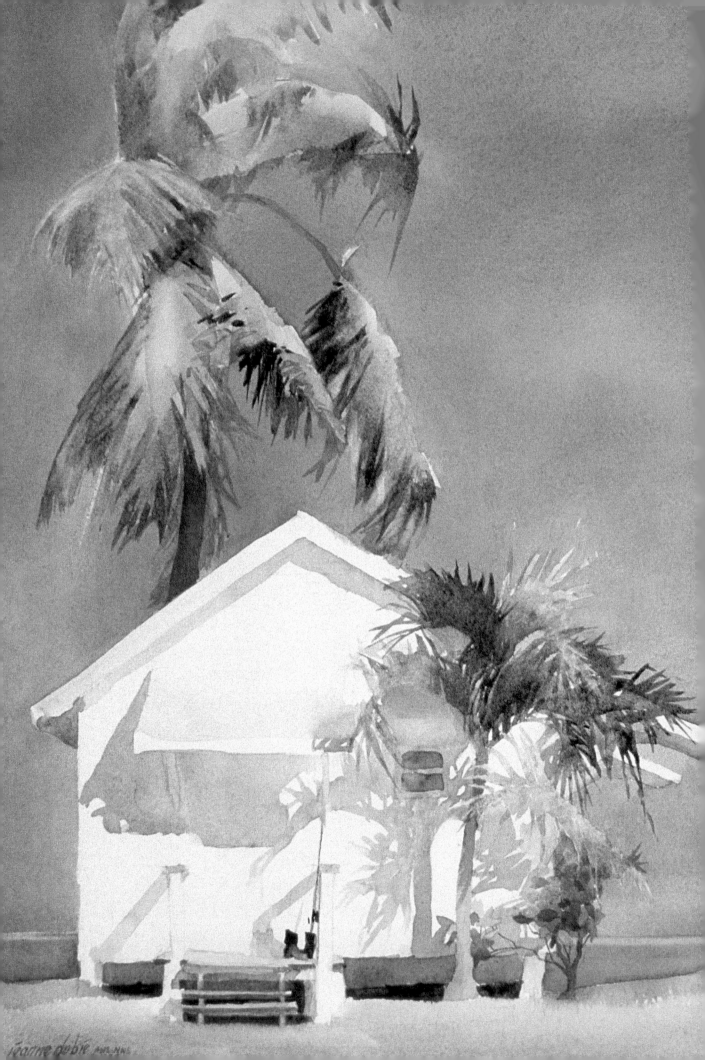

TECHNIQUES FOR LIGHT AND SHADE

As we have seen, painting light and shade in watercolor requires planning. Some artists view this as the inspirational part of a painting. It is vital to plan how your painting will evolve before dipping your brush into water. First comes the underdrawing, in which a painting's highlights are located. Then come your ideas about how you will build up the color and areas of shadow. Knowing how watercolor paints behave and how you can manipulate them becomes important. In this chapter, we will look at techniques that are particularly useful for painting light and shade—from both natural and artificial sources.

As in all painting, there are no shortcuts to experience. But learning and practicing don't have to be arduous. Playing around with paints is time well spent, and can be both relaxing and fun. Try mixing different colors and see how they interact. See what a difference more or less water makes. Try dry paint and drippy washes; add wet paint to dry, and vice versa; flick it; stipple it, sponge it. Note how the paint changes color when it dries, and sometimes tone also.

Even when you think you have mastered them, watercolors will surprise you. They won't allow you to get stuck in a rut. This delinquent side to watercolor paints should be seen as a positive element, which forces you to think laterally, reassess, and regroup. When a wash granulates into textured color when you are least expecting it, harness the result in your painting and write down the recipe for it so that you can use the technique again. Painting is meant to be a relaxing experience, but with watercolors, your powers of invention are constantly tested.

V.I.P. Cottage
JEANNE DOBIÉ
You can feel the heat and light emanating from this painting. But you can also sense the drama of the storm, with the wind whipping up the palm fronds. The blue-gray sky was created using superimposed washes and color that was fed in, to prevent it from looking too even.

Painting light from the sky

Painting the sky, or the "atmosphere," is where the painter of light and shade is likely to start. And indeed the sky deserves special attention. It is where light comes from; it is the fount of energy and light. Of course, light emanates specifically from the sun, and usually the sky is brighter around the sun. But the sky, filled with tiny particles, also reflects and carries light from the sun, bathing the landscape below.

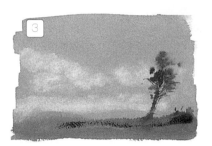

Simple Wash with Clouds Lifted Out

Are you ready to paint with your paper taped to board? You'll need a good brush and plenty of paint. Here, the artist has used a square brush and a dilute mix of Cobalt Blue and Indigo. To give the sky the intense color shown here, the paint was applied straight onto the paper, without the paper being made wet first.

1 Load your brush and, starting at the top, run it across the paper. Quickly load it again at the end of the stroke if you need to. Then repeat the process, overlapping the previous stroke so that the two merge.

2 Now, lift off fluffy white clouds with a tissue before the paint has time to dry. If the paint is drying quickly, spray it with a mist of water from an atomizer (as used for spraying plants). Make sure you choose a color with minimal staining power for your wash, or you may find that the color won't come away.

3 The landscape is added while the sky was is still damp, so the edges blend into it, merging the sky and land. You can see how much less intense the wash is, now that it has dried.

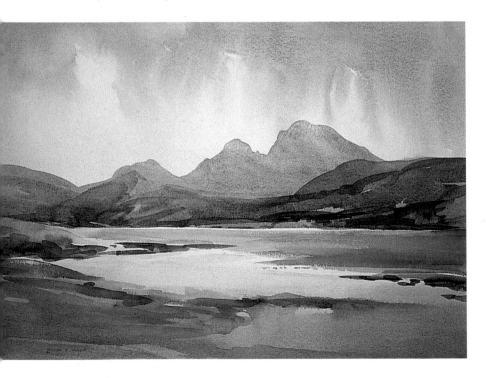

Skye—Bleven from Loch Slapin *AUBREY R. PHILLIPS*
Heavy rain approaches across the loch. Into a broken wash of blue, yellow gray is fed in, allowed to merge, and then encouraged to drip down the paper. Note how touches of white paper show through for highlights.

Watercolor washes

Painting skies in watercolor is particularly satisfying, as the medium lends itself naturally to the subject with wonderful, luminous washes where the white of the paper shines through a transparent layer of paint. Simple washes—plain, graduated, and superimposed—miraculously turn into blue or cloudy skies, sunsets, or snow storms.

Laying a wash

For a wash to be successful, you will need good-quality watercolor paper, which will absorb water without buckling. Your paper should also be stretched and taped to a board with masking tape. This makes the paper easier to handle when controlling the paint, which often drips and runs. You will need to mix more paint than you can possibly imagine needing. There's nothing more annoying than having to remix paint halfway through a wash. You will also need a jar or small bowl in which to mix it, using only clean water. (You need two water jars, one in which to clean your brush and one with which to mix paint.)

Trees
DAVID HOLMES
A few simple washes come together to capture the misty early morning light. A superimposed scumble of watercolor pencil picks up the texture of the paper and softens the edges between the sky washes.

Ready to go? Then charge your brush. A good-quality, large round brush works well, as it holds a surprising amount of water, although I have seen a one-inch decorator's brush, and also a sponge, used to good effect. Apply the paint in strips from left to right, recharging your brush, if necessary, at the end of a strip and overlapping the previous one slightly. Having the paper attached to a board makes it easier to support it on your knee at an angle so that the paint drips downward. Don't be alarmed by the state of your "wash" when you have covered the area, as it will dry at very different rates. It will take a while to judge how dilute your paint should be. If the wash is not intense enough when it has dried, all you have to do is add another one on top.

Superimposed washes— complementary colors

You will have seen watercolor paintings which literally glow with an intangible quality of light. This effect can be created simply by painting one pale transparent watercolor wash and then superimposing another over it. The first wash should dry completely before you apply the second. The vibrant nature of these two washes is increased if you can make use of the alchemy of complementary colors. Sky colors, cool yellow and blue—or warm orange and mauve, superimposed as washes, will produce surprising results. Try some combinations of your own to see how they work.

Superimposed Washes
Here, the first wash was applied, wet-on-dry, and the second applied, wet-in-wet, to allow the colors to mix more effectively. If you allow the first wash to dry first, the effect will different.

1 Over the top of a Cadmium Yellow wash, add a second wash of Permanent Mauve with a touch of Indigo. These colors are near-complementary, so the combination is full of energy. Don't worry if it's uneven.

2 Lift off the moon using a tissue wrapped around your finger.

3 Lift off the reflection in the water with the tissue pulled into the correct shape.

4 With a darker mix of the mauve and indigo, and a dry brush, paint in the horizon and water shadows.

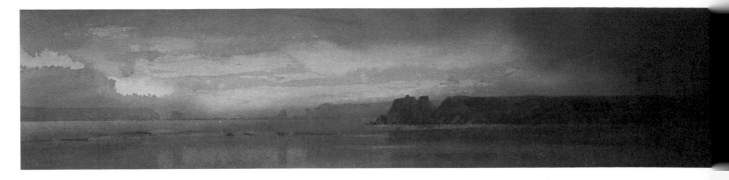

South Beach *NAOMI TYDEMAN*
This painting displays a wonderful mixture of washes for a stormy sky: wet-in-wet to produce the darker soft washes on the right, and wet-on-dry to allude to the hard-edged clouds on the left.

Off the Holcot Road *MARTIN TAYLOR*
To capture this luminous winter sun, the artist first laid down a pale, cool yellow wash and allowed it to dry. Then, a blue graduated wash was added over the yellow and made paler toward the horizon. This created the effect of light emanating from the lower part of the sky.

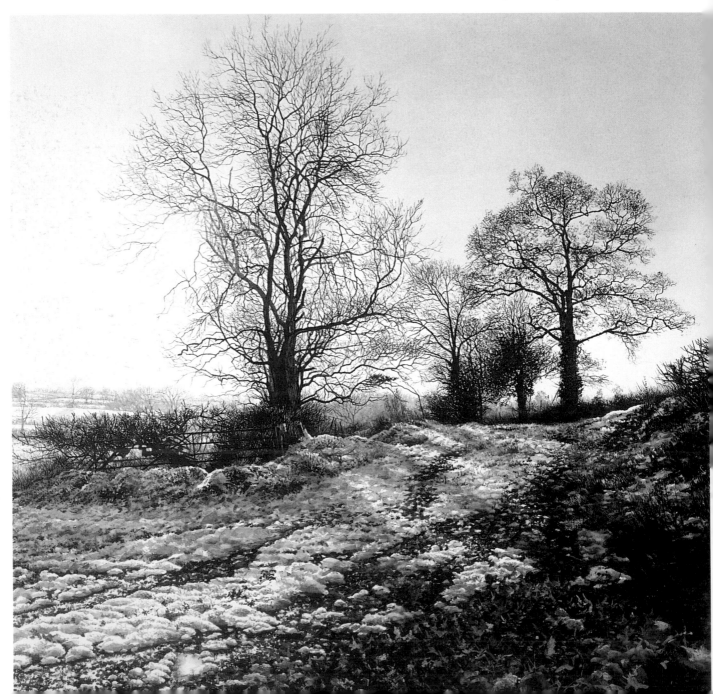

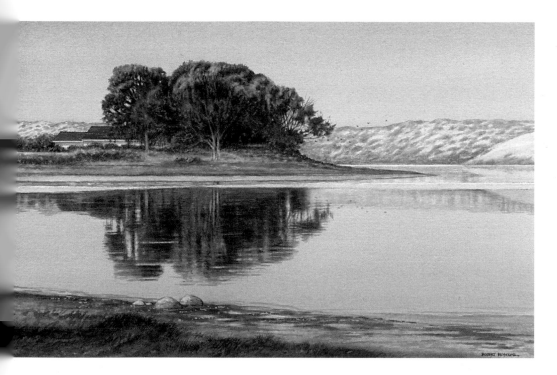

Coastal Reflections
ROBERT REYNOLDS
A perfect blue sky tinged with pink on the horizon is executed as a graduated wash. The paler color on the horizon helps to create a sense of recession in the painting.

Waiting for washes to dry

Watercolor painters can spend a lot of time watching paint dry. But there are ways around this, not least working on more than one painting at a time. If you are working indoors, you can use a hair-dryer to speed things up, but do not use it too close to your painting or on a very hot setting. Outside work can prove more trying. On a cool, damp day you may need to take up bird watching, as the paint will take forever to dry. This can be very frustrating. However, a blistering hot day can be equally challenging, and you may find yourself mixing pints of paint for your washes, only to find them drying in streaky layers. This will force you to work with alarming speed and accuracy.

Graduated wash— atmospheric perspective

Once you have mastered a straight wash, you can try graduating it—making it darker at the top and lighter on the horizon. This is, of course, what happens in nature: a blue sky appears darker above and paler toward the horizon. This effect is the result of atmospheric perspective, which you can also see in a landscape and, if you paint a sky in this way, it will help to express a feeling of recession toward the horizon. If you paint the same effect into the landscape below, the sky and the land on the horizon will come together, and you won't have the problem of the sky appearing to hang in front of the land.

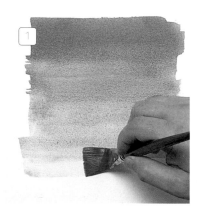

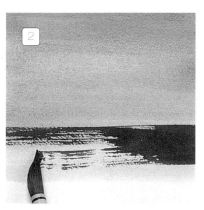

Graduated Wash

In a graduated wash, the color becomes more dilute as you go down the page. Start with a good mix of color and then dip the brush into the water pot before you reload it with paint at the end of each stroke.

1 More water is added to the Cerulean Blue until it reaches a very dilute state near the bottom. You can always add more water to the paper and take off paint with your brush if the color is not dilute enough.

2 A Permanent Mauve and Indigo mix is used, together with a dry brush, for the waterscape.

3 The paler sky on the horizon mimics the effects of atmospheric perspective, and keeps the sky behind the landscape.

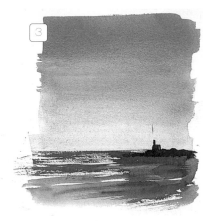

Variegated washes

Skies are rarely just one color, and a good way to suggest the different layers of color in a sunset is by washing the whole of the sky area with clean water, using a large brush, and then feeding in a mixture of colors—blue at the top, and streaks of yellow and red below. Have courage, as the effect is alarming at first, and the colors can look far too bold. But you can push the colors around by tipping the board or clearing off drips with a clean brush. When dry, the colors will meld and soften dramatically. However, if you can see that the effect is going to be too strong, run the whole sheet of paper under the tap, gently encouraging the paint to come away with a soft brush. Then start again.

Lighthouse—Shoreham JAMES HARVEY TAYLOR

You can see how the variegated wash for the sky—blue, red, and yellow fed unevenly in diagonal bands onto wet paper—has been carried on down the paper. The lighthouse and shoreline have then been painted, wet-on-dry, over the top of the lower half.

Variegated Wash

Sunset colors—Cadmium Red, Cadmium Orange, and then Permanent Mauve and Indigo—are dropped into a fresh Cadmium Yellow wash and allowed to run into each other.

1 With the yellow wash still wet, lightly feed in the red and then the orange. Lift off color with a squeezed-out brush if it's not going the way you want it to. You can also control it by tipping the board to guide the merging of the colors.

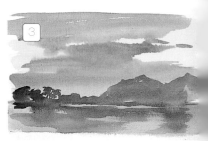

2 Now add the cooler color of Permanent Mauve mixed with Indigo. Feed in saturated color with the tip of the brush, and then mix it, using broad strokes, into the other colors at the bottom for a layer of cloud.

3 Dried with a hair-dryer, the colors do not merge much more. But be careful you don't move the paint with the jet of air. Place your hand between the dryer and your painting to deflect the stream of air. The landscape is added later, wet-on-dry.

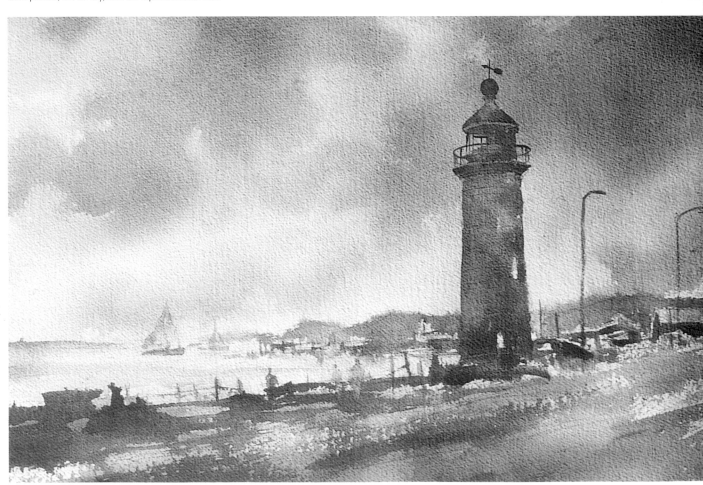

enetian Mist
PETER KELLY

r the misty early morning
ky, a number of subtle
ashes are built up. After
lowing the paint to dry, add
reas of textured dry brush.
he sun, and the aura around
, can be taken back with
ome clean water on a brush,
efore the yellow disc is
dded, wet-on-dry.

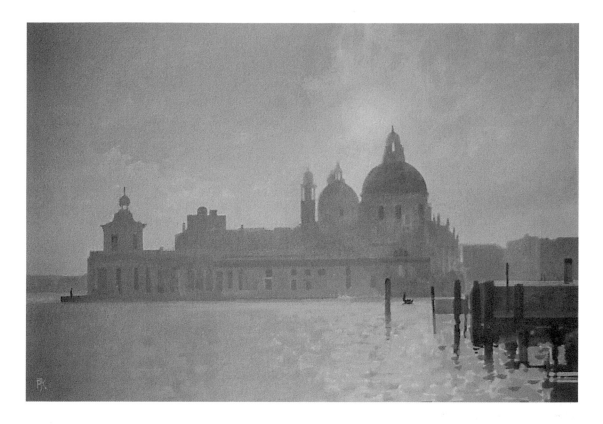

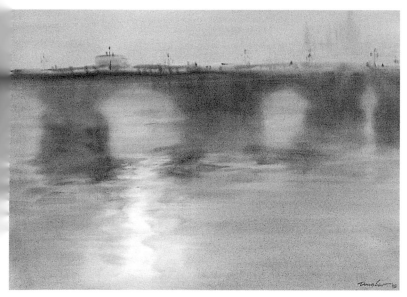

London *DOUG LEW*

Although this watercolor has been executed,
wet-in-wet, to achieve the soft edges created by
misty light, an initial wash has been taken down
the paper and allowed to dry. The artist then wet and
worked on areas like the bridge, which allowed him
some control of the outcome. To extend the drying
time, and to allow extra time to paint, you can add
blending medium to the water you use.

Taking the wash under the landscape

Taking a wash under the landscape carries the color of the light in the sky to the highlights in the landscape below, neatly unifying the two. This is useful when the sky is bright and close to the horizon, as it is in the early morning or evening. The landscape will appear dark against the horizon, but it helps if the tonal values come from the sky hues that are laid down initially as the first wash.

Evening Distant Sea
ROBERT TILLING

To create subdued evening
light after the sun has gone
down, bold variegated washes
have been fed in, wet-in-wet,
taking them down the paper.
Then, before the paint has
dried, the reflections on the
water have been scraped
back with a blade.

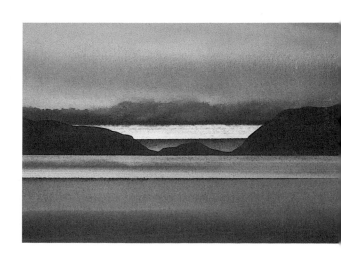

Reserving points of light

Cutting in with dramatic darks

Scratching out highlights with a blade

Capturing highlights

The real art of capturing light in painting is in representing contrasts—areas of light and areas of shadow. Highlights are as important as shadows. As we have seen, highlights are affected by the quality of the light, by its strength and color, and also by the materials off which they are reflected. Strong, bright light creates hard-edged, white highlights. Softer, more diffuse light produces soft-edged, paler highlights. For example, the highlight on a fluffy cat will be softer than that bounced off a shiny car—although both will be softer if seen in a misty light. But how can we show these differences?

Evidence of light does not necessarily have to be bright or stark—a touch here and there is enough to give the idea of the sun's rays or the

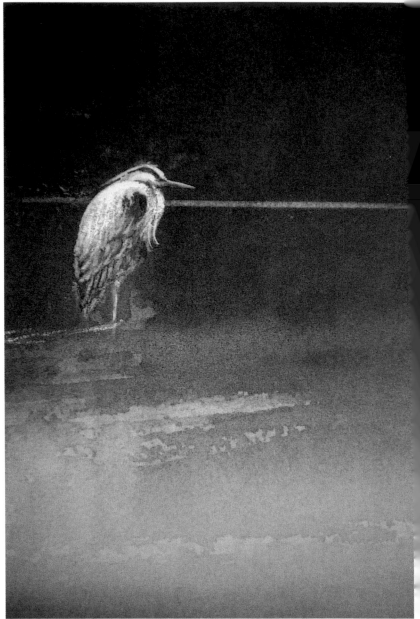

beam of a lamp. But of course with watercolor, a highlight is not so much a touch as a part of the plan you made before you started to paint. Highlights must be isolated and conserved. Results should look like touches, but they are usually more contrived than that.

Heron *NAOMI TYDEMAN*
Seen in the distance at dusk, the highlights on the heron's feathers will be soft-edged. Here, on good quality paper, they have been scratched out with a blade. For even softer effects, try scratching out highlights with the broken edge of an old credit card.

Joan's Bouquet with Wicker *WILLIAM C. WRIGHT*
The contrasts here are extreme, with areas of darkest dark and whitest light creating an upbeat mood. In high focus and strong light, the emphasis is on harder edges, but there are variations in the softer-edged highlights within the bunch of flowers.

Masking Fluid

The strength of light has an effect on the physical nature of highlights. Strong light produces hard-edged highlights. Working around clearly defined lines, or patches of highlights, can be tricky, and you may find that masking fluid is the answer. This magic potion is applied to areas of highlight; the fluid dries quickly and can be painted over, keeping the paper underneath white. Although derided as cheating by some artists, it can produce some truly wonderful results and is definitely worth exploring. If you're the sort of painter who gets carried away easily, happily painting over areas that you originally meant to reserve as white, masking fluid will suit you well.

After you have made a tonal map of your subject, with the highlights outlined, you can reserve these patches of brightest light by filling them in with masking fluid. Masking fluid is a rubber-like solution that isn't easy to manipulate and ruins a good brush. Keep an old ragged brush for the purpose of applying it and don't bother to clean it. The fluid dries to a pale yellow, so when you reach the point of wanting to rub it off (which is best done with a kneadable eraser), it is often something of a shock to see the brightness of the white paper. Most of the painting's highlights will then have to be toned down a little.

Rush Hour
JEANNE DOBIÉ
Imagine painting this subject without masking fluid. For thin lines, apply the mask with a dip pen and ruler held away from the surface. If edges of paint appear too stark once the masking fluid has been removed, gently tease them away with a wet brush and blotting tissue.

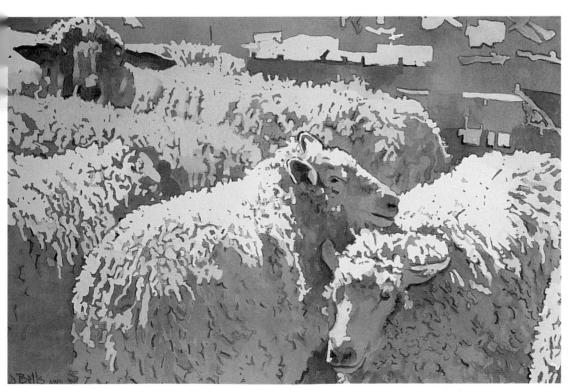

Snug Harbor *JUDI BETTS*
Invented and exaggerated light patterns convey a feeling of intense sunlight. The hard-edged highlights on the sheep's wool and the abstracted shapes in the background are usefully conserved with masking fluid.

Cutting in

The same hard-edged highlight can be made by cutting in with dark paint around a shape. This is easier if shapes are larger, so you might use this technique for a tree in the foreground, but use masking fluid for small patches of dappled sunlight. You might work up from white paper, adding mid-tones, and then cut in darker shadows in the background along the length of the trunk of a tree, leaving the very edge as white. This is usually done wet-on-dry so that a crisp edge results.

Soft-edged highlights

Soft light produces soft-edged highlights. Soft edges are best created, wet-in-wet, by adding paint to washes that have been allowed to dry a little, but which will still merge slightly with the newly introduced color.

Flowering Dogwood *JOAN ROTHEL*

This is a dramatic study of light and shade, where the passage of light from left to right is almost palpable. Once the soft-colored neutrals of the flower shadows have been established, the background darks can be cut in, wet-on-dry, around the petals to display crisp edges and highlights. Masking fluid was used to preserve the sharp edges of the tablecloth.

Shadow Dance *JOAN ROTHEL*

In this intriguing painting, dappled sunlight plays on the lily pads, combining with cast shadows and reflections in the water to produce an almost abstract study in light and shade. Areas of highlight on the lily pads are soft-edged, and have been gently coaxed from the layers of qualifying watercolor that surround them. Keep edges blurred by removing paint from them with a wet brush and blotting them with a tissue. Brighter dots of highlight-reflections on the water take the eye into the depths of the subject.

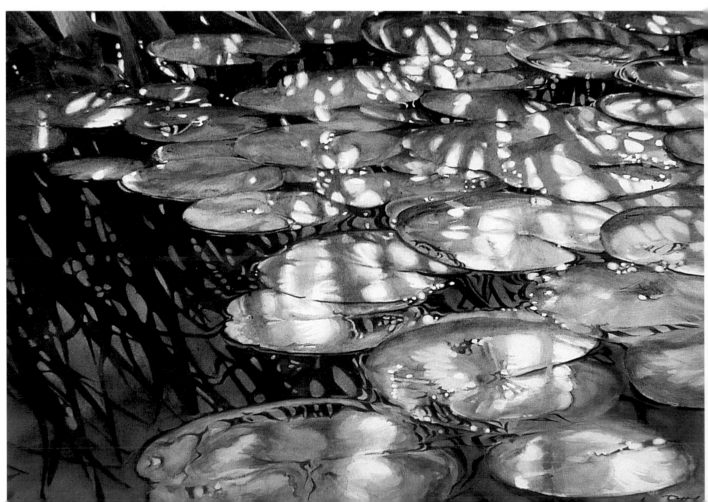

Grandma's Gate Half-Shut
RUTH BADERIAN
The hard edges of the man-made surfaces of the fence and gate contrast with the softness of the flowering shrubs. This also applies to the highlights here. For the gentle contrasts in the background flowers, color was added, wet-in-wet, and then, once dry, softened along the top edge, by the artist lifting it out with a clean wet brush and blotting with a tissue.

Blotting

Soft-edged highlights can be lifted out of darker colors with a soft tissue or absorbent cloth manipulated into the appropriate shape. This needs to be done with a deft action that comes cleanly away without disturbing the surface of the paper. Some paints stain the paper more readily than others and don't come away so easily, so it is worth exploring this possibility before you make it part of a plan for a painting. Edges that appear too hard can be blotted immediately with a tissue. If they have dried, then wet them with a clean brush, gently work at the paint, and then blot them with tissue.

Stippling

Stippling involves applying very dry paint with a coarse stubby brush in a stabbing motion. It is useful for soft-edged highlights, reproducing textures such as fur. It can be applied over a previous wash, or by adding one color to another and mixing them.

Curve in the Road
NAOMI TYDEMAN
Drybrush techniques, including stippling, have been used to create the dappled sunlight on this country lane. The soft highlights of the rough-textured road contrast with the harder edges of the surrounding foliage.

Techniques for artificial light

Artificial light is generally regarded as harsh and unforgiving, yet there are many different sorts of lamps producing a multitude of qualities of light, including so-called daylight lamps which emulate the real thing. The type of artificial light you choose will depend on the effect you want to achieve. Restricted light from a spotlight produces a brightly lit cone of light. Diffused light from an ordinary lightbulb bathes everything near it in a flat light.

Painting scenes that are lit by artificial light sources has its advantages. First, your light source will stay where it is and remain constant in strength and color—qualities you cannot expect of the sun. A simple light—from a bulb, match, or candle—casts a globe of light, that creates bolder contrasts and

harder-edged highlights the closer you are to it. This globe of light is often modified and directed by a shade, so that where the light peters out at the edge of its sphere, its range of values is reduced to the dark end of the tonal scale.

Try out scenes with lamps shining on your subject from all angles; the constancy of the light allows you to study how highlights are effected. Strong directional light, as that produced by a spotlight, can produce dramatic effects, with a strong focus and bright, hard-edged highlights. Spotlights intercepted by a flat surface will cast circles of light that cut into shadows and create interesting geometric shapes with variations of tone.

Number 2 Line MAF
LOU FERBER

This dramatic scene mu
have taken a great deal
planning before brush w
put to paper. In this dimly
interior, the light created
the molten metal casts
harsh yellow light on
surroundings. Hard-edge
bright highlights are painte
wet-on-dry, at the source
the light. These become les
intense and softer edge
painted wet-in-wet, th
farther away they are

The Buena Vista
BYRN CRAIG

Look at the different kinds of artificial light in this painting. In the restaurant below, the lighting is so-chosen because it exudes warmth. Wet-in-wet color, with touches of paper showing through for highlights, evoke this mood. The light shining from the top-floor windows is, by contrast, chillingly flat and stark.

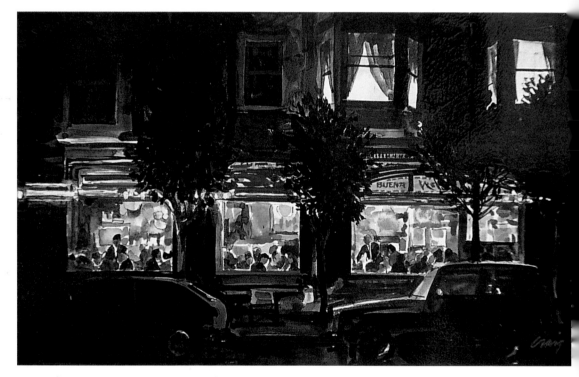

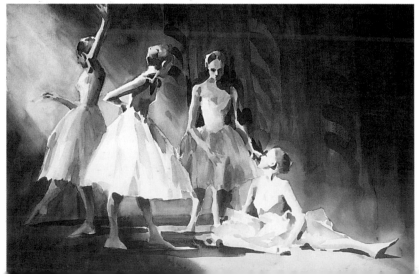

Dress Rehearsal *DOUG LEW*
A spotlight's beam rakes across the stage of the dress rehearsal, producing a strong directional light that you can almost touch. Highlights are bright and hard, and were formed by the artist cutting in around the figures by using the background shadow colors, wet-on-dry. Note how, in the full glare of the light, all detail is lost, but that there are subtle tonal passages beyond it.

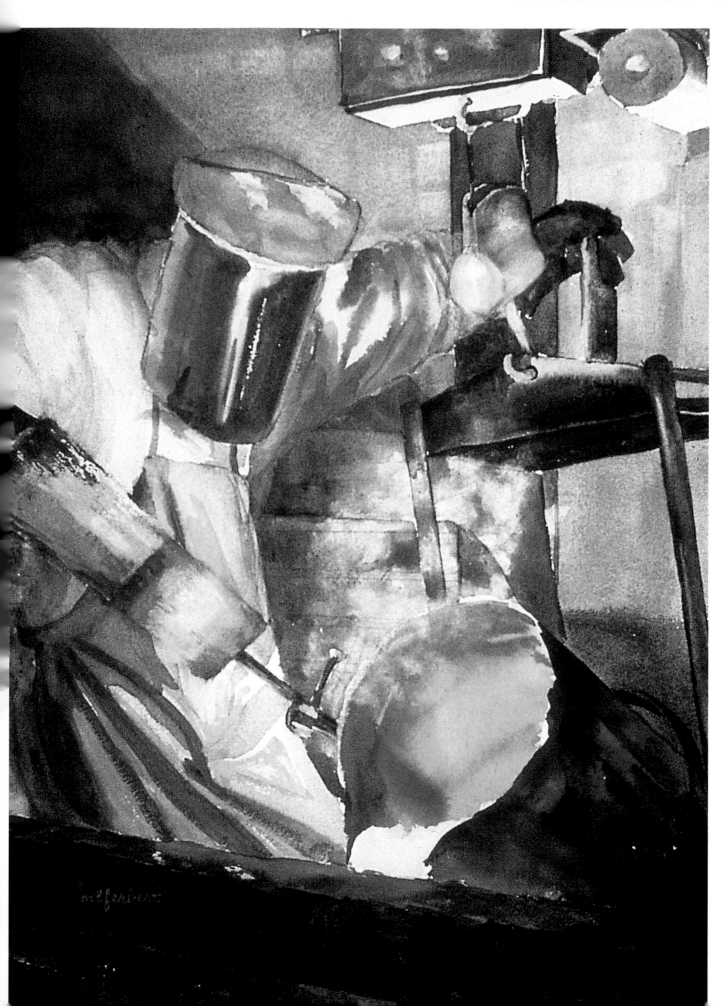

Cindy in Bed *DOUG LEW*
The brightness of the bedside lamp illuminating this interior scene bleaches out all detail at its source. The gradations of tone within the arc of light have been carefully controlled. There are small touches of drybrush throughout the painting–to soften the highlights on the edge of the bed linen and covers, for example.

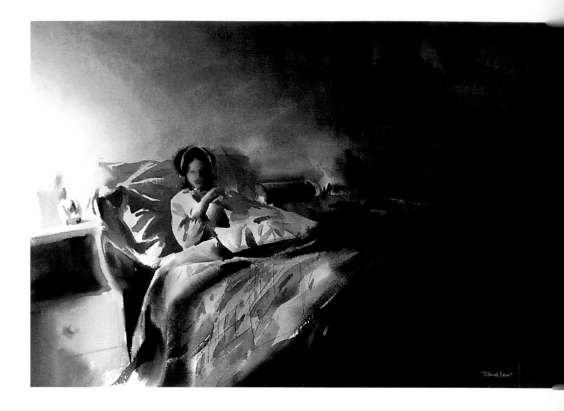

Working into darks with a blade

Many interior scenes concentrate on areas of dark shadow with brightly illuminated corners. This means that, at the center of the focus of light, the highlights will be hard and, at the edges, they will be softer. If you need to create a highlight in an area already painted in dark shadow, you can work back to the white paper by scratching into the shadow with a blade. This is not necessarily a technique of last resort, as it has a graphic quality that is useful in its own right. But make sure that the paper is properly dry before you work into the darks, or you may damage the paper surface and it will look more like a gouge than a scratch. Other "tools" will produce different qualities of highlight. Try plastic–the corner of a credit card works well–for softer marks.

Body color

You can also use body color, an opaque white, to touch in highlights when you're close to finishing your painting. You don't want such highlights to be too white or too impasto. You can apply body color neat to get greater covering power, and then blot it with a tissue to allow the preceding washes to qualify it and flatten it into the picture surface. You will need to practice, as body color behaves differently from most watercolors.

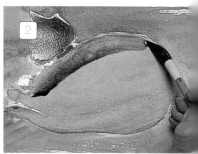
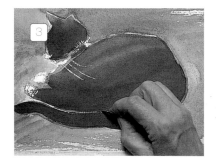
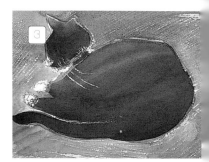

Scratching Out
The whiskers and other highlights on this cat lying in a dark corner are best scratched out with a blade. Paper used for this needs to be of good quality. The best effects come if you build up a true depth of tone to start with.

1 The background has been built up with variations of Viridian, Cadmium Red, and Raw Sienna. Now the cat itself is filled in by adding Ultramarine Blue to the main background mix.

2 Once dry, add another layer to the cat, this time a layer of black, building up the tone. Take this wash almost to the edge to bring some light into the painting.

3 With an angled blade, scratch into the darks for the whiskers and then add the line between the body and tail.

4 Graphic lines have also been scratched into the background, adding movement and light.

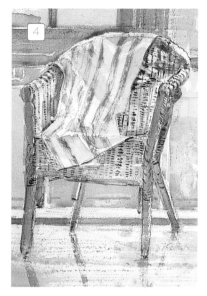

...ses of Drybrush

...rybrush has so many ...ses–to capture a texture, ...o recreate broken color, ... to express a soft outline– ...l of which help to bring light ...to a painting. This painting ...f a wicker chair is a case ...a point. For drybrush, ...he paint used should not be ...oo dilute, and the brush ...hould be squeezed out on ...ome tissue before it is ...ipped into paint.

1 Drybrush is first used for the towel on the back of the chair. The red brushstrokes for the stripes are broken up by the paper's texture, thus recreating the texture of the towel.

2 To capture the woven wicker, small horizontal drybrush marks are painted carefully over the under washes, which in turn suggest the structure of the chair.

3 The soft-edged shadows cast across the floor by the chair are broken up not only by the drybrush technique but by clear wax, which, with a household candle, has been drawn in horizontal strokes across the floor area.

4 All of this drybrush work comes together in the finished painting to create an image suffused with light. Highlights help to communicate the form and texture of the chair and towel, and the floor's shiny surface.

Drybrush How can you capture highlights that are no more than glistening nuances of light, which you might see reflected off rich materials or textured surfaces? It is difficult to see how the artlessness of such a vision can be captured without laboring it. Try using a drybrush and dryish paint to scumble a layer of paint over a thin dry wash, or simply over dry paper. If the paper is rough-surfaced, the hairs of the brush are encouraged to separate, allowing the paper to show through in subtle points of light. Using more opaque pigments on your drybrush–such as Cadmium Red rather than Alizarin Crimson–will increase a sense of depth. You can also use this technique to produce a softened edge, such as a fringe on a piece of material, and for the softer edges of larger areas of highlight.

Indigo *FRITZI MORRISON*
An eerie golden light from a single window qualifies the whole painting. Laid down as a paler, diluted wash over the whole paper, this golden light can be seen shining through the main washes of the snow. Most important are the tiny points of highlight that show through. These have been created with a drybrush in the foreground darks, and by scraping back with a blade along the roof edges.

Painting shadows

Shadows are often regarded as a negative part of any painting—dark patches that are black and uninteresting. But this need not be the case. Just look at the shadows in a Monet snowscene, where the shadows sparkle with subtle colors such as touches of pale Burnt Orange among mauves. These shadow areas have attracted as much thought and devotion from the artist as any other square inch of his painting.

Natural light produces natural shadows, and a painting without shadows will look flat and two-dimensional. Shadows describe an object, modeling its form, and placing it within a space by showing where it stands in relation to other objects. When painting a scene, you have first to decide where the light is coming from—from the side, behind you, or in front of you—and at what angle. The direction of the light and the resulting shadows must remain constant throughout the composition.

Tonal values

The range of tonal values from light to dark, that is, the contrasts, that your painting covers will depend on the quality of the light, particularly its strength. If the light is very strong, your painting could cover the whole spectrum of tonal values, from brightest white to darkest black. But such a painting would be harsh, and wouldn't actually emanate light as successfully as less extreme contrasts. A less bright, misty light would create less extreme contrasts covering a narrow band of tonal values, maybe more toward light than dark. The paintings here show how different scales from dark to light can be. Sometimes the range has been chosen to convey a certain emotion—perhaps a range on the bright side to evoke a sense of well-being, or strong, unnaturally extreme contrasts for a surreal painting.

Potter's Workshop
NAOMI TYDEMAN
Misty light filters into this dusty workshop, casting soft-edged shadows in an area of great detail—note the potter's lunch, complete with glass of wine. In this area, the range of tonal contrasts is narrow, and tends toward the light end of the scale. On the other hand, the shadowy darks of the foreground framework of shelves are at the dark end of the tonal scale.

Four Windows
CLAIRE SCHROEVEN VERBIEST
Bright, warm, golden light casts sharp-edged shadows, particularly on the even surface of this building's façade. But the tonal contrasts are not too extreme. Shadows on the washing reflect the blue sky above.

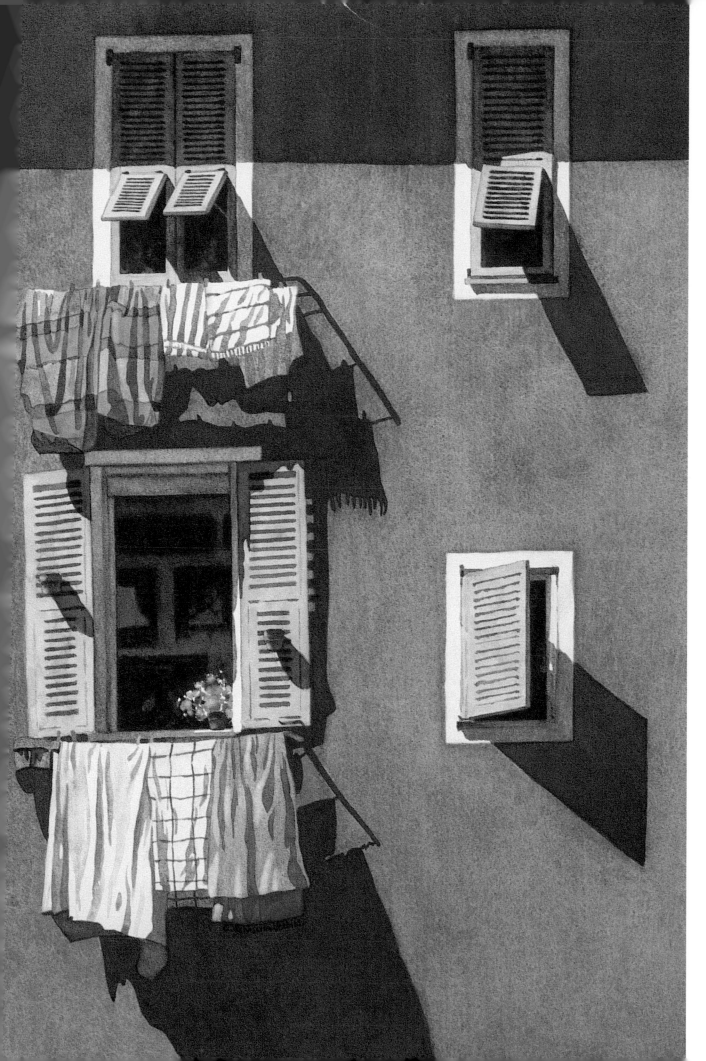

Feeding in color

The nature of the light—whether bright, dull, hazy, or colored—will also affect the shadows in a scene. Outdoors, the quality of the light sometimes seems to change from second to second through the day, with the sun momentarily eclipsed by clouds, and with trees waving in the wind, disturbing the light. Indoors, you will have more control. Basically, bright light will produce dark, hard-edged shadows; hazy light, pale, soft-edged ones. Wet paint applied to dry will produce hard edges, while paint applied wet into wet results in softer edges. Wet-in-wet is harder to control and its outcome more difficult to gauge. One way to overcome this is to first apply overlapping washes, allowing them to dry completely. Then, with clean water, paint the area to which you want to add depth of tone, and feed in colors to blend. This confines the added wash to the area covered with water, yet allows an uneven mixture of colors to mix, wet-in-wet, over the top. The edges can then be blotted with a tissue if they are too stark.

Hard edges

You can exaggerate the hard edge of a patch of shadow, wet-on-dry, by allowing the paint to dry for a while and then blotting the center of the patch with a tissue. The paint will have started to collect and dry around the edges as though it has been outlined.

Feeding in Color

To keep shadow colors vibrant, it's better to feed in colors, wet-in-wet, so that they mix together on the paper. The effect is different if you allow the first wash to dry, and then wet the required area with water before feeding in a second color, a technique that also allows more control.

1 The initial yellow wash of the pumpkin extends to the area below the lower outline, where there is reflected light in the cast shadow. More saturated yellow is fed into the initial wash to deepen the color around the stalk.

2 Allowing the yellow to dry a little, the area of shadow is wetted, and then some Permanent Mauve added, combining with the complementary yellow to form a colored neutral.

3 When the initial washes have dried, the area of shadow on the pumpkin is wetted with water, which is allowed to sink in; then mauve is fed in with the tip of the brush.

4 Finally, more saturated mauve shadows are added, wet-on-dry, underneath the pumpkin to tighten up the outline, and green is added to the stalk.

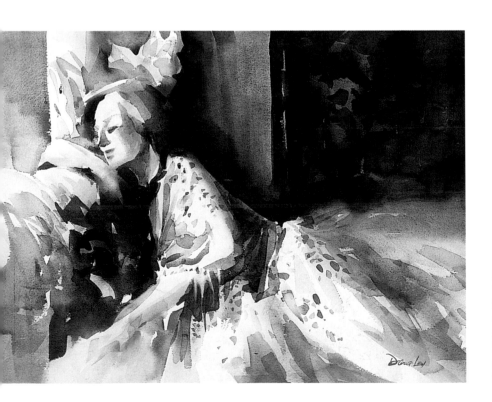

Girl by the Window *DOUG LEW*
The shadows on this girl's dress are built up in superimposed patches of colored grays, carefully placed, wet-on-dry. Paint has been encouraged to gather at the edges, making them darker, so that shadows appear crisper. This is particularly useful for emphasizing linear folds in the dress.

Shadow Colors

Shadows are not black or even dull gray. They are every color conceivable, borrowing from the pink color of a cast light and the green of the grass on to which the shadow may be cast, for instance. They also include points of reflected light from the object that casts the shadow (as the complementary color of the actual color), and from the blue sky above. The more color you can include in your shadows, the more vibrant your painting will be. Shadow colors do not necessarily have to be mixed on the palette. A sense of immediacy can be introduced by laying your shadows in transparent glazes on top of each other, as superimposed washes of color, or by feeding colors into your shadows, wet-in-wet, so that they merge into a not-too-perfect mix.

Certainly, shadow colors will not be the same color or strength throughout your painting. If, on a hot summer's day, you should paint a woman wearing a straw hat and a white dress, seated in a deckchair on a patch of grass, the shadows cast by these parts of the subject would all be different. The crown of the straw hat would cast

onto the brim a shadow containing the warm blue of the sky, as well as the straw color of the hat–naturally complementary. The white dress would reflect a range of tonal values–sky blues, as well as greens from the grass. The deckchair would cast darker shadows, their color influenced by the green of the grass and qualified by blues from the sky.

Pure Italian
NANCY BALDRICA
The vibrant purple shadows of this composition complement the golden yellow of the light cast from the left. The shadows modeling the pears show touches of the red and purple light reflected from the cloth; these transparent colors are combined, wet-in-wet, on the paper.

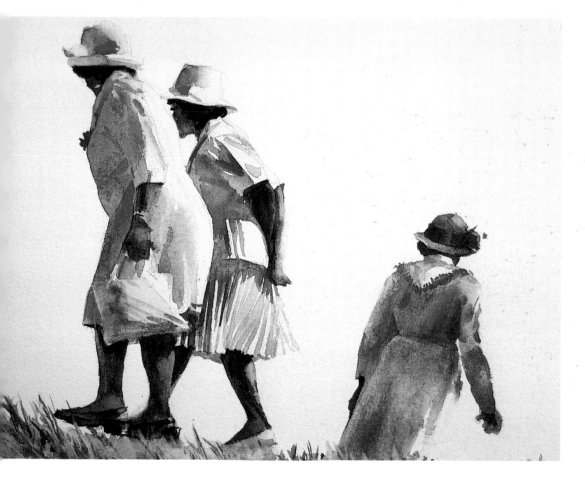

Bahama Mamas
RUTH BADERIAN
Look at the range of subtle colors used to express the shadows and "whites" here–blues, pinks, and palest yellows, in warm and cool tones. The feeling is of intense tropical heat, yet there is no obvious blue sky, no dark shadows on the ground. The information about the sky and heat is crystalized in these wonderful colored shadows.

Lines of Washing *PETER KELLY*
An expanse of potentially uninteresting rooftops has been enlivened with imaginative broken-color techniques. Transparent hues have been fed in, wet-in-wet, to make fresh color washes, and then bolder colors and color mixes have been spattered and worked in, wet-on-dry.

Broken color

With broken color techniques, the introduction of subtle complementary colors can enliven otherwise dull areas of shadow. Spatter them or build them up with pointillist dots. Lay down a wash first. It can be quite extreme—a Yellow Ochre or dilute Alizarin Crimson. Then spatter cooler blues and greens over the top so that they merge, yet still allow points of the underwash to show through.

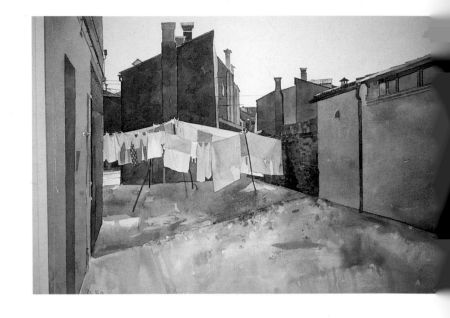

Colored grays

Grays and neutrals found in the middle of the tonal range can be mixed in such a way that they lean toward certain colors—pink, yellow, or green. You can start with Payne's Gray, which is a ready-mixed blue-gray, and add a little Burnt Sienna (see the result below). Alternatively, try mixing the grays by adding one complementary color to another—green to red, or yellow to magenta, for example. The reddish-brown Burnt Sienna is good for this purpose, as is Yellow Ochre. Push the neutrals toward one color or the other, and then lay them side-by-side, building up your area of shadow. These colored neutrals are definitely worth exploring and will help to enliven your painting.

Neutral Energy
If you dispense with straight gray or black as contenders for painting your shadows, and think in terms of colored neutrals, you will go a long way toward bringing energy and light into your paintings. How you mix these colored neutrals is important, too—preferably on the paper, by feeding one color into the other, wet-in-wet, so that the constituent colors remain visible and it is the eye that does the mixing.

The Vestry *NAOMI TYDEMAN*
A glance at this painting would inform you that the shadows of the vestry window are "gray." Try copying it and you'll discover the subtle variations of gray used—cool blue grays and warmer yellow grays, built up in controlled layers, wet-on-dry.

Transparency of paints

Watercolor paints are like people; they vary tremendously in character. Some are good mixers, like Yellow Ochre, which brings out the best in almost all other hues, while other colors, like Cerulean Blue, have an independent quality that should be left alone for ethereal blue skies.

The transparency also varies enormously. Look at washes of Cadmium Red and Alizarin Crimson alongside each other. The Alizarin is so much more transparent. Some colors are strong and so only a very small amount of them is needed in mixes—Phthalo Blue is a good example. Staining power also varies, and it's worth trying out the colors of your chosen palette to see how different each one can be. Add a patch of each color and then run the paper under a faucet.

Aureolin Translucent Orange Permanent Rose Alizarin Crimson

Winsor Violet Winsor Blue Cobalt Blue

Viridian Raw Umber Burnt Sienna

Colors for Glazing
Bring light into your painting by using transparent colors. Mix these colors by feeding one color into another on paper, wet-in-wet, or by superimposing one transparent glaze over another, wet-on-dry.

Tip: If you make a mistake with a wash of a powerful stainer, you will have to move fast to remove it. First, try wetting the paper with more water and blotting it with a tissue. When it is completely dry, you can scrape away a small patch with a blade, or, as a last resort, cover the patch with white body color.

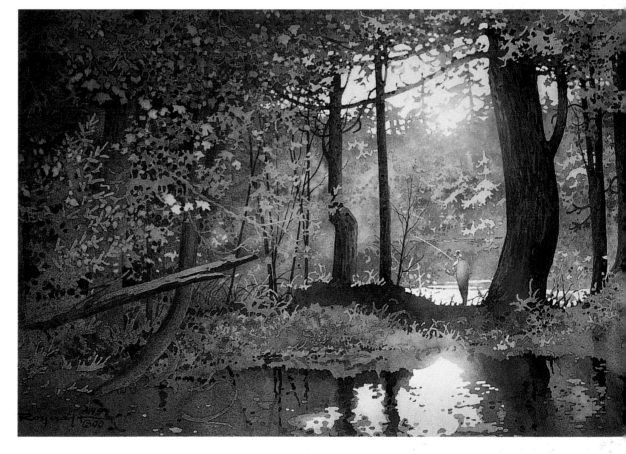

Reflections *ROLAND ROYCRAFT*
This shady corner of the woods burns with luminous shadows in the sunset light. The area of deepest shadow is a riot of jewel-like shapes of transparent color. Note how the sun seen through trees "eats" into the leaves and branches around it, bleaching color and obliterating detail.

Capturing changing light

Painting outdoors involves painting light and shade, and anyone who has tried it knows how tricky it is to capture ever-shifting light. You set yourself up with everything ready to go: a perfect scene in bright sunlight, painting planned, paintbrush poised. Then the sun goes in, the shadows fade away, and you are left with your creative energy jangling and your hopes dashed. But there are ways to deal with this without tearing your hair out.

Sketching To catch the ever-changing quality of light, you need to get down on paper the essential aspects of the scene which first attracted you. Try sketching with a soft graphite pencil, colored crayons, and also with paints. The information of your perfect scene can be crystallized into your own brand of shorthand. Look for areas of bright highlights and dark shadows. Use an arrow to record the direction in which the light falls, and a tonal strip to summarize the range of values. Make color notes, including ones about the cast of the light. Photographs, particularly those you can take with a digital camera, are useful reminders of what the light is doing, but sketching will force you to look more closely and somehow will burn it more effectively onto your memory.

Sebastion's
ROBERT REYNOLDS
In an expressive sketch, the artist creates the effects of light on the landscape. He records the steepest contrasts–the areas of bright light and shade–with just a few mid-tones.

Changing Light

In the course of the day, the light changes in direction (east, west, high, low); in strength (misty, cloudy, clear); and in cast (yellow, pink, blue). You can record these effects out in the open, or simply try out a few ideas as the artist has done here in a few sketches. Take a tropical scene and imagine how it might change when viewed at different times of the day.

1 A low, misty yellow light in the early morning brings contrasts in the middle of the scale and qualifies all colors.

2 Midday brings a bright, clear overhead light and high contrasts. Blues are reflected from the sky in the palm greens and in the shadows.

3 At the day's end there is barely any strength left in the light, so there is little color and the contrasts are at the lower end of the scale.

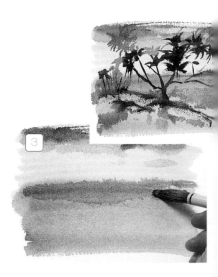

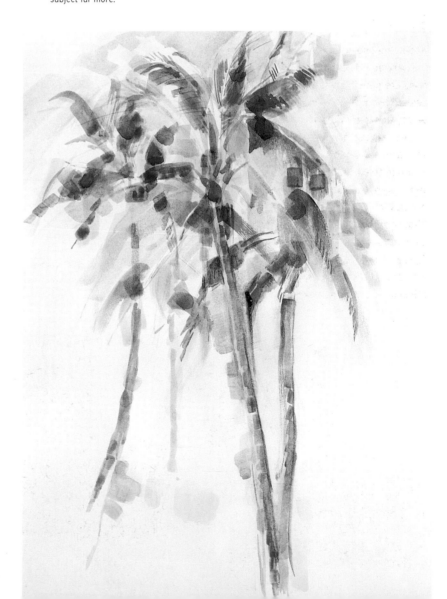

Recording the Light

Observing a busy market scene in France, the artist is impelled to record the dappled light coming through the plane trees, the colors of the displayed cloths, fruit, and vegetables, and the general clamor. The decision is, where possible, to restrict the sketch to blocks of color.

1 First, the direction and cast of light go in as bold diagonal strokes. Blocks of incidental color, and then the plane trees, are picked out.

2 Bolts of cloth and crates of produce are recorded quickly by painting them with a small square piece of card dipped in paint.

3 The artist brings in some quick visual notes on the produce and people.

4 The result is a record of a busy market that can be used as the basis for a number of paintings. A painted sketch is, in many ways, more useful than a photographic record, because it forces you to scrutinize your subject far more.

Sketching with watercolors

Sketching with watercolor paints will teach you to be nimble in your mental approach to painting. You are learning to analyze the state of the light in the scene, and also to memorize it so that you can record it in a few strokes. Use only a few paints—three or four—and a large brush, so that the detail is automatically edited out and you have to concentrate on simplified areas of color and contrast instead. You can work such sketches up into finished paintings back in the studio, or just use your newly acquired skills of painting with speed and accuracy to paint more finished paintings outdoors.

Palm Trees
AUDREY MACLEOD
A quick watercolor sketch, without a pencil line for guidance, will help you to memorize patterns of light and shade. Here, the fragmented nature of the light and shade has been captured in blocks of tone.

Changing light through the day

If you're out painting for a whole day, make notes on how tonal values and ranges change in the course of the day. It's easy to get into the habit of choosing bright light with simplified extreme contrasts, but it's more fun to vary the range of contrasts in your painting.

The weather also affects color and tonal contrasts. Think of how dark a stormy sky can appear. Often there's a strong, eerie light which throws up bright highlights. A pervasive greenish light often qualifies the colors of a landscape, making grass and foliage appear an unnatural, electric green. In contrast, a hot summer's day seems golden because that is the color of the light filtering through the particles of atmosphere in the sky—a hot, misty, golden light, creating rich intense colors that vibrate and resonate on your optical nerve endings.

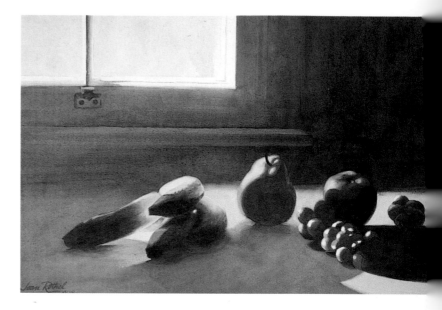

Early Light *JOAN ROTHEL*
You don't have to be outside to capture the changing light throughout the day. Here, the misty, cool-yellow light of the early morning filters in through the window, lighting up this arrangement of fruit.

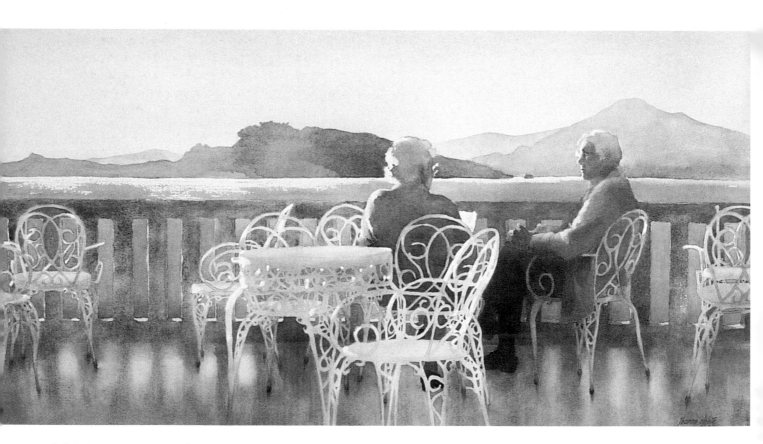

Twilight Zone *JEANNE DOBIÉ*
Such a delicate ephemeral light as seen in this painting must be captured with speed—with the eye, sketches, and maybe a camera. The result here is completely successful, and a soft pink light permeates the painting. Softer light produces a wider range of values within a narrow band of the tonal scale. With the sun below the horizon, cast shadows are created by diffused light from the sky and tend to be weak and blurred.

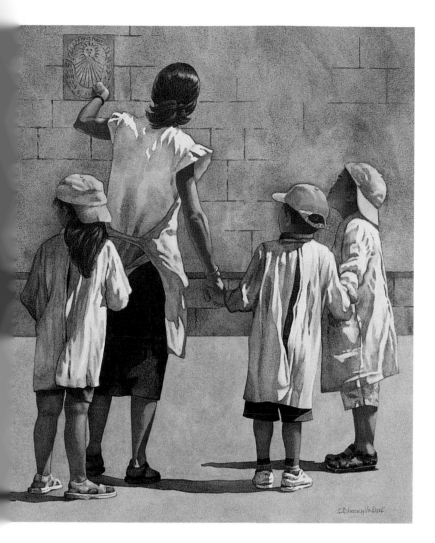

Field Trip *CLAIRE SCHROEVEN VERBIEST*
You don't need the truncated shadows to tell you that this painting was executed in the full heat of a summer's day. Complementary golden-warm yellows and mauves carried across the entire painting articulate the sensation of pulsating light. When trying to capture such fleeting nuances of light, explore options for color mixes on cut-offs of good paper before you begin.

Sky tone

The sky is always a lighter tone than the landscape beneath it. This may seem obvious, but, sometimes, with dark stormy clouds or even a pulsating summer blue sky, it's tempting to work up to something too solid and too deep in tone. The best way to keep yourself in check is to work on the sky and the landscape at the same time, thus building them up in parallel. It's always easy to strengthen tone but, as we learn from bitter experience, it's difficult to knock it back (although not impossible).

Before Storm
ROBERT TILLING
Even though the sky tones here have been worked up in bold washes to an exaggerated degree of darkness, the spit of land in the middleground is even darker, allowing the sky to recede into the distance.

Building up washes

A good way to capture the fractured effect of moving light in your painting is to use small overlapping washes—patches of color and tone superimposed, wet-on-dry. Begin with a pale, watery wash, allow it to dry, and then build up with small shapes of less dilute color to form a patchwork of color and tone. This technique can be used equally well in the sky for clouds, for the dappled effect of light on foliage, or for the broken color under trees where light filters through their branches.

Clouds

Painting clouds has always tested the skills of watercolor artists. Clouds are difficult to pin down: droplets of water vapor that mutate as they scud across the sky. It's worth taking the time to study them and record the different types, and at what level they lie in the sky. They can be used as part of a painting's compositional structure—reflecting an important shape in the landscape below, or to give a sense of movement. Nature is never short of imagination, which gives you the freedom, once you have learnt the vocabulary, to invent the forms that suit you. Use illuminated vapor trails to lead the eye into a cloudscape, or to punctuate the narrative of the landscape below, with clouds above.

Charleston Backroad *JAMES HARVEY TAYLOR*
An ambitious cloudscape is successfully executed in bold washes of complementary colors, which have been allowed to mix, wet-in-wet. Where the light bursts through the clouds, however, the hard edges of the backlit clouds are expressed with a drybrush, wet-on-dry, allowing the texture of the paper to break up the brushstroke.

The most important point to remember is that clouds are diaphanous, and it's a mistake to make them too solid. Lifting them out of a watercolor wash will ensure that their edges are not too stark. Shadows can then be fed in, wet-on-wet. Remember, clouds as part of a skyscape will always be paler than the landscape below. They also exist in a space, so a cloudscape needs to show the effects of perspective as the landscape does, growing paler toward the horizon, and, if the sky is full of fluffy clouds, smaller toward the horizon.

te of Old Theatre, Lublin
AUL DMOCH
ht filtering through a
e beyond the picture
ace (see left) casts
ppled shadows on the
ound. The sense of
oving light comes from
e overlapping washes—
all patches of color
perimposed, wet-on-dry.

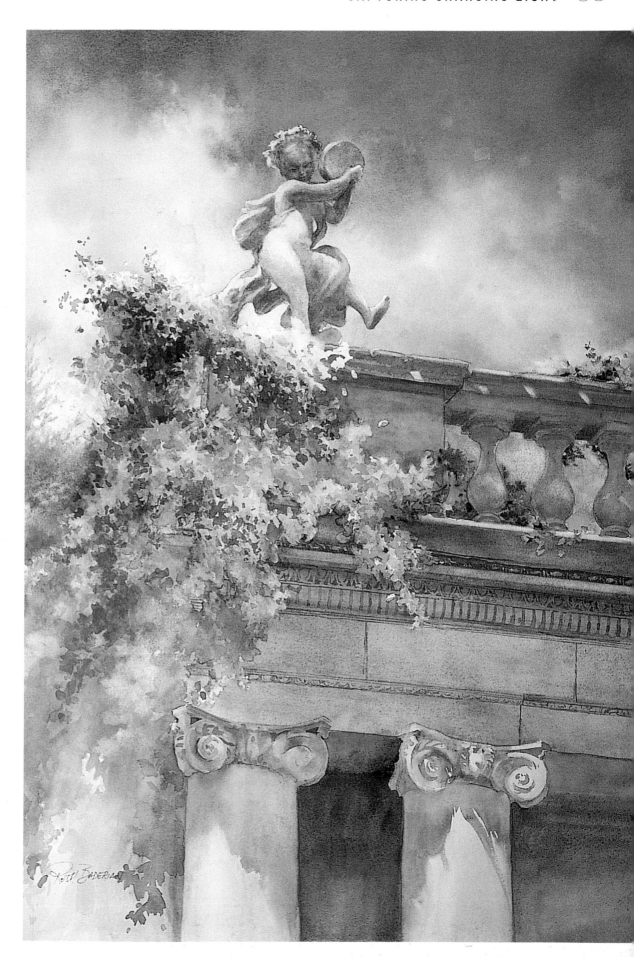

Cherub
RUTH BADERIAN
An intense, warm, blue
sky is broken up by
soft-edged summertime
clouds. The blue was
worked up with super-
imposed washes, and the final
one allowed to granulate for
a textured surface. Before the
washes dried, the clouds were
lifted out with a tissue. Then
cloud shadows were added
in pale washes and lifted
out once more.

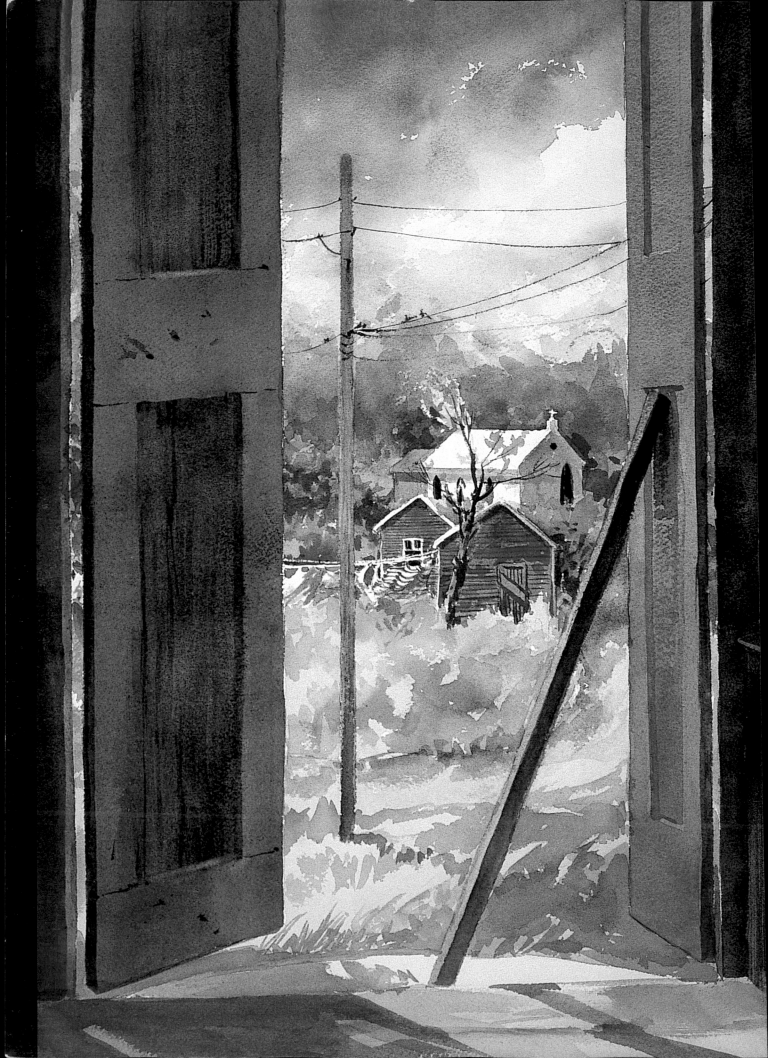

THEMES: EXPLORING LIGHT AND SHADE

Light is always a vital part of a painting, whatever the aim of the artist. But you can choose to make it the focus of your work by becoming a painter of light. Most artists work at their technique until they find a method of painting that develops into their own unique style. You will be able to see this in the work of some of the artists represented in this book. It is not only the way artists paint, the techniques they use, and the color range or the mood that they create, which constitutes their style, but it is also the subject matter and the approach that they choose. To develop your own style, you need to try everything and experiment widely until you find something that works for you.

Exploring themes for painting light in watercolor will help you find a way of working and to develop a style. Throughout this book we take an in-depth look at tonal values, as this is really what painting light is about. The aim is to make tone work for you and, to this end, we are trying to develop a shorthand, a way of suggesting what is there, rather than slavishly reproducing reality. So we look at tone as color; at manipulating values in order to create an effect by using counterchange and suggesting form; and at losing and finding edges. Then we focus on the effect that light has on color, looking at how artists can create different optical effects. This is where watercolors come into their own. Finally, we explore special light effects, such as reflections, and recipes for expressing mood through using light and shade.

Savannah Sound
RUTH BADERIAN
Foreground shadows lead you to the view beyond. And what a view it is: full of light, color, and movement. Note how the expansive mood of the background, with scudding clouds and dancing washing, is emphasized by the stillness of the interior with contrasting cool neutrals in the shadows.

Transition to color

Once you start seeing the world as being made up of tonal values, you will find your painting filling with light. However, it is not easy to transfer monochrome strengths of tone into color values. Experienced artists tend to build up color and tone gradually, constantly reassessing tonal balances. This is because color values are affected by their neighbors and also by where they stand in the picture space. Start off simply by looking for subjects seen close up, in bright light, with a few tonal steps, then graduate to viewing the effects of distance on tonal values.

Suggesting tone

Tone can be suggested in watercolor through dilution, that is by mixing a color with either more or less water. But as we have seen, the difference between the highlights on, for example, a red coat and the deepest shadow in its folds, will not come forth by starting with very dilute red and building

up to the least dilute, most intense red you can manage. Shadows are affected by the color of the light falling on the object as well as reflected light from other objects and the sky. They are achieved through changes in the mixture of colors as their tone is built up, by painting one layer of paint on top of another.

Flesh tones

Painting a portrait can be treated in the same way, by building up successive tones in superimposed washes. This does not necessarily mean darker and lighter versions of the same color but, rather, individual recipes for each tone. If, as described above, you can reduce the modulations of tone to three—light, medium, and dark—distinguishing between warm shadows and cool ones, then your form will develop.

Start with a tone map of your subject, outlining different areas of tone. As we have found, it is easier to start with a simple, clear subject seen in bright light, such as a photograph of a close-up of a head and shoulders in bright sunlight.

You can create the change in color and tone by keeping a base color to which you add different colors, building up the tone by superimposing washes. For a range of tones for a young girl, for example, take a Brown Madder and Alizarin Red mix as the base color and add Chrome Yellow for a first basic, very dilute overall wash, followed by a more intense wash of the same. For warm shadow colors, add Yellow Ochre, and for cool shadow color, Cobalt Blue. Of course, different artists have their own particular recipes for skin tones and these will vary according to the color of the skin and the age of the person portrayed.

Creating recession in a landscape

Light and shadow will play a big part in creating depth in your picture. You will have noticed that in a landscape colors are affected by the atmosphere, which causes them to acquire a bluish tinge toward the horizon. Colors therefore lose tonal value and strength and tend toward blue in the distance—a

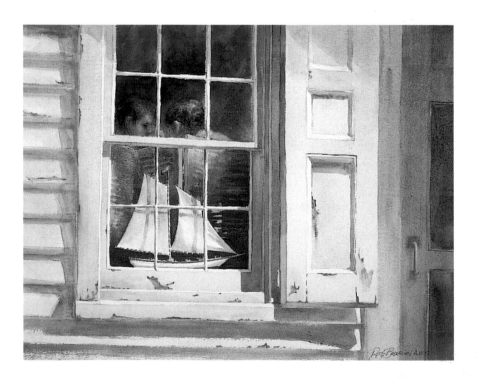

Inside Story *RUTH BADERIAN*
Starting with the white of the paper for the brightest highlights, the simplified shadows are built up with superimposed washes, wet-on-dry. Colored reflected light is seen in these washes, coming from influences beyond our vision—green, no doubt from the grass below the window.

Watercolor Study: Patricia Seligman *IAN SIDAWAY*
This is a study for an oil painting where the artist explores and simplifies the gradations of tone that are modeling the face, matching them to a limited number of color mixes. The bright sunlight helps to polarize the tonal range into dark and light, and a few midtones. Note, too, the simplification of the tonal range for the hair and shirt.

mplicated prospect, you might think. To make
ngs simpler, divide the distance between
urself and the horizon into three: the
ckground; the middleground; and the
eground. In the background, you will find the
rrowest band of tones from, say, 2-4 in a range
1-10. The middleground will contain the middle
es somewhere in the range of 3-7. In the
eground, the contrasts will be most extreme—
e you will find the darkest darks and brightest
ts, with the full range of 1-10.

All of this may still sound a bit complicated, but it isn't, because with watercolor, you will naturally work from the background to the foreground, building up the tone and the color as you go. It is sensible to bring forward the whole area of your painting at the same pace; otherwise, you can lose the balance in it. Sometimes, however, there is a part of the painting that you want to focus on and so you will move this area on first so that you can balance the tones in the rest of the painting with this particular space. But, in order to create depth, you must remember to conserve highlights in the foreground and build up shadows to match.

Knocking back

Colors appear lower in tone the farther away they are from the viewer; these are not only more dilute but have also lost some of their strength. An artist will start off with background colors that have been "knocked back," that is taken toward their neutrals, by adding a touch of a complementary color to them. Try putting pure color against a color that has been knocked back and see how the two colors appear to recede from one another.

Duomo *PAUL DMOCH*
Atmospheric perspective is at work here in a Florentine street, noted and maybe exaggerated by the artist to emphasize the effects of light. In the foreground, the range of tones is wider, with darker shadows and brighter highlights. The Duomo, in the background, appears bluer in color, with narrower contrasts of tone.

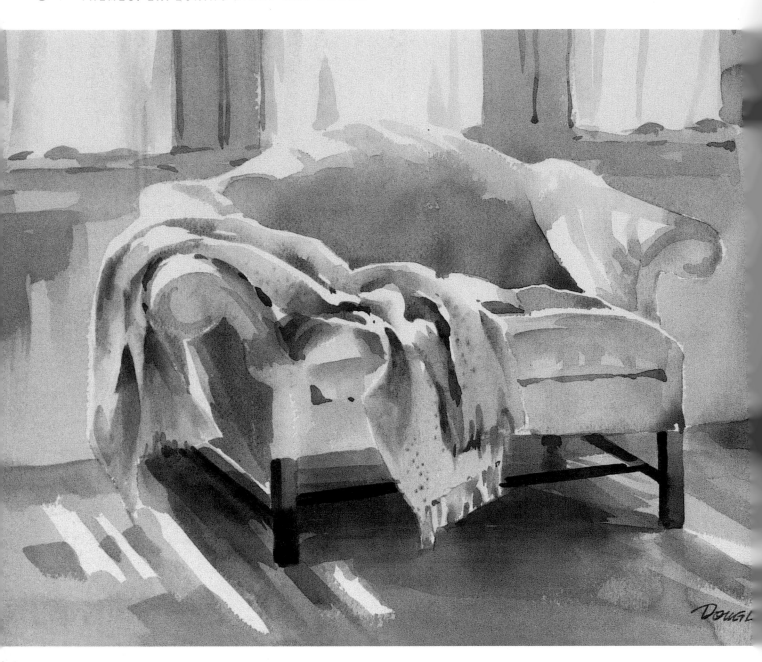

Measuring the South *SUSANNA SPANN*
The bright light disposes of any subtle mid-tones in this still-life made
up of objects chosen for their lack of obvious color. Even so, without
a tonal study, it would be hard to judge the subtle differences
between the disparate "white" elements—the roses, tape measure, and
ornament—which create a natural rhythm in the painting. The artist has
concentrated on building up successive layers of watercolor, carefully
choosing the more transparent colors, which go on like glazes and allow
the white of the paper to shine through, bathing everything in light.

Three Shades of White *DOUG LEW*

A wonderfully simple composition that illustrates so well how little you need to put into a painting in order to express light and form. The composition is all "white," so, as you can see from the black-and-white version of the painting, the tonal values are the same, with only slight variations in the color when it comes to the multicolored painting.

Misty Forest

BETTY BLEVINS

Look how the misty early morning light eliminates any extremes of tone (see left) and brings out subtle mid-tones that would be lost in brighter light. These tonal values are explored with a range of neutral greens below.

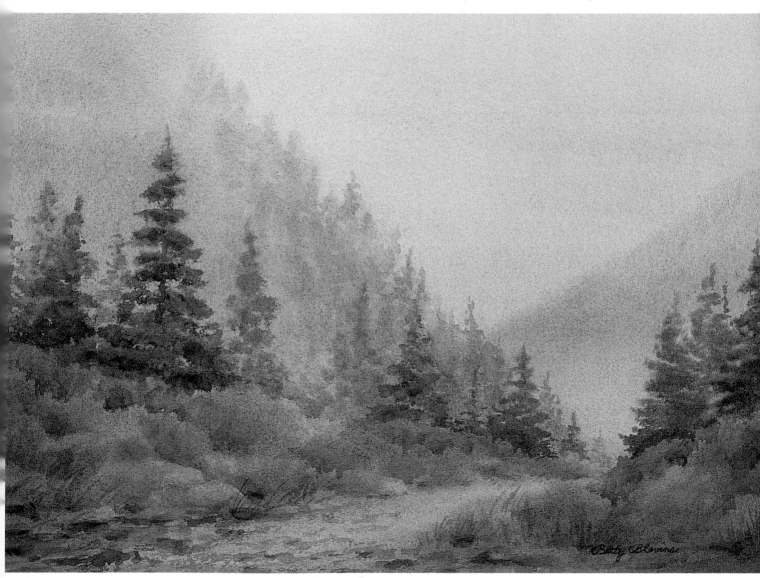

1 A careful sketch is necessary for architectural paintings. If is it too dark, erase it before you start, leaving just enough t guide you. The artist chooses watercolor boar with a NOT (also known as medium, or cold-pressed) surface, with the paper already fixed to a rigid backing.

Demonstration:

Tuscan summer

by *MOIRA CLINCH*

This isolated chapel at Rosennano in the Tuscan hills caught the artist's eye. It appears guarded by a circle of trees, and lies cool in their shadow in the silence of the afternoon heat. No single photograph showed the scene as the artist wanted it, so she taped together several shots for a composite panoramic view. Another photograph was used for the detail of the foreground grasses. The grasses were added to bring an extra layer of light into the painting: the points of light where the sun catches the seed heads were allowed to break into the darks of the central band, creating foreground interest, texture, and depth. The painting is built up very gradually, layer by layer. It would be impossible to show every step of this subtle process, but you can follow the main stages of it in these photographs.

2 Having used masking fluid to reserve the points of light reflected off the foreground grasses, the artist applies a Yellow Ochre wash. This is a weak wash that helps to establish the main shapes and areas of the painting, and captures the warmth of the afternoon sun.

3 While the yellow is still damp, lay a wash of Light Red over it. Add some masking fluid to the resulting peachy color to conserve some more grass highlights.

PALETTE
Yellow Ochre, Cadmium Yellow, Light Red, Cadmium Red, Cobalt Blue, Cerulean Blue, Ultramarine Blue, Dioxazine Purple, Ultramarine Violet, Sap Green, Hooker's Green Dark, Payne's Gray, Burnt Umber, Opaque White

PREPARATORY WORK
The artist's painted scene was made up from a number of photographs together with a separate shot of the foreground grasses. She decided to make the sunlight come in from the right in the painting, rather than from the left as in the photos.

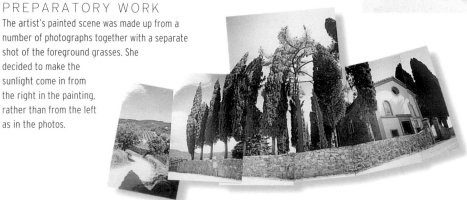

4 **THE FIRST STAGE**
A tentative wash has been added for the sky—a mixture of Cobalt and Cerulean Blues. The artist debates the shape of the top edge of the sky, and considers the quality of the trees' edges. The sky-blue is also painted on the shadow side of the trees to indicate reflected light from the sky. The painting's main shapes have now been established.

5 The distant view of an olive grove is built up, wet-in-wet, [us]ing simple washes. Feed in Light [Re]d and Ultramarine Blue for the [so]il, and Sap Green and Hooker's [Gr]een Dark for the olive trees. [Le]ave the white of the paper [sh]owing through, and keep the [w]ashes dilute, as this area is in [th]e background. It will be painted [ov]er later, as you will see.

6 Now the middleground must be brought to the same stage as the background. The cypress trees are built up with Cadmium Yellow where the light touches them, and with Sap Green on the shadowed sides. Wet the areas with water before adding the color, so that the edge is not too sharp.

7 Next, paint in the pine tree which breaks up the tidy circle of cypresses, using Hooker's Green Dark. First, apply small patches of green, then break up the edges using a splayed brush, its hairs pressed between thumb and forefinger. This captures the spiky outline of the pine needles.

8 THE SECOND STAGE

Paint in the trunk and branches of the pine tree, using a Light Red and Ultramarine Blue mix, and knock back the distant hill on the left with a thin glaze of Dioxazine Purple over dry Sap Green. You can now begin to see the development of layers in the painting—the foreground grasses, the strong circle of trees, and the background view through to the olive grove, vineyard, and hillside beyond. The central section needs more work.

9 Moving across to the chapel, paint in the shadows using a mix of Ultramarine Blue, Payne's Gray, and Dioxazine Purple. Here, the first strokes beneath the roof were a little strong so the artist took them back with a squeezed-out brush. Suggest the brickwork and other architectural features on the side wall with thin broken washes of Light Red, Yellow Ochre, and Burnt Umber, occasionally dropping in a little Opaque White.

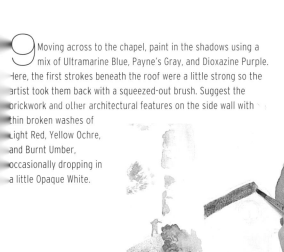

10 Now build up the tone on the trees by adding more saturated washes of Sap Green, Hooker's Green Dark, and Ultramarine Blue to the shadowed sides, feeling for the irregular shape of each individual tree. The depth of shadow is exaggerated when seen side-by-side with the pale stone of the chapel. These stark contrasts will attract the viewer's eye and strengthen the highlights on the chapel. Now you can see how the tone has been built up in the central part of the painting, bringing it forward from the distant view. To keep a sense of the burning sun, build up the shadows with colors that are as pure as possible.

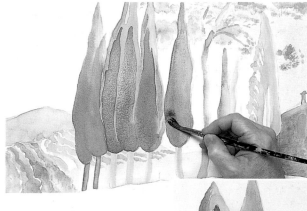

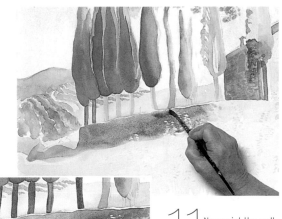

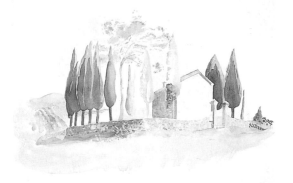

11 Now paint the wall in the shadows of the trees. First, apply a wash of the shadow color that was used on the chapel, taking it over the wall area and beyond, and leaving a thin line of highlight along the top. The masked highlights on the grasses break up this expanse nicely. Then, as with the chapel wall, add suggestions of the brickwork to the shadow area and, using Light Red and Yellow Ochre, lay the basis of the grass in the shadow under the wall.

12 THE THIRD STAGE

The pattern of brickwork has been built up, continuing along the wall to the right, to the area in full sun. Beyond that, a small village has been touched in on the right. Shadows have also been added to the gateposts and to the step. The grass in the shadow under the wall is applied as a Sap Green glaze over the previous washes, thus forming subtle neutrals. You can see that the cypress trees are setting the standard for the rest of the painting: they are close in tone to what the artist wants for the central section, and the rest of the area must be brought up to the same level. But first the background must be built up.

13 Having added the tree on the far left, go back to the olive grove. Repeat the process shown in Step 4, but use more saturated colors. Don't cover everything with paint; leave some of the early washes to show through, and paint the Sap Green over the white paper for touches of bright yellow green. Finally, paint in the all-important raking shadows with an Ultramarine Blue and Payne's Gray mix.

14 Returning to the circle of trees, bring the trees up to the same level. Build up the shadow washes further with Sap Green and Ultramarine Blue, working, wet-in-wet, for soft gradations of tone, and leaving the yellow highlight edges. Add shadows to the trunks of the cypresses, blotting the color with a tissue so that they don't appear too stark.

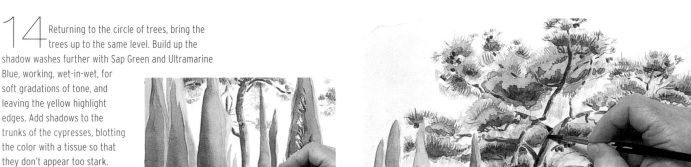

15 Now the pine tree needs to be brought forward to match up to the other trees. Over the now dry pale-brown wash, touch in a stronger shade of Burnt Umber along the shadowed sides of the trunk and branches. Allow this to dry, then add a darker shadow mix of bluish Ultramarine Blue and Payne's Gray to reflect the sky; merely touch this in, occasionally dabbing it with a tissue to vary the depth of tone and create a sense of flickering sunlight. The pine needles are also built up in places with Hooker's Green Dark, using a fine brush to draw in the spikes.

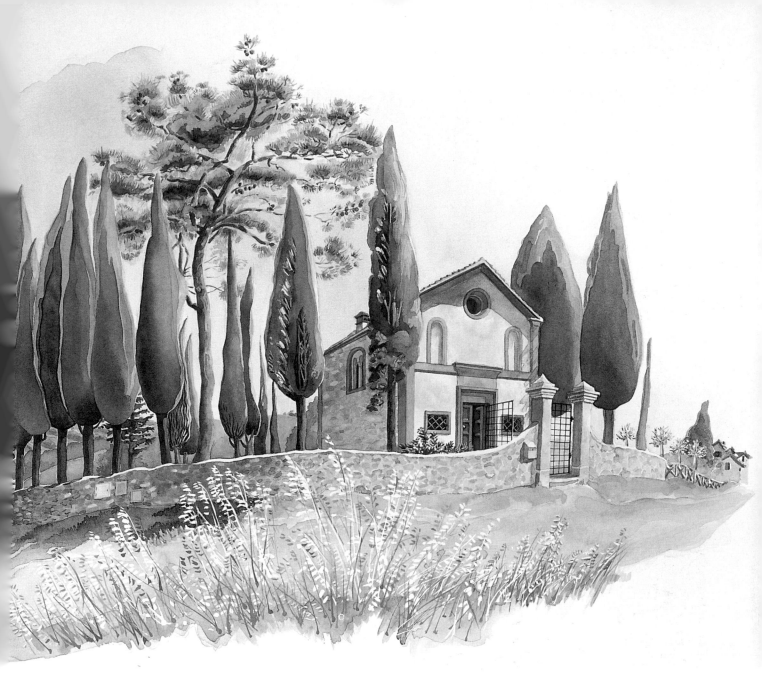

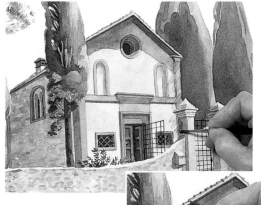

16 Begin the detailed work on the chapel and entrance by painting in the stone architectural detail with washes of Yellow Ochre and Burnt Umber, and some Light Red for the door. Build up the shadows in two layers using mixes of Ultramarine Violet and Light Red. Glaze the mixes over the brickwork, including the oculus window under the eaves. Here, you can see the second layer being applied over the shadow on the gatepost. Suggest the roof tiles by adding Cadmium Red and a touch of Ultramarine Blue with a very fine brush. Use the same brush dipped in strong Payne's Gray to carefully paint in the wrought-iron gate and the darks of the lower windows and doorway.

THE FINAL PAINTING

The foreground has been left until last so that the relative values can be judged. First, Yellow Ochre and Light Red are added to build up the tone, with tree shadows added while the washes are still damp. Then the masking fluid is removed from the seed heads, and the grasses are built up with dilute washes of Sap Green, and more saturated washes of Burnt Umber and Ultramarine Blue applied with a small brush. The completion of these foreground grasses makes the rest of the painting recede. But, most importantly, the grasses bring touches of light into the painting, breaking up the shadows of the middleground section. Standing back to admire the painting, you can see how the artist has worked hard to reproduce the golden light of this Tuscan summer, establishing the quality of light in the underlying golden washes, and building up the shadow tones with pure color.

Modeling form

When you look at a painting, you can read the three-dimensional form of an object by the way it is affected by the fall of light. An outline will tell you a great deal about a form, especially if it is one that you recognize, but, for three-dimensional information, the use of highlights and shadows will relay to the viewer the shape of that form. Again, the artist has to provide some clues to the viewer so that the painting can be understood.

Pick of the Crop
JOAN ROTHEL
The raking light coming through the window on the left describes these apples in patterns of light and shade, with their cast shadows confirming their position on the polished table. Each apple's form is modeled with color, light, and shade, with careful consideration of the outline, and the reflective nature of the skin. Yet no two apples are exactly the same, and differ slightly in every detail.

Simple forms

Start your practice of modeling form with a simple object that has an uncomplicated surface, such as a hat, an apple, or a mug. Place whatever you choose in a strong light, natural or artificial. Taking a shiny, red apple, you need to think what it is which informs us that it is indeed just that. An apple can be understood through the shape—the outline—of the fruit and the three-dimensional form indicated by the highlights and shadows on the apple itself and those cast on surrounding forms. Shiny will mean bright—that is, leaning toward white—highlights. Red will mean various tones and colors of red, and maybe green, to shadow-colors with added blue. All of this information must be conveyed as economically as possible.

Human form

When practicing modeling light and shade, the human form is particularly trying and will show up any weaknesses. Artists who specialize in painting the human form learn about every detail of its construction—bones, muscles, and ligaments. For most of us, we know the basics and, if we paint what we see, that is enough. What we are trying to put across is the pneumatic roundness of the human form—whether fat or thin, old or young. If you look at examples of watercolor paintings of figures, you will see how this can be done with very few strokes, by relying on the viewer to understand your clues.

Outline

If you are painting forms in close-up—people, animals, or still lifes—then you will need to show an understanding of the outline of those forms. It is the edge which gives expression to a form. A stark edge will tell you about the nature of the material it encloses: stone, wood, and metal will have hard edges, whereas leaves, grass, textiles, and fur will have softer ones. But there will be variations within these categories, depending on the quality of the light and where the objects are in the picture space.

Yes, there's no escaping it, you will need to know how to draw. But the truth is that anyone can learn; it just takes practice. In the meantime, while you are practicing, you can copy forms. Even experienced artists like to work on a composition in rough form until they arrive at something they are happy with, and then to transfer it to the paper on which they are going to paint by copying it across via tracing or squaring it up.

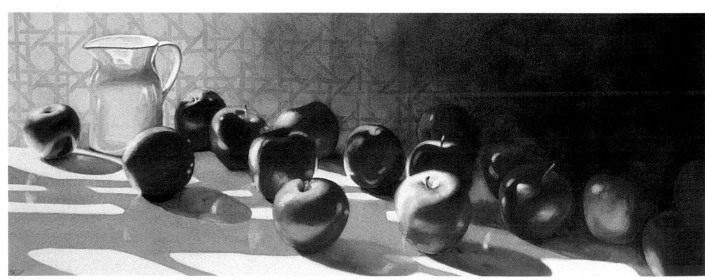

Day's End *JOEL SMITH*
Exaggerated color helps to convey the effect of the warm evening light shining in from the top left, and models the form. Without allowing the paint to dry, color has been fed in, wet-in-wet, to create the soft contours of the body.

The Dinner Bell
ROBERT REYNOLDS
A simple composition is explored in a sketch so that the outline and then the modeling of the form can be seen in relation to its surroundings. In this case the drawing has been squared up in order to transfer its outline to the paper chosen for the painting.

Light and shade

Having established the outline, now the three dimensional shape of the form has to be modeled. This modeling of the form comes from strict objective observation, coupled with a knowledge of what information the viewer needs in order to understand what is going on. Gather together a number of photographs of people—in a landscape, sitting inside, or playing sports. Most of us have concentrated for so long on the outline of the world around us that we can barely see beyond it and so we often fail to identify the piece of information that will convey what a figure is actually doing. To help you get the hang of this, try reproducing some of the individual figures in your photographs with a pencil and then, separately, with a large brush and two tones of paint. If you feel your attempt hasn't worked, try again and this time isolate the part that informs you about the object's shape—it may be a highlight on a hat or glove, or the shadow between a sleeve and the wrist.

Draw in the highlights, the areas of midtone, and the shadows. Now is the time to decide how the painting will develop. You will be starting with the highlights, so if you are reserving them by painting around them, note them well. You will want to paint around them carefully and confidently and avoid creating a build-up of tone around them. Conserving the highlights with masking fluid can help solve this problem. Shadows that cross over from one object to another, rather than being treated individually, can be applied with a thin glaze of shadow color over the different objects affected.

Chicory and Fireplug MARY LOU FERBERT

Even a lowly fireplug (fire hydrant) can star in a painting. The black-and-white version, right, helps to sort out the values between the chicory in the foreground, the fireplug in the middleground, and the background flowers. Then look at the painting, left, and see how the fireplug has been carefully modeled with delicate modulations of tone in the shadows, which reflect the blue of the sky, above, and the green of the grass, below. The chicory in the foreground is seen as a co-star, as it were, in the spotlight against the shaded part of the fireplug.

Gene DOUG LEW

Expressive brushwork helps to explore the facial features here in a lively painted sketch, far right, that captures the animated expression and gestures of the sitter. It is a useful exercise to practice sketching with a single medium-sized brush and a limited palette, with only a rough pencil outline as a guide. You will not be able to be sidetracked by detail. Work quickly, wet-in-wet, remembering to reserve the highlights. The monochrome version, right, shows the successful distribution of tone.

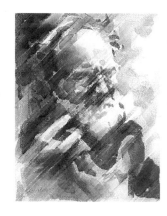

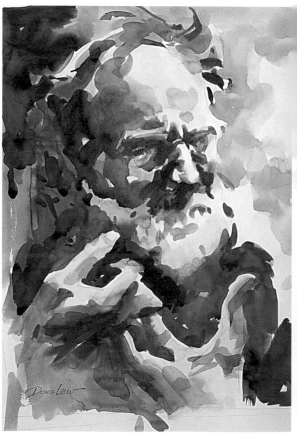

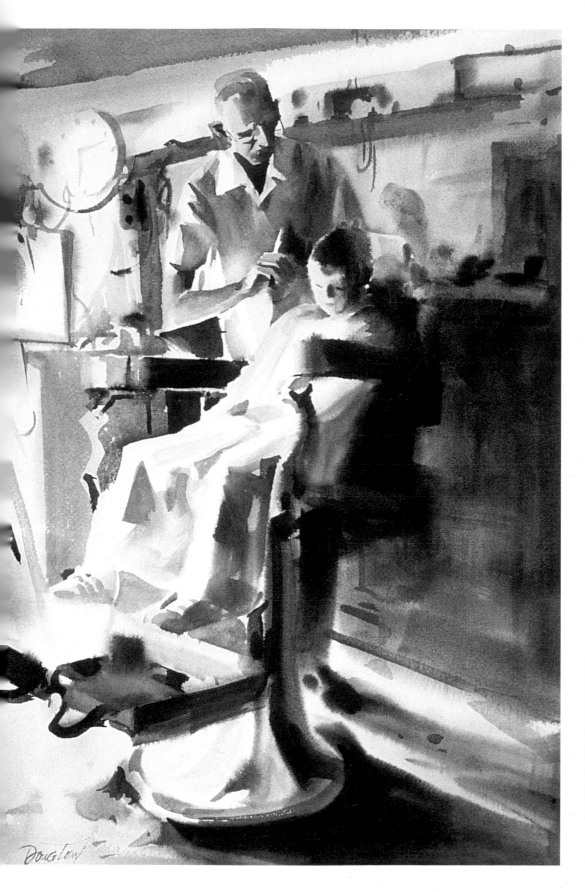

Barber Shop *DOUG LEW*
Seen from a certain distance
and in soft light, the modeling
of these figures becomes
less detailed, with fewer
gradations of tone. Colors
are muted too, with the use
of a very limited palette, as
you can see if you compare
the monochrome version,
below, with the painting. Note
how the light catches the
edge of the clippers. In this
context, that edge is all the
information we need
to "see" the clippers.

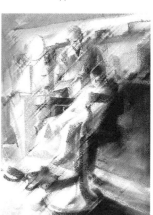

Laying down washes
Building up structure
Balancing values
Reinforcing color

Demonstration:

Portrait of a young girl

by *GLYNIS BARNES-MELLISH*

The fall of light on this portrait of a young girl plays an important part, not just in modeling her facial features, but also in expressing the mood of the painting. The natural light, which enters top left, falls on her face and hair, on her shirt, and, importantly, on her hands. There is obviously a difference between modeling a figure and painting a portrait, where a likeness becomes crucial. This portrait is a good compromise, as it's more than a painting of a particular girl; it's a touching portrait of young womanhood, with the focus as much on the facial likeness and the hands as on the sitter's pensive mood.

PALETTE
Alizarin Crimson, Yellow Ochre, Indian Yellow, Ultramarine Blue, Viridian Green, Lemon Yellow, Burnt Umber, Cobalt Blue, White Gouache

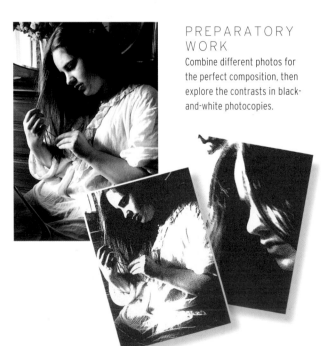

PREPARATORY WORK
Combine different photos for the perfect composition, then explore the contrasts in black-and-white photocopies.

1 A very light underdrawing acts as a guide for the first basic wash of a mixture of Alizarin Crimson and Yellow Ochre, which is taken over the hair and skin, except for the areas of brightest highlight. Use a dry brush fo the soft edge of the hair and soften other edge with a clean, wet brush, allowing the tone to vary naturally. Then, while the first wash is still damp, add Indian Yellow to the shadow areas on the hand where the light shines through the skin, producing an intensity of color.

2 Continue to plot the areas of high color by adding touches of the original mixture, weighted toward the red, onto the other hand and the lips. Blot the edges of the lips with a tissue. In these early stages, controlling the edges is critical in getting a likeness.

3 Now the shadow areas are explored. On the face, build up the tone on the eye and nose with less dilute applications of the original mix. Then, add Ultramarine Blue to the same mix for a purple-gray which, in a dilute form, should lay down the shadow areas on the hands, the shoulder, and over the hair. All the colors in this mix are transparent, so, by taking it over the hair as a glaze, it qualifies the first wash.

4 The lower shadows on the face have a green cast, a reflected color, which also happens to be a complementary to the pinkish reds. Add a touch of Viridian Green to the original mix, and feed it gently in a dilute form, wet-in-wet, into the cheek area. Then the areas of high color are reinforced with the redder mix—on the lips, her right hand, and, more dilute, on the chin.

5 Now, for the background. To the left side, a strong wash of Lemon Yellow is brought in around the figure, wet-on-dry. Keep the brush dry along the hair, so that the paper breaks up the brush stroke. While the paint is still wet, quickly feed in Alizarin Crimson and a violet mix, encouraging them to swirl together by tilting the painting on its board. Note how the color with the deepest tonal value, the violet, is cut in around the hand (inset), following the original drawing, to create the area of white highlight along the back of the hand.

6 The right background receives similar treatment, with a pale blue wash coming down to delineate the arm where the color is allowed to build up along the edge. Now work on modeling her left arm with a shadow wash, fed wet-in-wet with green, violet, and red. You will need to be brave, but remember it dries paler.

7 THE FIRST STAGE

By now, the basic washes have been laid down and, at this stage, the painting must be allowed to dry completely. You can see how some of the colors, which looked extreme when applied, have dried less so. The tonal values on the left are stronger, however, and so now the rest of the painting needs to be brought on to match them.

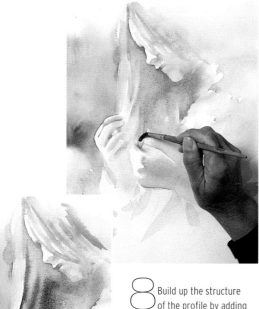

9 A pale version of the Umber mix is taken around the fingers of her left hand, carefully preserving the white highlight–again to bring on the structure.

8 Build up the structure of the profile by adding another wash to the curtain of hair, then (inset) build up the tone further, by feeding in Burnt Umber shadows and reestablishing color with touches of Indian Yellow. Note how the dark edge, where the light catches it, is hard, leaving a sliver of white paper as the highlight. Then softer dry-brush strokes are added to the fringe.

10 Colors are reinforced throughout: a stark splash of cool Virdian and Lemon Yellow is added to the left side, to spice up the warm colors there already. Less obviously, some Indian Yellow is added to the neck area. On the right, a blue wash of Ultramarine Blue, with Burnt Umber added, comes down to form the shadows of the shirt.

11 Now go back to building up the tone. First, paint, wet-on-dry, with a concentrated mix, to reinforce the fringe with drybrush strokes. Then wet the back of the head with clean water and add a dark Umber wash.

12 This wash is taken on to reinforce the profile and build up the top right-hand corner. Then the edges are tidied up–here, carefully creating a hard edge, wet-on-dry.

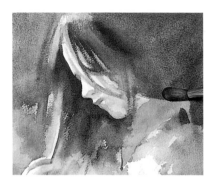

13 THE SECOND STAGE
Having taken the darker wash across the left-hand side, once again, the areas of color are strengthened: in the curtain of hair, the lips, under the chin, and along her left arm. At this stage, the painting is a battle between three conflicting, but equally important, aspects of painting light, those of: building up tone; asserting structure; and maintaining color.

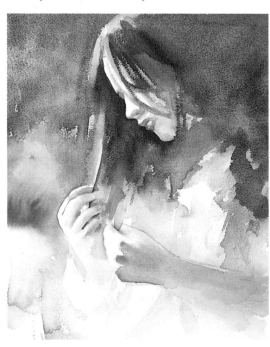

14 Additional dark washes–Burnt Umber, Yellow Ochre, and Ultramarine Blue–are added to the background, alternating areas of wet-in-wet and wet-on-dry.

15 Having checked the areas of highlight, touches of opaque white gouache are added to reestablish any that need to be sharper–like this one between the fingers. You can see also that the color has been fixed with more intense washes being added to the face, and to the purple shadows on her right hand and sleeve.

16 With the darker blue shadows dry, such as those establishing the structure of the lower arm, white highlights on the shirt are clawed back with opaque white gouache washes, which allow some of the shadows to show through.

17 Final touches are added to the lips and other features, so that they stand up to the build-up of tone in the background.

THE FINAL PAINTING
Built up slowly, with countless superimposed washes, the final painting has a real sense of depth and an inner glow. The delicate process of balancing the depth of tone, establishing the structure, and keeping the color fresh means that the artist cannot afford to lose concentration.

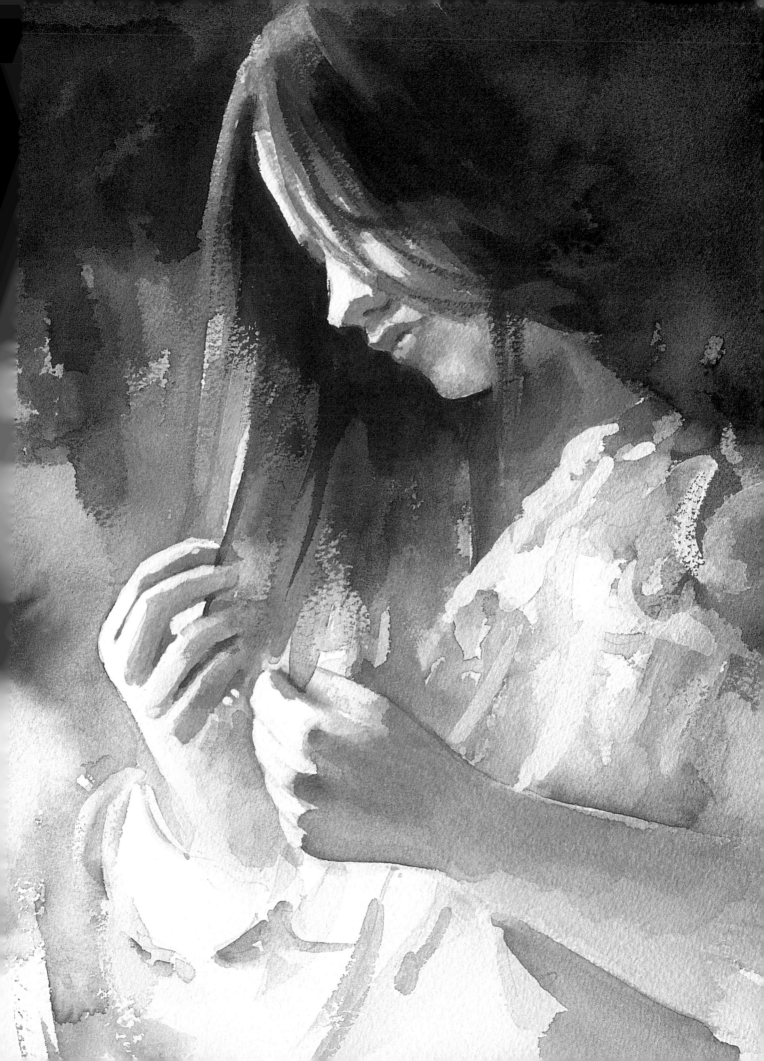

Focus through contrasts in tone
Energizing your painting through light
Achieving tonal balance

Manipulating tone

So let us now explore more ways of enlivening a painting through manipulating areas of light and shade. A painting should offer more than the interest provided by the subject matter. It needs to be viewed as a mental and visual amusement park where the eye explores the picture space and the brain computes a dazzling variety of information. Before brush meets paper, this journey of discovery has to be planned like the route through a maze. The final destination is somewhere in there but must be reached via a preordained route with a few twists and turns, ups and downs, and the odd dead-end street thrown in for good measure.

Minehaha Creek
DOUG LEW
Small figures playing by the river animate this composition. Yet they might have been lost had the background foliage not been exaggerated in tone around them so that they stand out, light against dark.

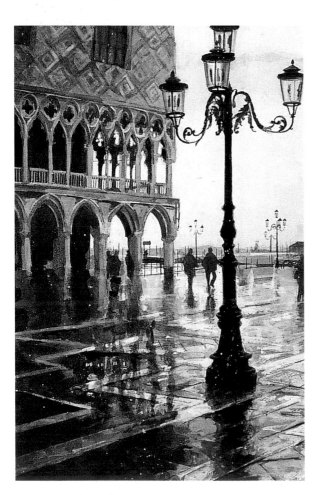

Doge's Palace, Winter's Afternoon *NICK HEBDITCH*
In this painting, the artist has divided the composition into three parts: a lighter side, a darker side, and a part in the middle crossing between the two. Harnessing the power of counterchange, in the lighter side, the street lamp is painted black against the bright sky, balanced by the dark side, where the arched loggia of the palace is pale against the dark shadows.

Experimenting with counterchange

One of the ways to create focus and drama in a painting is through counterchange. This is where an element of the composition is made to stand out through contrasts of tone—that is, by placing it against its opposite: light against dark or dark against light. Nature is a natural composer so, if you look at any scene on a bright sunny day, you will see counterchange in action. But often the artist has to exaggerate or rearrange what nature has suggested. A fair-haired boy in bright sunlight will stand out against dark shadows cut in around his form. In reality, there may be a diversity of light and shade in the background but, to focus the eye this needs to be edited out and the shadows need to be darkened around him.

Bringing out the energy of light

To practice seeing opportunities for counter-change, sketch small scenes around you or find a photograph to copy. Once you have sketched your subject, identify areas of extreme light or dark. Now, increase the tone around the bright objects. If the contrast is not extreme enough, re-sketch your subject, making the bright object even brighter, or add some white body color. Do the same with dark objects against a bright background. Clear the subtleties of tone around your dark object with white body color and build up the darks of the object. You will find that these highlights and shadow depths will have brought out the energy of the light, creating areas in the painting that draw the viewer in.

If you draw a line of trees on a riverbank, for example, you can relieve the tedium of repetitive shapes by working up tone to darken tree trunks

against a bright background and by bringing in dark shadows around those trees in bright sunlight. The eye then lingers on these areas, exploring them instead of rushing past.

Keying values

If you flip through this book, you will notice how some paintings are generally low in tone and others high. You might describe an interior scene of dark muted shadows as moody or even spooky, whereas a view across a lake at dawn in a pale rosy light you would more likely describe as ethereal or romantic. This reaction from you, the viewer, can be manipulated by you, the artist. You can affect the overall mood of a painting by choosing to make it high- or low-key in tonal value.

To begin with, it may be easier to record what you can actually see, which means sketching and painting a particular scene or still life in different kinds of light. Remember Claude Monet's experiments with observing light in his many studies of haystacks at different times of the day and in all seasons? He was observing how bright light, dull light, strong light, weak light, warm light, cold light, and so on, affected his chosen scene.

Try some sketches in colored pencils, choosing colors of darker tone for one attempt and then a set of lighter, more pastel, colors for a high-key version of the same scene. This will show you how you can transpose the tonal key to suit your needs. You are sketching the same scene in both cases, but imposing your own interpretation of it by choosing a particular tonal key in order to communicate something to the viewer.

Fine-tuning

Most artists find they fine-tune the tonal balance in a painting in the last stages when there is an opportunity to look at it objectively. This balancing of tone takes place throughout the painting—not just across the picture's surface but within areas of that surface—areas of extreme light and dark have to be balanced to bring out the light. Tonal values also have to be balanced within the picture space, between the background, middleground, and foreground—so that they are most extreme in the foreground, and least pronounced in the background. Therefore, it may be necessary to add more darks to the foreground or maybe knock back the tone in the background. One of the most common problems with watercolor painting is

ensuring that highlights are carefully conserved, but then the darkest areas of shadow may not be given their full strength. The result of this is insipid but can be cured by balancing your contrasts. If you use the full strength of your white paper as your highlights, your shadows have to be equally dark. This takes tremendous courage to paint, because you will be adding to what may seem like a good painting and you will be afraid to spoil it.

With watercolor, you can add these final darks gently, stage-by-stage, with transparent washes, wet-on-dry. If you want a softer effect, you can wet an area with water and feed in color, wet-in-wet. You have to be patient in these final stages, however, as it is easy to overdo things, and there comes a time when you have to stop. It is sometimes difficult to know when this moment has arrived. For some sense of objectivity, try viewing your painting through a mirror, or leave it for a few days and come back to it with fresh eyes.

Quiet Journey
ROBERT REYNOLDS
The artist prepared for the painting (below) with a sketch (inset) which allows us to see how he has manipulated the values in the painting to give it structure, and make it more dramatic. The painting has been divided into three areas: the foreground, now in the shadows; the near middle-ground, where there is a focus of light which draws you in and where the river now runs darkly through the snow; and the background, now seen in more muted tones.

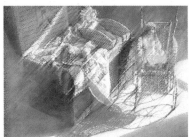

My Treasures *JOAN ROTHEL*
The contents of the toy box, the treasures in question, are seen in high key, drawing the eye in to linger on every detail. Looking at the monochrome sketch, left, you can see how highlights have been used to direct your gaze to these individual treasures—along the lid of the box, along the edge of the quilt, the back of the cane stroller, and so on.

Neist Point 2 Study, Lighthouse, Skye, Scotland
PETER S. JONES
The full drama of this lighthouse in its dominating position on the clifftop is expressed through the artist's choice to paint it in such extreme weather and light. Exaggerating the counterchange already in existence, the lighthouse shines out, as it is meant to, against the dark sky.

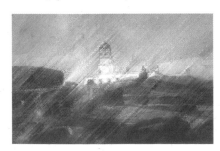

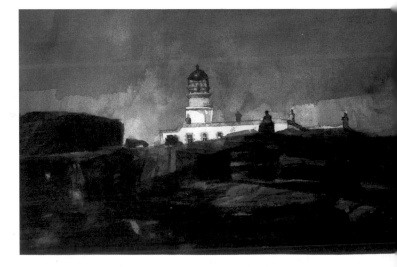

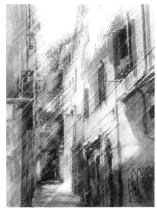

Red Houses of Santa Croce, Venice
PAUL DMOCH
The warm reds of the terracotta
walls are given an added fillip
through the high values of the line
of rose-colored washing and its
shadows. This is necessary to
balance with the extremes of
contrast at the end of the façade,
where the bleached plasterwork
stands out starkly against the dark
foliage. This delicate balancing of
tone is evident in the monochrome
version of the painting shown left.

Stargazer *NANCY BALDRICA*
Every effort has been made to capture the exhibitionism of this showy
flower. The artist has chosen to view the subject close-up, with the flower
head cropped on three sides, drawing you into the heart of the bloom.
Then the glorious colors are captured in an upbeat fashion by laying down
successive glazes of
transparent paint.
Finally, the radiance
of the flower is
exaggerated by
setting it against
the darkest of
backgrounds.

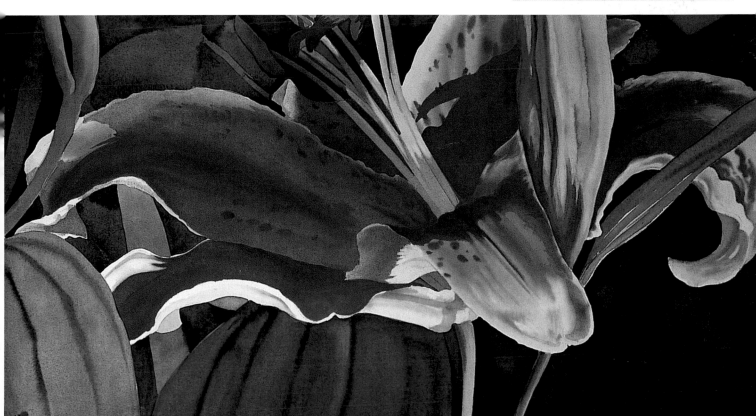

PALETTE

Cadmium Yellow, Lemon Yellow, Indian
Yellow, Cadmium Red, Dioxazine Violet, Cobalt Blue

Demonstration:
Barcelona Gothic quarter

by *HAZEL LALE*

A photograph taken of a street in the Gothic quarter of Barcelona is the starting point for this painting. It is midday and the sun beats down on one side of the street, leaving the other in deep shadow. To convey the essence of this light, the artist decides to exaggerate the contrasts in areas of counterchange. The three dark figures seen against the light are balanced by the figure on the right, closer and therefore weightier, which is tonally adjusted to be seen light against dark. To capture the sense of light, the artist aims to suggest these depths of contrast with color and temperature instead of with neutral grays or absolute darks.

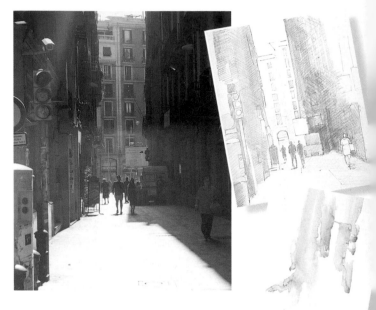

PREPARATORY WORK
You can see how the artist has adjusted the balance of contrasts in the tonal sketch (top right), with dark figures against light, and vice versa. In order for this to have impact, the details have largely been edited out, but there are enough references, such as the traffic lights and billboards, to give a flavor of this busy street. The artist experimented with some colors (above, right) before starting.

1 First the artist makes an outline-sketch, then, looking closely at the photograph, she searches out areas of warm color, feeding in Cadmium Yellow and Cadmium Red, wet-in-wet. These early washes are very dilute, in order to map out the painting's values.

2 Next, cooler blues are added in the background, with warmer Dioxazine Violet and Cadmium Red added to the blue in the foreground. These washes should be uneven, and merge with other colors in some areas and have a sharp edge, wet-on-dry, in others. The white paper is allowed to show through in places to suggest highlights. The first of the darker figures must be put in so that the other values can be judged. It is important to get the comparative values right from the start.

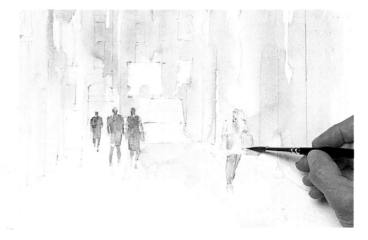

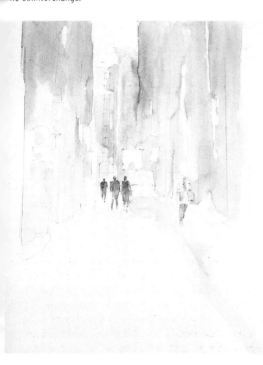

3 The figures are painted carefully with a small brush—red for the local color, purple-blue for the shadows. You can see (inset) how the shadow color is dropped into the local color, wet-in-wet. Note how a little sliver of white paper is left above the heads of these figures as a halo of light.

4 Having established the values in the center-left side of the painting, with the counterchange of the dark figures against the pale yellows and pinks of the background light, it is time to develop the right-hand side of the painting to the same degree. Keeping to her initial objective, rather than simply leaving this figure pale against dark, the top part of the figure (which in the original photograph is in the shade) is painted in a pure blue, as though catching the light. The lower half is painted with a warmer shadow mauve. Eventually, the top will be pale against dark, and the bottom, dark against pale.

5 THE FIRST STAGE

Against the first tentative washes establishing warm and cool areas, the figures are now in place. They are important, as the rest of the painting will relate to them; they are the indicators for the tonal balance of the rest of the painting. The next stage will center on the tricky task of bringing forth the background to establish the structure, without allowing it to come forward too much, or lose the pizzazz of the extremes of contrast in the counterchange.

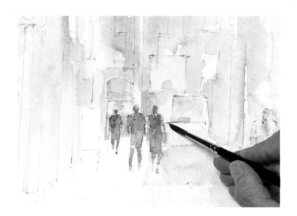

6 Working on the background behind the dark figures, the artist is dropping in areas of color seen in the photograph—blues, reds, and yellows—keeping the colors dilute and the edges soft so that they stay in the background.

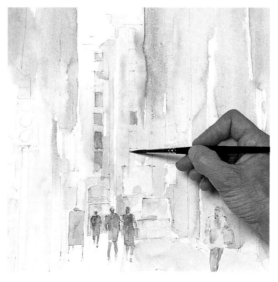

7 Next, pale washes of cool blue go on over the underlying red to indicate windows. You can see how, since the initial wash was uneven, the windows vary tonally, as they do in the photograph.

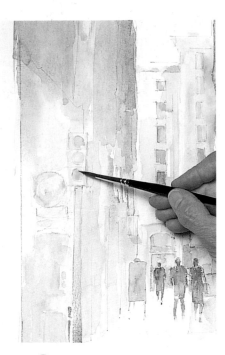

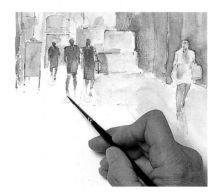

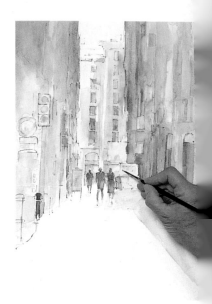

10 Constantly juggling one area of the painting with another, it is the turn of the figures, which appear to be falling back a bit, to be painted. Not wanting to increase the tone simply with absolute darks, the artist makes them stand out more with glazes of color—in reds and blues. A pale wash of the blue is applied for the shadows of the central figures, wet-on-dry.

11 Now, to energize the painting, the original linearity is reinstated with a fine long round brush—literally "drawing in" the original lines of the sketch.

8 Now for the left-hand side. First, build up the mauve shadow washes—which are more intense along the edge seen against the light. Second, describe the traffic light in the foreground, which should be in stark contrast (see original photo) but, as such, will divert the eye from its path along the street. Compromise with suggestions of intense color and form.

12 Having reestablished the structure, now build up the color. Color is dropped in throughout—the red background buildings; the mauve on the right; and then to balance the foreground with the rest of the painting, the yellows are intensified. To effect a feeling of recession, three yellows are used, from the back, Cadmium, then Indian, and finally Lemon.

9 THE SECOND STAGE
To suggest the structure and to build up the tone behind the figure, the right-hand side of the painting has similarly been brought forward by reinstating the original colors, drifting in Dioxazine Violet, Cobalt Blue, and Indian Yellow. Overall there is a sense of balance. Now it's time to introduce some energy with higher colors and contrasts without losing the structure.

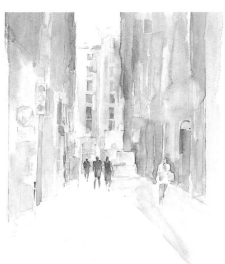

THE FINAL PAINTING
The result has captured the sizzling heat of this Spanish street. But you can see the battle the artist has had with the counterchange, going backward and forward to bring out the contrasts, build up the depth, reinstate the local colors, and tighten up the linearity. It all comes together to form a wonderful light-filled painting.

13 Balancing the shadow on the road with the sunny side of the street, over-glaze with the mauve shadow color—Cobalt Blue, Cadmium Red, and Dioxazine Violet.

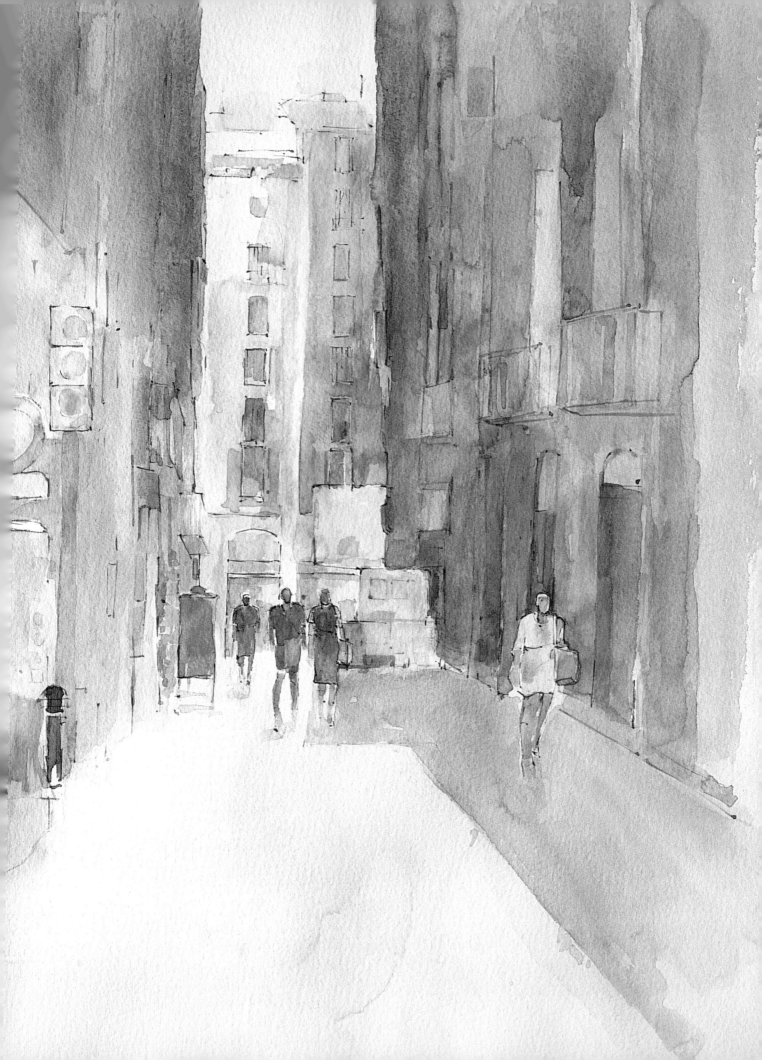

Color and light

Afternoon Light
ROBERT REYNOLDS
The warmth of the afternoon light filtering through the trees is put across by juxta-posing warm and cool colors: warm greens, such as the patches of sunlight on the grass, surrounded by cool greens. The same applies to the reddish browns. Adding to the buzz of light is the fact that these intermingled colors are complementary.

In nature, color does not exist without light. So, logically, where there is color, there is light. You could say that painting in color is the first step toward representing light. Laying down transparent washes of color, one on top of another, as you can with watercolor, is imitating nature, where colored light bathes our lives, qualifying all colors it touches. We have learned through color theory that the energizing quality of light in painting comes through contrasts of color, just as it does through contrasts of tone.

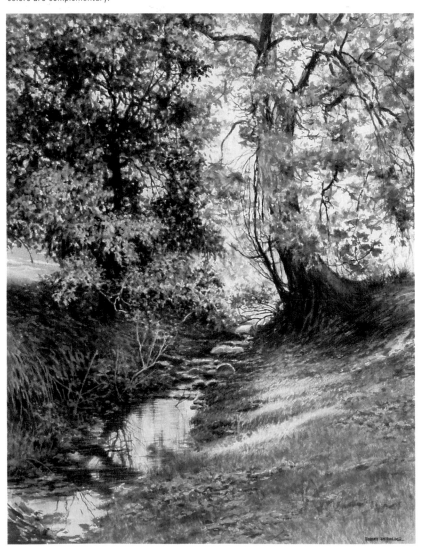

Color temperature

Being aware of color temperature in painting will ope a door for you into another wor of picture making. We know that certain colors a regarded as warm, such as red, yellow, and orange, and others as cool, such as blues and greens. Yet all colors have a warm and cool side to them. Lemon Yellow and Cobalt Blue are cool, and tend toward green, whereas Yellow Ochre an Ultramarine Blue are warm, and tend toward red. A warm color will appear warmer if it is placed next to a cool one, and vice versa. It is this interplay of color and temperature in a painting that can give a sense of pulsating light.

Making colors "sing"

Perhaps you have already introduced contrasting areas of light and shade into your painting and yet have been disappointed that you have failed to achieve the "singing" quality that colors show on a hot summer's day. This will probably be because you have failed to contrast th warmth of the sun-bathed parts of the painting with the coolness of the shady areas. This means, for example, using warm greens in the sunlit parts of the painting next to cool greens in the shady part.

This approach to picture making doesn't necessarily have to relate to the logic of a painting. It's the contrast that is important. You just need to contrast warm areas with cool ones to add a certain buzz to your painting. This can mean sandwiching a warm third of your picture area between two cooler areas or, more specifically, painting a warm, red apple with a cool shadow.

But remember that areas of warm color tend to come forward in the picture plane and cool areas recede. These are useful characteristics if you want to nail down a passage in a particular part of the picture space, but you will need to take care of warmer sections in the background also. Build up such passages carefully or you will have trouble keeping them in the background.

Once you start looking at potential subjects with temperature in mind, you will see how easy it can be to introduce temperature contrasts. Practice on photographs in magazines, coloring warm parts of a scene red and cool parts blue. Do a painted sketch of the scene, bearing these contrasts in mind, and you will see the difference.

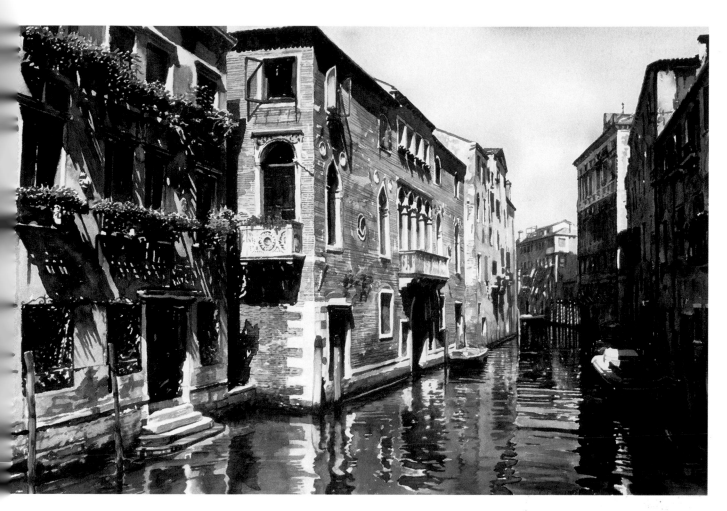

Rio di San Paolo, Venice
PAUL DMOCH
Touches of color high in value, both warm and cool, lead the eye through this painting: the red flowers on the balconies set in their complementary greens; a scarlet curtain in the top floor window to their right; touches of terracotta plasterwork; and, lighting up the shadows on the right, a patch of red among the boats on the canal. You will find a similar pathway with the blues.

Complementary colors

To further intensify the colors imitating light, look for opportunities to combine complementary colors. These are colors that, according to color theory, find themselves on opposite sides of the color wheel, that is: green and red, yellow and violet, and orange and blue. Placing these colors alongside each other—a few red flowers among warm green foliage, for example—will create a visual buzz. These colors don't have to be used at full strength and are just as effective, in fact sometimes more so, in their dilute or less pure forms.

If you mix true complementaries, you will find that a gray emerges. Try juxtaposing complementary colors in small points of color, touching the first one on to your paper with the tip of a pointed brush, wet-on-dry. Allow the paint to dry and then add points of the complementary in and around the first color. You will get an area pulsating with energy, which, when viewed from a distance, looks like an area of gray. You could also try adding both colors, wet-in-wet. Lay down a wash of Yellow Ochre and then, after it has dried a little, add touches of violet. You don't want the colors to combine, but to swirl together so that both are visible in their own right. These techniques are useful for areas of shadow that you want to energize.

Mixing colors

But mixing warm and cool colors is not always as simple as mixing together two so-called warm colors, because pigments have many other characteristics that must be considered. The more transparent the paint, the more easily you will find that it mixes. Viridian is a wonderful transparent green that can be modified by less transparent Cadmium Yellow to produce a solid pea green. Mix it with Burnt Sienna, though, and the greens produced will have a quality that comes from the transparency of the two pigments. Color mixing is an art in itself, and it will become second nature to you once you get to know the personalities of the paints in your chosen palette.

Autumn Leaves *ROBERT REYNOLDS*

Contributing to the celebration of light in this painting is the use of complementary colors—red and green—carefully distributed in a balanced pattern of tonal values, strong reds matching strong greens, weak matching weak. Warm and cool versions of these colors are here, too. Notice how the use of color has energized the shadow side of the painting, which appears uninteresting in the black-and-white version.

Sunset, River Chelmer
PETER KELLY

A wonderfully restrained painting in muted colors, which, nonetheless, glows with light. The last strains of evening light in the sky are expressed in neutral complementary colors—shades of orange and blue, yellow and purple—reflected in the water below. These colors have been allowed to mingle, wet-in-wet. Note the different quality of the artificial light—a harsh, greenish yellow. Again, the rather dull monochrome version of the painting, above, shows the effectiveness of these color combinations.

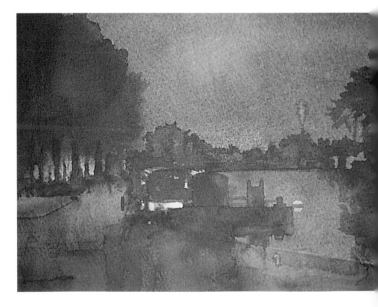

Barcelona Street Scene
HAZEL LALE

Abandoning the restrictions of realism, the artist here conveys the flavor of the scene in concentrated high-value watercolors, so that it glows with color and light. Note how the background reds have been kept in their place by the artist by blurring their edges, suggesting distance, and also by neutralizing them with a little complementary green. The brightest area of highlight, as may be seen in the monochrome version above, is reserved to draw attention to the seated figure on the left.

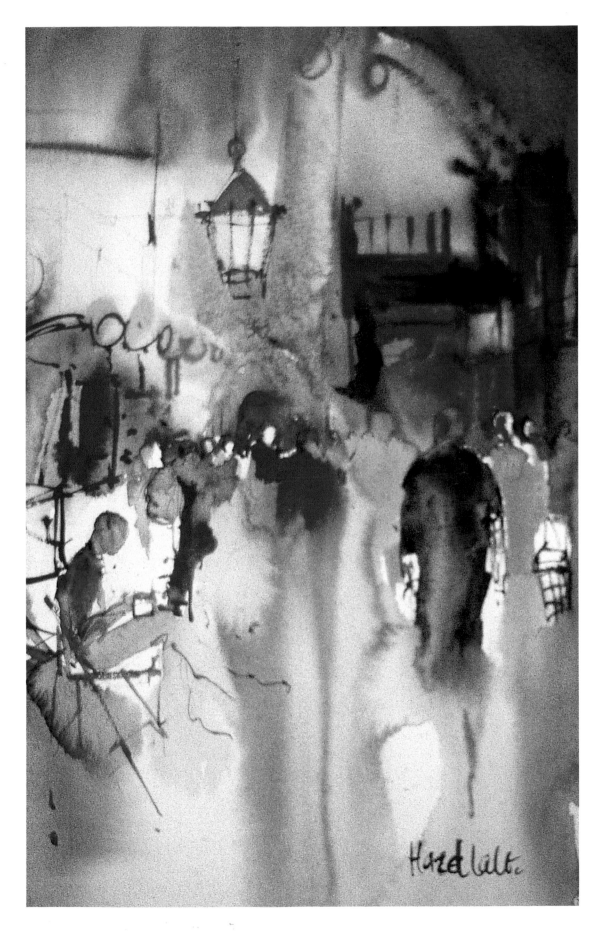

1 After transferring the edited drawing onto the paper, areas of highlight, such as the roofs, are conserved with masking fluid. This type of masking fluid is pale blue, rather than yellow, which allows one to judge color values more correctly while it's in place.

Demonstration:

Alpine pastures

by *GEOFF KERSEY*

This is a lush alpine scene with a good, clear, yellow light coming from the left, behind the viewer. The artist aims through controlling color temperature and juxtaposing complementaries, to capture the sparkle of this summer scene. The tonal sketch gives the artist the opportunity to edit the scene. Extraneous buildings and sundry cows are left out and a pathway, taking the eye into the painting, is put in. Tone is added to the middleground trees and the foreground grass, and the positioning of the remaining houses is subtly changed, so that there is a sense of progression into the picture space.

PALETTE
Cobalt Blue, Cobalt Violet, Cerulean Blue, Ultramarine Blue, Raw Sienna, Burnt Sienna, Aureolin, Lemon Yellow, Viridian

2 First add the sky washes. Make up two mixes of blue: a warm one–Cobalt Blue with a bit of Cobalt Violet; and a cool one–Cobalt Blue with Cerulean. Wet the whole sky area down below the mountain tops, then float in the color–warmer at the top and cooler toward the horizon. Leave white areas to suggest clouds and also specks of white so that colors are not too solid. Slope the board you are working on about 15 degrees, so the paint drops down a little but does not drip. Allow the wash to dry naturally and see (inset) how the paint softens when it does.

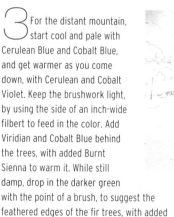

3 For the distant mountain, start cool and pale with Cerulean Blue and Cobalt Blue, and get warmer as you come down, with Cerulean and Cobalt Violet. Keep the brushwork light, by using the side of an inch-wide filbert to feed in the color. Add Viridian and Cobalt Blue behind the trees, with added Burnt Sienna to warm it. While still damp, drop in the darker green with the point of a brush, to suggest the feathered edges of the fir trees, with added touches of Lemon Yellow (inset).

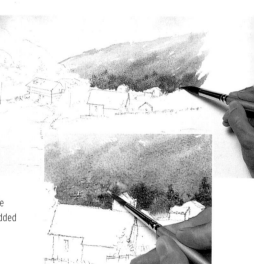

PREPARATORY WORK
The original photograph is subtly rearranged in the tonal sketch without losing the essence of the scene.

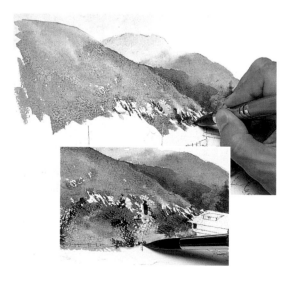

4 Now paint the mountains on the left. Vary the blues, making them paler in the distance. To suggest the rock formation, draw with a darker gray using the point of the brush around the areas of white. Now work downward (inset), introducing warmer greens and yellows.

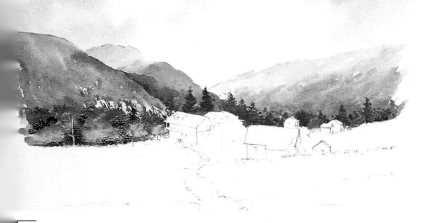

5 THE FIRST STAGE

Even though it is not obvious, the juxtaposed areas of warm and cool colors give the painting a freshness that is typical of the Alps. As the colors come down into the foreground, they become warmer and brighter where the sun catches the greenery.

6 To help integrate the land and the sky, knock back the edge of the distant mountain by working at it with a clean brush and water, and then blotting it with a tissue. Soften the edge in parts, and leave it strong in others. This edge is painted over the sky wash, which pulls together mountain and sky.

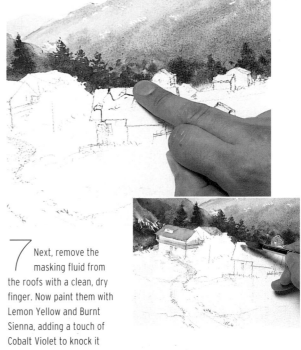

7 Next, remove the masking fluid from the roofs with a clean, dry finger. Now paint them with Lemon Yellow and Burnt Sienna, adding a touch of Cobalt Violet to knock it back (inset). Vary the mix for the different roofs. You can see how the exaggerated darks of the bank of trees behind these roofs helps to throw them forward and introduces a nice buzz of color in the center of the painting—no wonder, as these are complementaries of a sort: orange-red and blue-green.

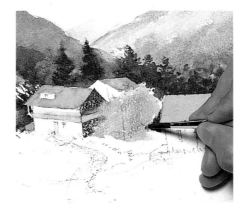

8 The end of the main house is painted in dark shadow. The tree in between needs to be light against this dark end, and dark against the light roof on the right. This may not be how it is in nature, but it will not look out of place. Paint in a good bright yellow-green against the dark end. Then add dark shadows to merge wet-in-wet around the roof on the right.

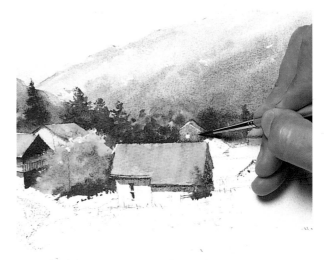

9 Now add the shadows on the white houses— an opportunity for some pure transparent color— Cobalt Blue and Violet, since the yellow sunlight will cast complementary violet shadows onto any white surface. It also acts as a link with similar colors in the painting, such as the sky, thereby helping to pull the painting together.

10 The foreground roof and background house need to be separated, as they seem to be on the same plane— almost as if one is sitting on top of the other. It is confusing. Add some dull shadow to the lower half of the background house and it falls back.

11 Moving to the right, lay down the color for the first part of the meadow—Lemon Yellow, Raw Sienna, Aureolin, and Cobalt Blue. While still damp, run some Viridian and Burnt Sienna—in a much thicker consistency than the yellow—along the boundary for the hedge. As you can see, the green bleeds into the yellow for the perfect hedge.

14 Now look at the foreground. First have your mixes ready so you can proceed without pausing: Lemon Yellow and Raw Sienna; Aureolin and Cobalt Blue; Viridian and Burnt Sienna. Apply a graduated wash with the three. Do not wet the paper first, because the color needs to be intense. Run the brush through the dark into the light so that the color is not too flat (inset).

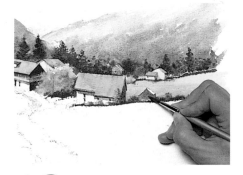

12 Still in the same area, move to the shed, which, in the painting, has been upgraded from a temporary shelter. The artist has decided to keep the strident, man-made color—a mix of Viridian and Cobalt Blue. This has the effect of pulling the eye away from the obvious pathway into the painting, inviting it to explore the area around the path.

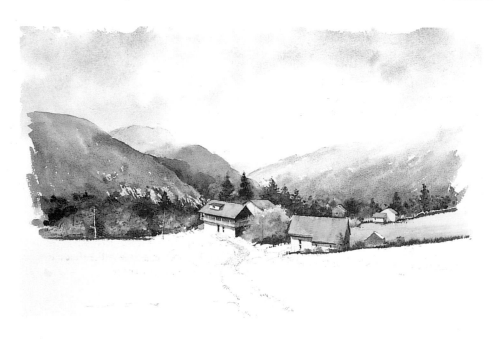

15 Dry brush along the edge of the path with the darker green—it should not look like a blacktopped road. Now wet the path surface with water and drop in at the back a pale solution of the violet mix, changing it gradually to Aureolin and Burnt Umber in the foreground.

13 THE SECOND STAGE

You can see here the linking of colors throughout the painting. The violet shadows on the houses perform an effective link across the center of the painting. The color is picked up again in a dilute form in the rocks on the left and also on the roofs of the background houses on the right. The yellows have the same effect.

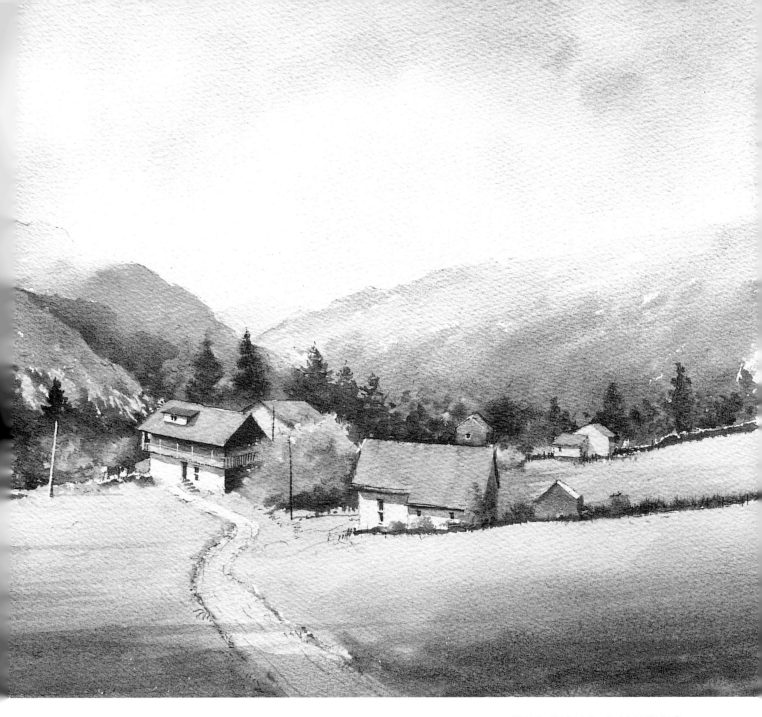

16 Once the foreground is dry, run a transparent violet shadow in a glaze over the top. This will have the effect of linking the violet color to other incidents of it throughout the painting. It will also pull together the disparate elements—the path and meadow—in the foreground.

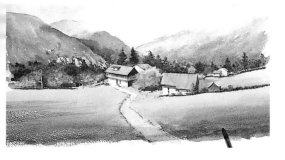

17 These telephone poles, conserved with masking fluid, now removed, would usually have been edited out of such a painting. But here they provide vertical structure and a sense of scale to a flat area.

THE FINAL PAINTING

Through the subtle manipulation of color, the summer light on this lush alpine scene has been captured. It is interesting to see how the original photograph has been turned into a painting. The snapshot has not been slavishly copied, but has been used as a reference and a reminder of the scene—of its physical layout, colors, and atmosphere. The artist, in this painting, has adapted the information in the light of his memories of the scene and his knowledge of what works with the watercolor medium.

Varying tone for lost edges

Bringing darks around a light edge

Lost and found edges for the boring bits

Lost and found edges

Front Door Geraniums
RUTH BADERIAN
Without it being obvious, great care has been taken to "find" and "lose" edges around the flowers and leaves below. A dark leaf sets off the highlight on one bloom, and dark cool shadows are added to another to distinguish it from the background. It is the same for the leaves.

As we have seen, the painter of light has often to abandon the comfort of the outline. Of course, objects have an outline but often they are lost—or parts are lost—where the tone and color of the painted object is the same as the tone and color of the background. If this loss results in the viewer not being able to understand the painting, then the outline has to be "found." For example, if, in a dull light, a girl wearing a white dress stands against a white wall, her outline will be "lost," and she will merge with her background as they will be similar in tone and hue. The artist has to overcome this problem, perhaps by coloring the background wall, or by inventing a cast light that will describe the outline through highlights down one side of her, contrasting with the wall behind, and similarly through the shadow on the other side. But there may be parts of the edge that are still "lost." This doesn't matter, as the eye doesn't have to have all the information. It just needs enough to understand what's going on.

Visual interest This "finding," and also "losing," of edges brings another dimension of visual interest to your painting. Take a bunch of flowers in a vase. Often the simplicity and beauty of the flowers that first attracted you to the subject are lost in the wealth of information present —a confused mass of shapes and intersecting lines. What you need to do is to find what captures the beauty of these flowers, and to make sure that the eye is drawn to that part. If, for example, it is the luminescent light shining through the edge of a rose petal, then you need to isolate that edge by setting it against a dark background or by bringing out the darks behind the telling edge of the petal. It will be more

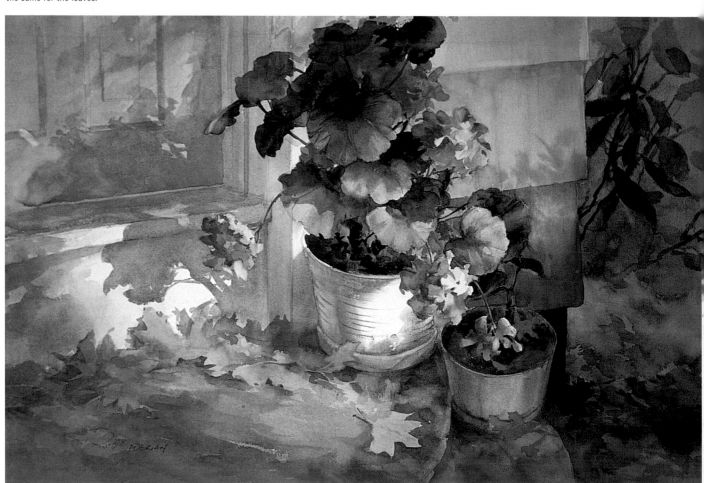

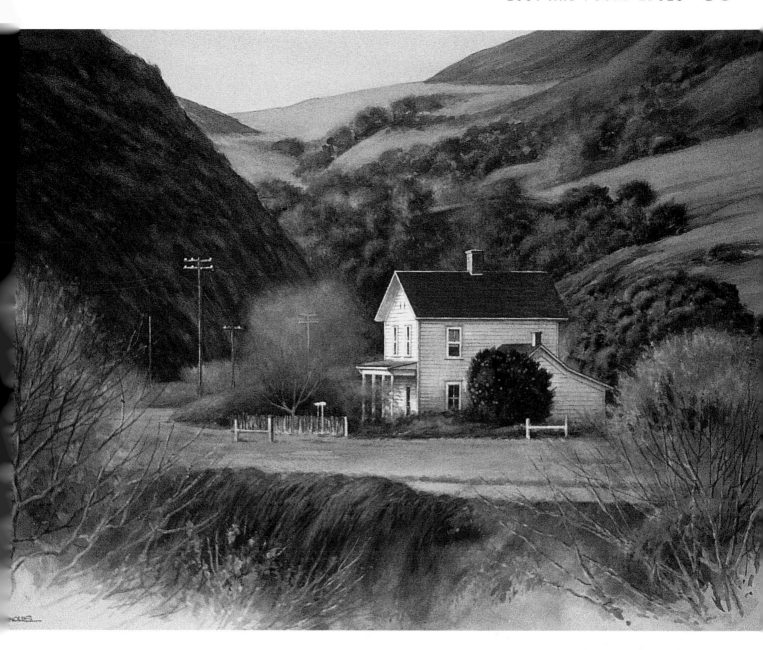

interesting, however, if the sum of all that is beautiful about a rose is not thrust into the viewer's face too obviously. So vary the background if you can, so that, in places, the edge stands out in stark contrast and, in others, it is lost in the background. In the same vase, express long stems with lost and found edges, with passages of contrast where the edge is seen, along with stretches where the edge disappears. This will add visual interest to what might be considered the boring bits.

Varying edges

As is nearly always the case, lost and found edges occur naturally. The artist just needs to recognize and capitalize on them, exaggerating this and editing out that.

Practice with a black-and-white newspaper photograph that will take your pencil marks (or photocopy a magazine photograph). See how you can vary the value of the outline by building up the darks on one side or the other, finding and losing edges. Use white body color to brighten up areas if necessary. A fully lit, white house against dark trees will be more interesting if the tone is varied along the house's outline, in places matching that of the house itself so that, for a bit, it disappears.

Once you are on the lookout for lost and found edges, you will find that, by fine-tuning what is before you, you can use this approach to express various forms of broken light in your painting: dappled light, light falling through trees, and so on.

Curtis' Place
ROBERT REYNOLDS
The finding and losing of edges is a subtle art, as shown here. The fully lit end of the house is left stark, exaggerated against the background darks, but the outline of the rest of the house ducks in and out of focus—to the right of the chimney, along the pitch of the roof. This adds visual interest to the image, arresting the eye as it skims along, causing it to linger momentarily.

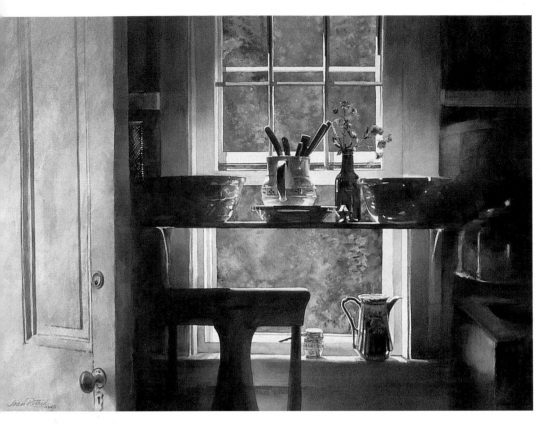

Inside Out *JOAN ROTHEL*

Seen against the light, you might expect these objects to stand out starkly against the background. But look at the jug on the shelf; parts are clear against the foliage, but other parts catch the light and melt into the window frame. The bowls on either side have useful highlights which "find" the edges against the similarly dark foliage, and yet their outer sides are completely lost in the depths of the shadows. The monochrome version shows the carefully manipulated balance of tone.

Erpekom Church, Belgium
PAUL DMOCH
Here the sun burns through the tree's canopy, obliterating the form where it is brightest and casting dappled shade on the sprawling diagonal of the tree trunk. Looking at the monochrome version, you will be able to see how, along the length of the tree, edges are "found" and "lost," encouraging the eye to dance along the twists and turns of its branches.

Saddhu *NAOMI TYDEMAN*
With the sun blazing down from the top right, but from behind, the outline of this figure alternates between "lost" and "found," and is exaggerated by the inky darks of the background. Down the right side, the turban and hair have "found" edges; down the left, there are undefined areas interrupted by passages in strong contrast, such as where the arm, thrust forward, comes into the full glare of the sun. This black-and-white study shows a careful balance of contrasts.

Hopper Cars *MARY LOU FERBERT*
The artist has carefully considered "lost" and "found" edges throughout this painting. Look how the receding parallel inside edges of these hoppers, which would have been "lost" against the deep blue sky, have been "found" with thin strips of reflected highlight that do not look out of place. But note how these strips have been broken up at stages, in order to make them more believable.

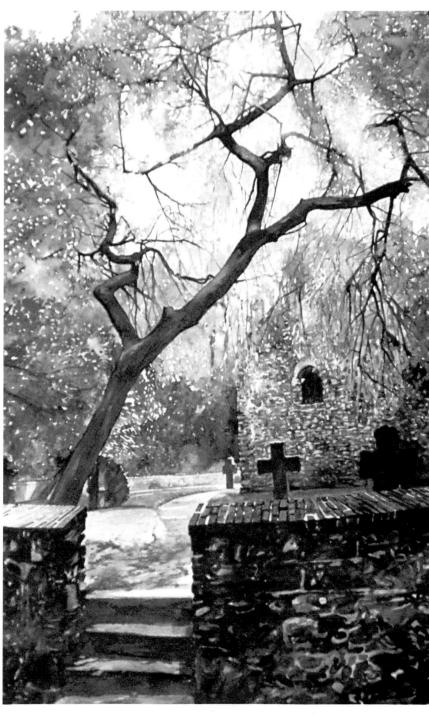

Masking fluid for highlights
Transparent glazes
Lifting off for soft edges
Cutting in around hard edges, wet on dry

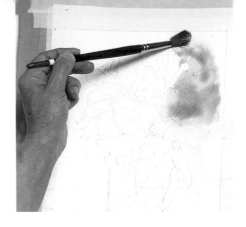

1 With a careful outline drawing used as a guide, the areas of highlight are conserved with masking fluid. Then, having wetted the whole page, color is fed in, adding more water or taking the paint away with a dried brush if too extreme. First Permanent Rose.

Demonstration:
Pretty in pink

by *ADELENE FLETCHER*

To bring out the glorious light-touched edges of this peony, the tonal layout was adjusted by cutting in the darks around them. The edges are varied—some "found" and some "lost"—primarily through changes in color and tone. Conserving the highlights is important, so masking fluid is used but only for the initial washes. The artist uses transparent colors and mixes them on the paper, feeding in color, wet-in-wet, to get fresh mixes that vary in hue and tone. The preparatory thinking for this painting can be seen on page 31.

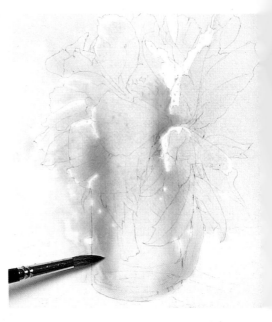

2 Next, Aureolin Yellow and touches of Cobalt Blue are added and allowed to run together in places. Tip the board to encourage this merging of color. You can see how the masking fluid protects the highlights.

PALETTE
Phthalo Green, Aureolin Yellow, Transparent Orange, Permanent Rose, Prussian Green, Green Gold, Olive Green, Dioxazine Violet, Cobalt Blue

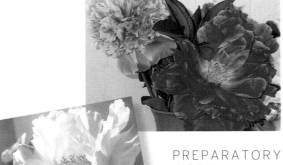

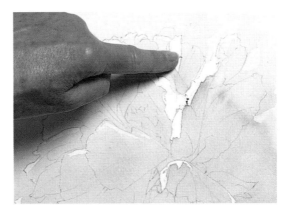

3 Once the paint is dry—the last stages encouraged by a hair-dryer—the masking fluid is removed with a clean finger. The colors have dried paler. But you can see that variations have been encouraged.

PREPARATORY WORK
The photograph used as a main reference was of a white peony, left, but the artist decided to paint the flower pink, referring to the photograph above.

4 Soften the edges of the highlights, where the paint has built up along the edges of the masking fluid, by working away at it with a coarse brush and clean water, and then dab it with a tissue.

5 Build up the yellow of the stamens in the center of the peony, keeping the edges [so]ft. Dab them with a squeezed-out brush to [ta]ke away the excess water.

6 Gradually build up the glazes of transparent color. Here the initial foliage [c]olor, Phthalo Green, is fed in while the [p]etal colors are still damp, for softer edges.

7 THE FIRST STAGE

With transparent glazes, the strength of [c]olor is built up gradually. In these early stages, [t]he boundaries of the petals appear to get lost, [b]ut they will be reestablished when the darks [a]re added.

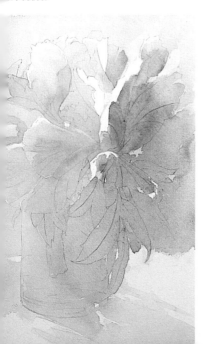

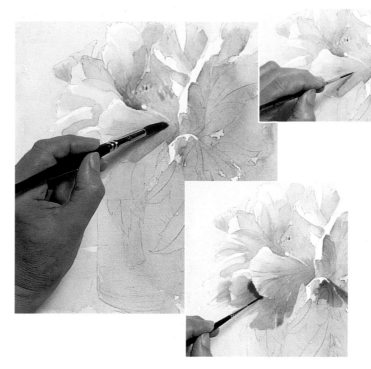

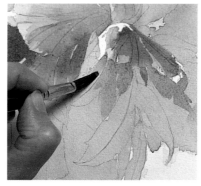

9 Now treat the foliage in the same way, creating edges and finding form. Apply the paint wet-on-dry, using stronger color—but not too strong.

10 To form the base of the vase, add Prussian Green with a touch of Dioxazine Violet. Allow it to run into the table area where the shadow lies.

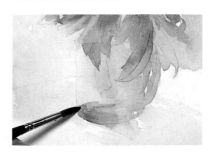

8 Now, wet-on-dry, more color is added to suggest the form of the flower—the edges of petals and the structure of the stamens. Inset above, a long thin brush is used to suggest ribbing in the petals. Inset below, more intense color "finds" the petal edges.

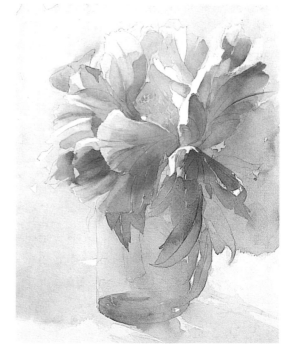

11 THE SECOND STAGE

The form of the peony is starting to appear by creating edges with color and tone. The colors are established with warm yellow pinks in the center, flanked by cooler blue pinks. There are warm and cool greens, too. At this stage, the stamens are conserved with masking fluid.

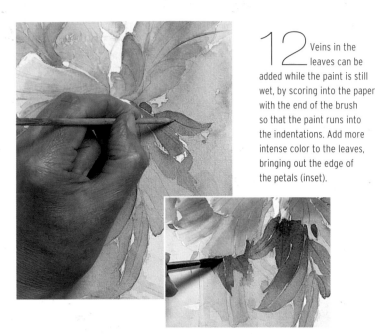

12 Veins in the leaves can be added while the paint is still wet, by scoring into the paper with the end of the brush so that the paint runs into the indentations. Add more intense color to the leaves, bringing out the edge of the petals (inset).

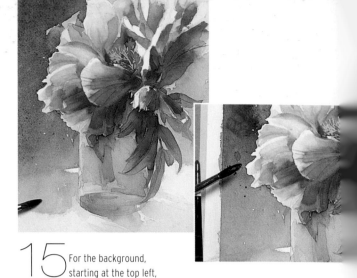

15 For the background, starting at the top left, Prussian Green and Green Gold are dropped in and then carefully taken around the edge of the flower. Additional colors are spattered in and allowed to merge (see inset). Where the lighter area is wanted, lift out the paint with a squeezed-out brush. Along the right-hand side, where the background is warmer, Olive Green and Permanent Rose are fed in. Lose the edge where the red and the green match in tone by wetting it and allowing the colors to merge a little.

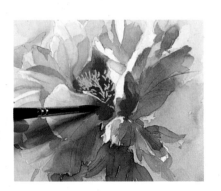

13 The colors, in general, are intensified by wetting and then feeding in color. The most intense color is reserved for the area at the center of the flower, fed with a mix of Permanent Rose and Transparent Orange. You can now see the masking fluid on the stamens doing its work.

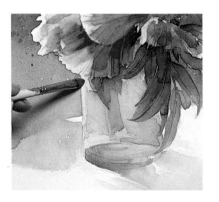

16 Adjustments are made to the vase and the shadow on the table. The reflection on the vase is taken back with a coarse filbert brush and clean water, and then blotted with a tissue.

14 THE THIRD STAGE
Having built up the tone in the center of the flower, the surrounding cooler pinks have had to be brought out to balance them. The form of the flower is now established and also the intensity of color, which has been created by superimposed glazes. Note how the white highlights have been carefully conserved.

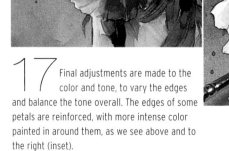

17 Final adjustments are made to the color and tone, to vary the edges and balance the tone overall. The edges of some petals are reinforced, with more intense color painted in around them, as we see above and to the right (inset).

THE FINAL PAINTING
A wonderful painting, this benefited from careful planning by the artist before brush touched paper. The painting process involved gradual adjustments to the tone and color and has resulted in an image with a variation of lost and found edges throughout. The result is emotionally captivating and stimulating to the eye.

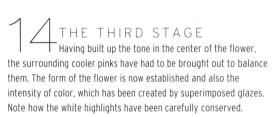

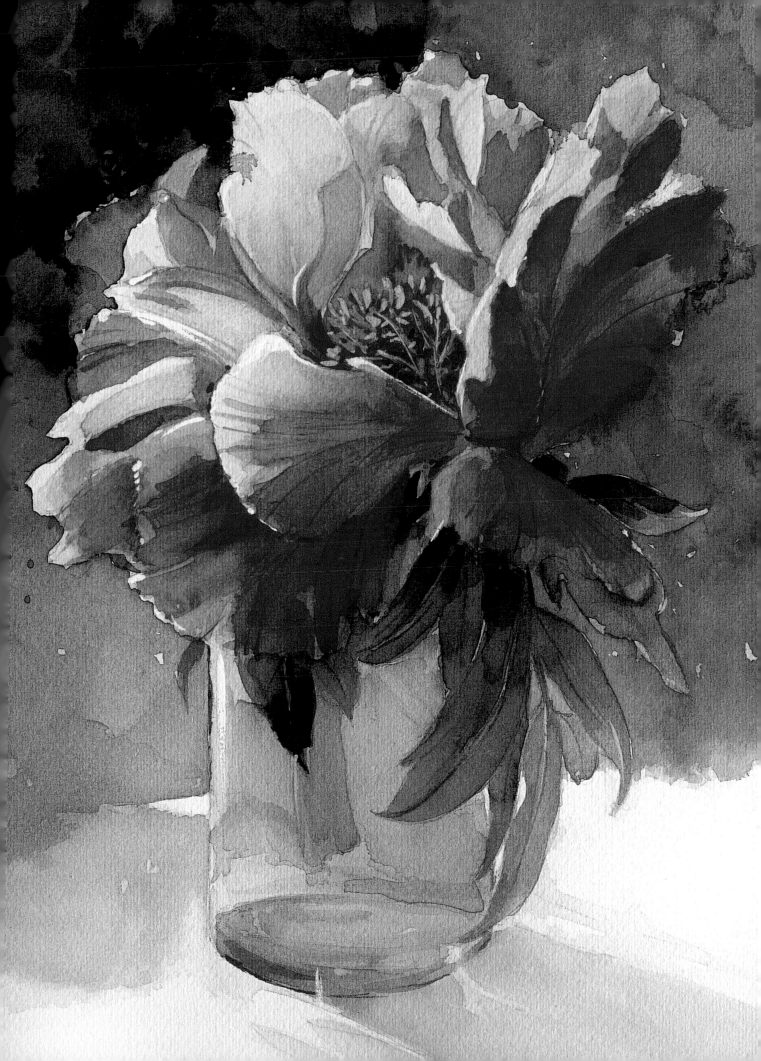

Reflections

It is light that creates reflections, bouncing off surfaces so that we can translate the information given and gather details about the texture and nature of the world around us. The extent to which a material reflects light depends on what it is made of, and on how rough or smooth, and how hard or soft, it is; the quality of the reflection will be affected by the strength of the light. We tend to think of a reflection as light being thrown back by highly polished or shiny materials such as glass, polished metal, or plastic, yet all highlights are a form of reflection and their quality will inform you about the nature of the object in question. A scruffy terrier will not reflect light as starkly as a shiny, smooth-coated dog, but the polished sides of a stainless steel coffee pot will reflect a distorted image of its surroundings.

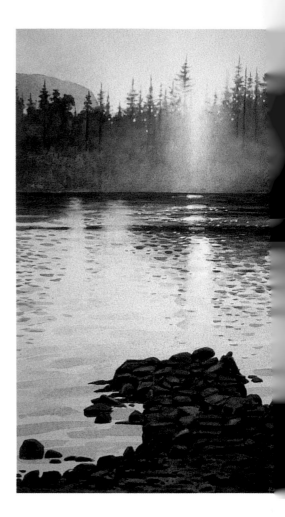

Mammoth Light
ROBERT REYNOLDS
The paths of light across the water obey the laws of perspective, with parallel edges receding toward the distance. Divided into three areas, this stretch of water is described with larger, more defined horizontal brushstrokes in the foreground, strokes that are smaller and closer together in the middleground, and broken washes in the background.

Reflections of Color
MARJORIE COLLINS
An amusing conundrum, which takes a while to solve, but here, seen from above, we have a highly polished platter alongside a pot containing non-reflective crayons. Connecting the two is the magnified reflection of the pot in the platter.

Glass and metal

Glass and metal objects, which reflect the world around them, are often considered hard to paint, but all they require is objectivity on the part of the artist. If you find this a problem, try setting up a still life with a few bottles, a shiny spoon, and any other reflective objects you can find. Make a viewfinder by cutting an oblong in a piece of card and zoom in on an abstract portion of your composition. This will help you see the reflections objectively as interlocking shapes and colors. You can also do this with a magazine photograph, masking off a section for study. Now record what you see, taking it step-by-step, one square inch at a time. To begin with, if you want to establish the tonal shapes in your chosen portion, explore them in monochrome with a pencil. Otherwise, try to capture them in a single layer of watercolor, using a thick brush.

Reflections in water

Water is colorless and transparent. Its "color" depends on what it reflects—the sky, or the trees around it, or houses—combined with reflected

lor from the depths and particles carried in the ater. All of this can change if its surface is ffled by a breeze or by the churning engines of speedboat. Because flat, glassy water will reflect e sky, it helps to take down sky washes into the ater area below. But the flat horizontal plane of e water has to be suggested by the brushwork superimposed washes. These can be painted in orizontal strokes, wet-on-dry. You will need to djust what you can see to make sure that the ea of water is read correctly. A few lines cratched out with a blade will suggest the plane f the water. Leave a horizontal stretch of lighter ater in the distance if you like; the phenomenon quite common when the wind disturbs a patch f water so that it catches the light.

aking a wash under the water area can also ct as a unifying factor. In a fast-moving stream, vater is fractured by patches of agitated white vater, dark pools of still water off the main tream, rocks, and overhanging trees. So the iversity of techniques required here can be ulled together by glimpses, across the picture urface, of the color of the prevailing light, vhich is laid down as an initial wash.

Watch those contrasts

Reflections come toward you. The path of light from the setting sun, as it is seen reflected across the water, will appear to stretch from the horizon, vertically below the sun to your feet. Like a pathway, it obeys the laws of perspective and its parallel sides meet at a point on the horizon. But watch those contrasts. On broken water, individual patches of light will be visible in the foreground, where the wavelets reflect the light individually. In the middleground, the touches of light will become more generalized with less contrast and, in the distance, the light will blend into a flat area of color. Try reserving such a path of light on rough paper with candlewax. Practice with this first, for once wax is applied, it cannot be removed and it repels watercolor. It gives a good impression of the broken quality of the light on the water; all you need to do is paint over it with watercolor.

Blurred edges

The reflections of houses or trees in water should not be too clear or sharp-edged, even if reality tells you otherwise. The reflected image should be blurred and qualified by the color of the body of water. This is usually

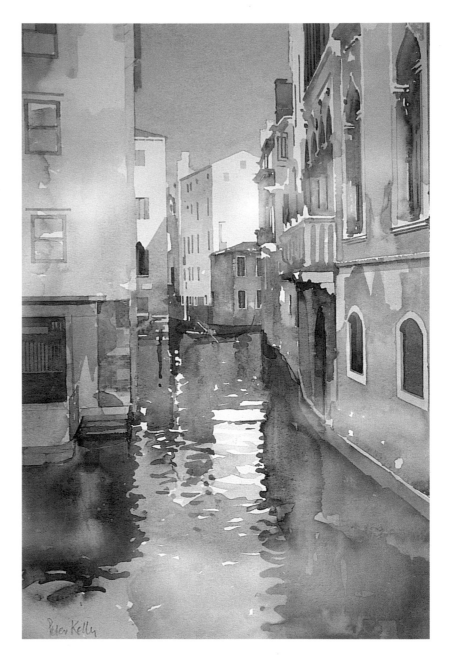

Venetian Backwater
PETER KELLY
The water here is a wonderful mixture of shadows, where you can see through the surface into the depths of the water, and reflections that remain on the surface. It also illustrates the fact that light objects appear darker in reflections and dark objects lighter.

just a case of knocking back the color and working it in to the area of water, wet-in-wet. Reflected clouds cause problems with the plane of the water and are better generalized in color. But patches of blue seen through the clouds make a colorful contribution to the patchwork of a river. Reflections from verticals above the waterline, such as trees, should be equal in length, but should also be measured from the base of the upright tree trunks, as if they could be seen over the landmass and into the water. These verticals seen in the water are seldom straight, even if the water is still. A squiggle made with the tip of a pointed brush in a not-too-dry wash will convey an impression.

Hall of Mirrors, Versailles *PAUL DMOCH*

If you wanted to set yourself the most difficult task of all when it comes to painting reflections, then this is the place to go to for mirrors, gilt, and polished marble. The resulting picture is a miracle of observation and controlled painting. The monochrome version, right, shows the pattern of higlights that create a certain movement in the still interior.

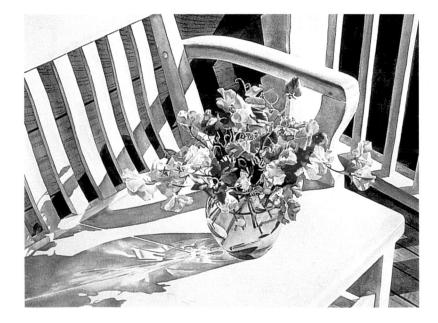

Sweet Peas on the Porch *WILLIAM C. WRIGHT*

Sunlight is refracted through the vase of water, making abstract patterns of reflected color and beams of light on the white bench. This is not something that can be invented easily. The artist has used the full extremes of the tonal range (see near left) to powerful effect.

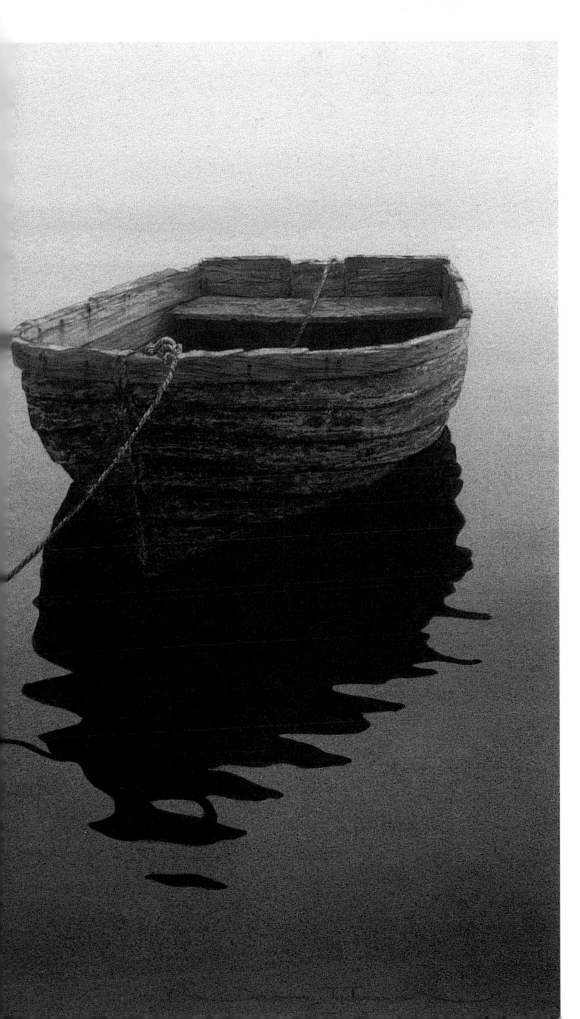

Old Boat
NAOMI TYDEMAN
An old boat casts a deep dark-shadowed reflection over the water, intercepting the overall brightness of the misty light on the surface of the oily water (see black-and-white version above). The shadow's edge is broken up by the slight movement in the water.

Complementary color glazes for shadow grays

Building up depth in color

Hard-edged distorted reflections

Black that is not just black

Demonstration:

Life is a bowl of cherries

by *MARJORIE COLLINS*

The reflections on this silver creamer of the OpArt print are an important part of the composition. You could say that this distortion of the regularity of the concentric circles of the print creates a focus in the center of the painting. This is a painting that has been very carefully considered and the preparatory work for it can be seen on page 28. Working from a precise underdrawing, and by mapping out the areas of tone, the artist pain-stakingly builds carefully controlled washes of watercolor to arrive at a depth of color and tone that defies belief.

PALETTE

Permanent Alizarin Crimson, Mauve, Phthalo Blue, French Ultramarine, Sap Green, Aureolin Yellow, Sepia, Raw Umber, Lamp Black

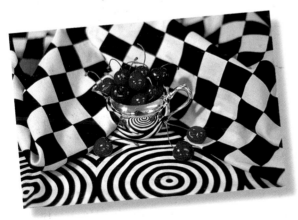

PREPARATORY WORK

This reference photograph was taken especially for the painting, with an incandescent spotlight lighting the still life.

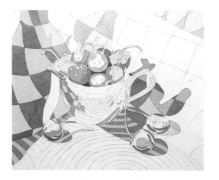

1 For the first stage of the underpainting, three shades of the mauve shadow mix—mauve and French Ultramarine—are combined in pots. The shadow areas—on the printed material, the cherries, and reflected in the creamer—are mapped out in three main dilutions of mauve. Paint pale mauve over all these areas, allowing to dry. Then add the next shade of mauve to the mid-tone shapes. Allow this to dry, then add the darker tone. To remind herself, the artist has placed a pencil dot on potential black shapes.

2 To work up the grays of the white squares that are in the shadow, now a complementary layer of Aureolin Yellow is laid over the top of the mauve to form a gray. The process is gradual and will be repeated many times.

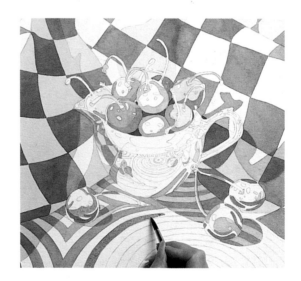

3 Once that is dry, it is the turn of the black. Lamp Black has been chosen because it tends toward blue and works well for this precise style. Dilute a decent amount in a pot before you start so that its tone is even. This wash must be pale so that color values can be judged. This black wash goes over the white paper for black squares in the light, and over the mauve underpainting for black squares in shadow.

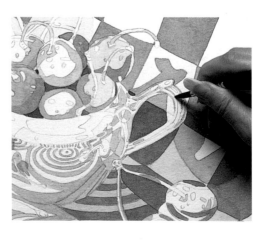

4 Now paint the creamer and the reflections of the black shapes. Following the rule that dark colors appear lighter when reflected, and vice versa, the black will appear lighter. No masking fluid is used, so you need to be very careful when painting around the highlights that are mapped out in the underdrawing.

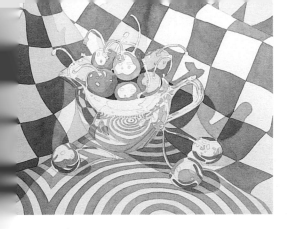

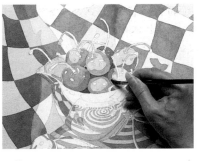

5 THE FIRST STAGE
There is an even distribution of paint and a balance of tone here. Bringing on the whole painting in this way allows you to keep this balance in check. But it is a good idea to stand back and check one's progress from time to time. Waiting for the paint to dry gives you that opportunity.

6 Now introduce the main attraction, the cherries. First, paint a dilute wash of palest Alizarin Crimson over the whole cherry, except the highlights. The highlights, outlined in pencil, have to be carefully negotiated. A synthetic round brush–No. 8–with a good point, gives you control.

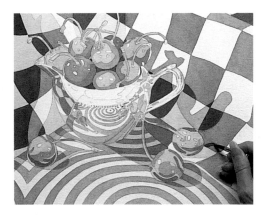

7 Now add the stems on the cherries in a pale wash of Raw Umber. Paint over the purple shadows, which have already dried.

8 The next step is to intensify the shadows on the black squares. Paint over these black shapes with the Lamp Black–not so dilute now.

9 Now go over the shadow and non-shadow parts of the black squares. Since you are using the same tone, the shadow areas remain distinguishable, as the wash qualifies the shadow and non-shadow parts differently.

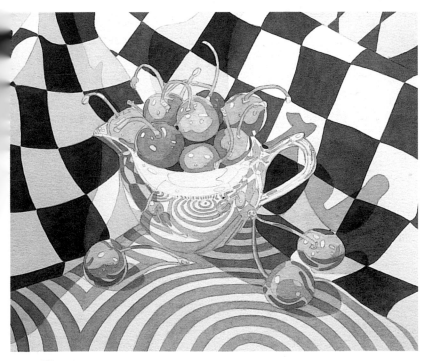

10 THE SECOND STAGE
You will notice that the reflected shapes on the silver creamer are as hard-edged as the patterns on the back-cloth. The checkered back-cloth has been brought on more than then rest of the painting, so now it is time to bring all the colors up to the same level of intensity.

11 Next, the reflections on the creamer need attention. First use the black–more dilute and therefore paler than the real thing. You may find it easier to turn the board upside-down to work at these curves.

12 Now work on the cherries again. The "real" ones have been given a wash of more intense Alizarin Crimson, over the shadows. The same goes for the miniaturized cherries in the reflection.

13 The collar of the creamer needs special attention. It is a jigsaw of colors and tones, reflecting lights and objects in the studio. There are four shades: pale blue (dilute Phthalo Blue); mid-blue (blue over black); dark blue (black over blue); and white.

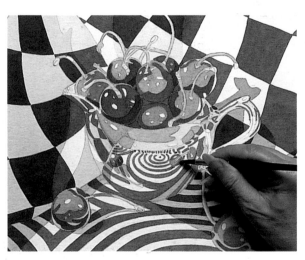

14 To build up the intensity of color in the cherries, add another layer of the original shadow-mauve: mauve and French Ultramarine. This time, paint it over the whole cherry, except for the highlight. Do the same in the reflection, only a fraction lighter.

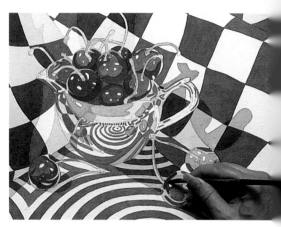

15 Still focusing on the cherries: once they are dry, add another layer of Alizarin Crimson over them, except for the highlights. They are starting to look round and juicy, but there is still a way to go.

16 THE THIRD STAGE
Gradually the colors and tones are being built up, layer by layer, which allows you to manipulate and balance the tones as you come to the final stage. Keep repeating those washes: black wash goes on black; yellow on mauve; and the cherries are built up with purple and crimson.

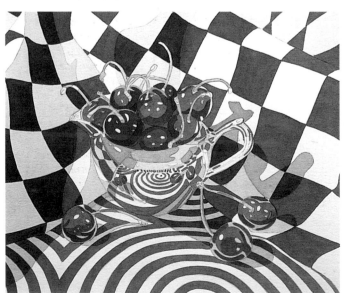

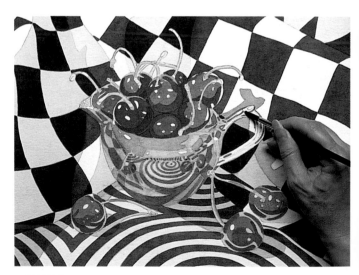

17 Mindful of the fact that light colors reflect darker, the creamer is given an overall wash of very, very dilute Burnt Umber to knock back its colors and, in particular, the white. Note that the black squares have received yet another wash of dilute Lamp Black, too.

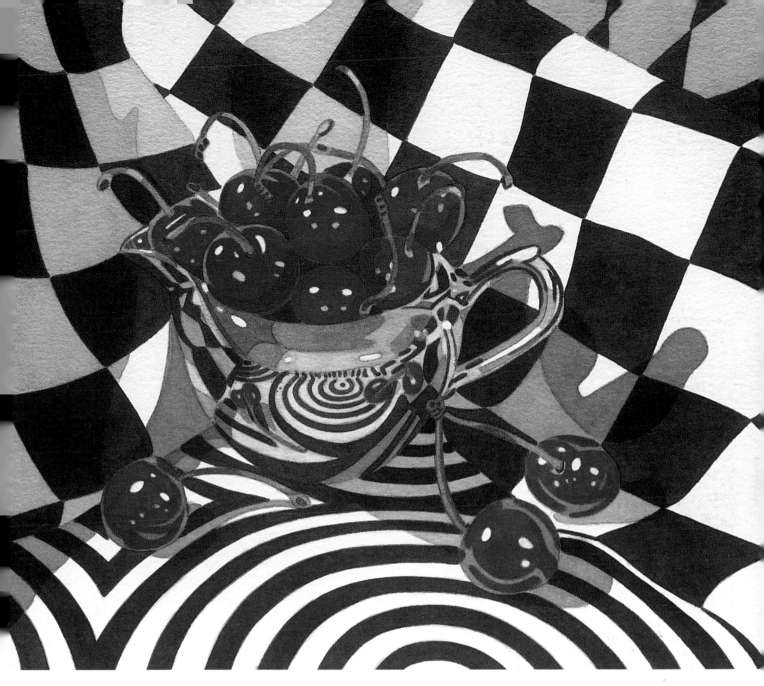

THE FINAL PAINTING

The final result is a creamer full of cherries that you feel you could eat! The leap between the last step and this final painting comprises the same repeated round of layer upon layer of progressively less dilute paint. The gray shadows emerge from superimposed layers of mauve and yellow, which finally build up to the intensity of tone required. The black squares appear solid but the underlying areas of shadow are there and give the painting a dimension not found in solid color. You want to touch the cherries, too. You can see, in comparing the finished painting with the last step, that many more layers were added to them. When the color becomes too red, add another layer of shadow mauve, and so on. Note that the highlights on the cherries are in three shades: white, mauve, and pink. Finally, the creamer. We left the reflections blurred and now they have been brought into focus and intensified. The result of this great labor of love is sensational.

18 Back to the cherries, and on goes another layer of Alizarin Crimson. Each time another layer is added, you think this will be the last, but there is still some way to go.

Demonstration:

Evening anchorage

by *MARGARET HEATH*

We are in Morar, on the West Coast of Scotland. The day has started off wet, but now the sun is going down, with warm misty light coming from the top left. The artist likes to take photographs that are as near what she wants to paint as possible, so she has waited until the light is right—reflecting across the water, catching the sterns of the boats, but with the background land and foreground beach in shadow. It is a hot painting day, so the artist has used a blending medium to keep her washes wet and allow time for them to merge.

PALETTE
Cobalt Blue, Manganese Blue, Ultramarine Blue, Cerulean Blue, Ultramarine Violet, Raw Sienna, Burnt Sienna, Light Red

PREPARATORY WORK
Working from an enlarged print, first prepare a careful line drawing. Then preserve the highlights with masking fluid. These can be seen (top, right) as pale yellow patches, for example, on the boat, the middleground islands, and on the house in the background.

1 Start with the sky washes. First, the area is wetted thoroughly and a blending medium painted on. Immediately start painting with the brush loaded sparingly, blue areas first–with very pale Cobalt and Manganese Blues–including blue areas of cloud-shadow, leaving yellow areas white. Then quickly add the yellow–Raw Sienna with a touch of Burnt Sienna–to all but the top edge, which will remain white. Now add the cloud shadows–with Ultramarine Blue and Violet, and a touch of Burnt Sienna–blending them into the yellow. Rub out any pencil when dry.

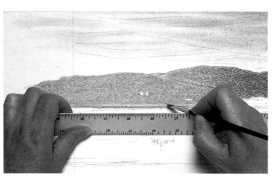

2 Once the sky is dry–don't use a hair-dryer or you'll lose the granulation–add a little Cadmium Yellow to the yellow cloud color (mix A) and paint the background shore area. While still wet, add another wash of Burnt Sienna, Cerulean Blue, and Cadmium Yellow, paler on the left. Lift out lighter parts with a squeezed-out brush, using a ruler held off the paper to lift out a pale line.

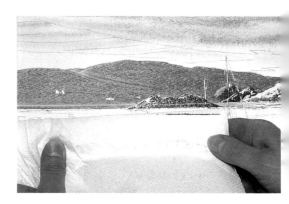

3 While still damp, paint in the shadows of the right-hand shore with Burnt Sienna, Raw Sienna, and Cobalt Blue. When dry, add the island with the same mixture but with Ultramarine Blue added. This time, lift out a pale band with a tissue.

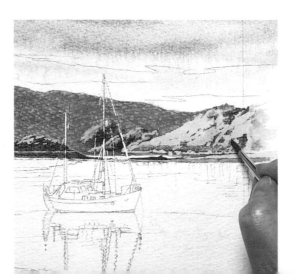

4 When dry, remove the masking fluid from the land only. Then paint over the highlights with the first yellow wash of the shore area (mix A), adding the horizontal line of red-brown at the base.

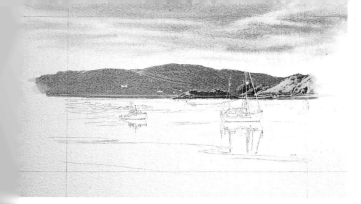

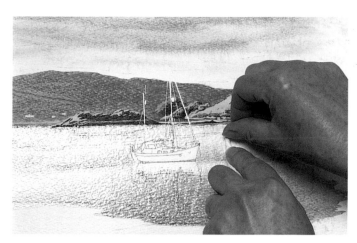

5 THE FIRST STAGE

The first stage is completed now, with the sky and land mapped out and brought to an almost finished stage. You have to be clear about your values to proceed in this way, section by section. You can always feed in more color at a later stage if tonal values are out of balance. The next stage is the water.

6

For the water washes, follow the same method as that used for the sky. The colors are the same for the land and sky reflections. Allow them to merge, lifting out vertical highlights with a twisted cord of tissue.

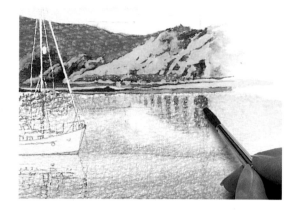

7

While still damp, build up the tone in the land reflections—slightly paler and cooler (add Cerulean)—working around the vertical highlights. Remember that dark colors reflect lighter, and light colors darker.

8

Lift out any highlights while damp. Here a large, clean, flat brush is used, dipped in clean water, and squeezed out on clean tissue.

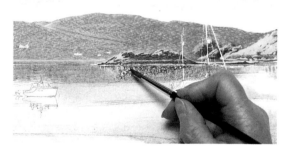

9

When nearly dry, continue building up the island reflection with the darker mix—Burnt Sienna, Raw Sienna, and Cobalt Blue—working around the lifted out areas of highlight. The masking fluid is doing its job in conserving the highlight along the shoreline.

10

When nearly dry, continue the reflections of the hill on the left, working around the ripple shapes. Lift out any light ripples.

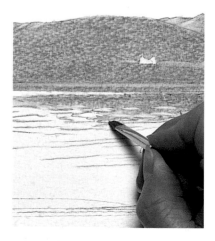

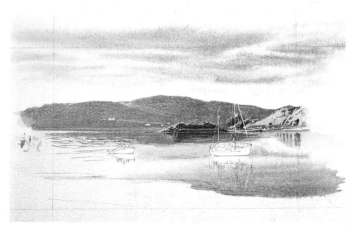

11 THE SECOND STAGE

When dry, check the painting's tonal values before you remove any masking fluid on the water area. Make quite sure that the overall tone is right in this area, as it will not be easy to make any general changes once the mask has been removed from, for instance, the reflected rigging of the boat.

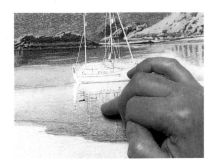

12 Once the painting is quite dry, remove the masking fluid with a clean, dry finger. If in doubt, use a kneadable eraser to do this.

13 Now start on the boats, bringing them together. Using sky colors, paint the cabins blue-mauve. When dry, paint the hulls with a wash of Raw Sienna, then immediately glaze them with mauve to make a mauve gray. Lift out lighter areas. When dry, paint darks with a mixture of Ultramarine Blue, Burnt Sienna, and Alizarin Crimson. Paint the edges of the highlight on the sterns yellow with a touch of orange. Use a ruler held off the paper so that the ferrule guides the brush for the rigging and mooring ropes.

14 Now add the reflection that comes toward the viewer. Mix a darker version of the hull color, dampen the area of the reflection with the yellow mix, and allow it to dry a little. When almost dry, drop in the mauve mix. Lift out soft highlights and add fine details of the reflection with a smaller brush (inset).

15 Using the enlarged print as a guide for the detail, the reflection of the other boat is added in the same way: first with the yellow wash, followed by the mauve.

16 For the wider ripples, use a ruler again with the diluted mauve. Use a fine brush with a good point and make sure the lines are not too regular in width or in tone, and tail them off at the ends.

17 Now add the reflections of the rigging in the water. First paint a wash of palest orange, then, on the reflection of the roller jib, add a squiggly line of reddish brown. Shadows are then added (inset), as well as indications of the folded mainsail.

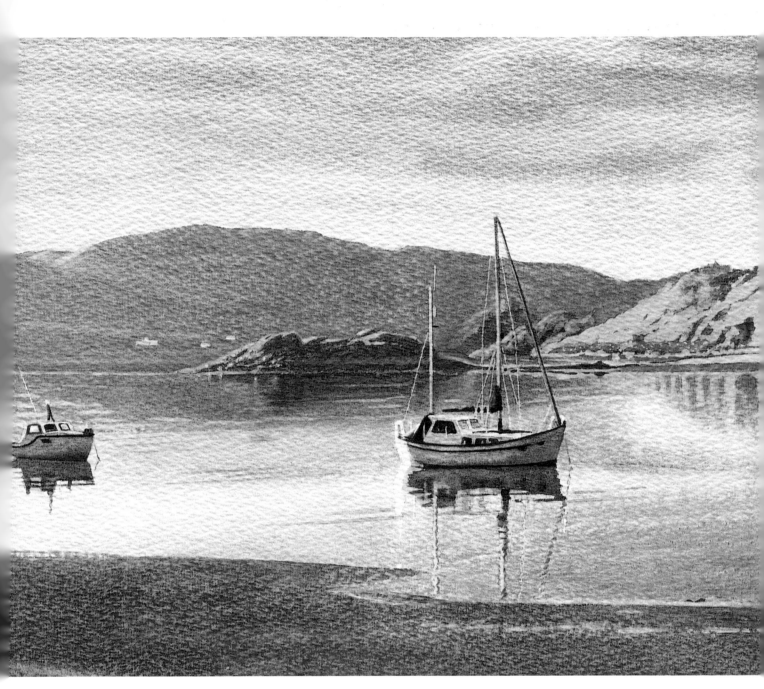

18 Finally, paint the foreground. First mix a large quantity of Raw Sienna and Light Red, and also one of Ultramarine Blue, Light Red, and Ultramarine Violet. With the board flat, wet the paper along the water's edge to soften the join between the two areas. Apply the first wash, allow it to dry slightly, and then add the second over the top, leaving breaks in the wash. Now tip the board at an angle to dry. While still damp, lift off a lighter area, bottom left.

THE FINAL PAINTING

After last-minute adjustments, the painting is ready. The misty evening light shines in this painting as it did in reality. It is an impressive exhibition of watercolor control. Getting the tone right for the foreshore is the work of an experienced artist. Most artists would try it out on a piece of scrap paper first.

Power of extreme light

Atmosphere and lamps

Light encroaching on the natural order

Creating drama and atmosphere

If you think back over the history of art to paintings that have entertained you with their sense of the dramatic, you will find that, invariably, this is conveyed not just by the subject matter but by the manipulation of light and shade. Take, for example, J.M.W. Turner and his atmospheric paintings of ships and trains. They are seen through misty layers of reflected color and light so that the subject matter is almost lost in their midst. The surrealist René Magritte painted disconnected, emotionless men in bowler hats and here, too, the sense of drama—in this case of the unreal or surreal—comes from the manipulation of light, and the artificial nature of the light. Grand statements can be made more dramatically if they are illuminated by extremes of stage-type lighting, or a sense of quiet can be found in the cold light of the moon. As the artist, the choice is up to you.

Southwest Hospitality

BETTY BLEVINS

We see greenish light shining out through these little windows that are not meant for looking out of, lighting up the trees and flowers at the dead of night, and wonder just what this southwest hospitality is that awaits us.

Drama of unexpected light

Paintings with bright light, and therefore, dark shadows are in themselves dramatic, but an extra frisson or tension is added you use what appears to be artificial light in a landscape and, vice versa, have natural light from outside stealing in through a chink in the drapes to light up part of an interior scene.

How is artificial light different?

What distinguishes artificial light from natural light? Obviously there are many different types of artificial lamps: spot lights with narrow beams, strip lights with hard overall lighting effects, and so on. The color of the light also varies, with a choice of using every color of the rainbow. What we are looking for, in order to bring a sense of drama to an exterior scene, is a combination of the most unnatural characteristics of interior lighting.

Multiple Sources First of all, there is the possibility of multiple light sources. You don't have to rely simply on light from the sun or moon from one direction. You can have a light coming from all directions, but greater effects will come from a more subtle approach—perhaps an overall overhead light, with a spotlight effect from another to draw the eye to the focus of the painting. This arrangement will immediately bring a sense of tension into your painting, with the viewer unclear about the reasoning behind it.

Constant Quality The quality of artificial light is different from natural light in that it is constant; it doesn't change position in the course of the day, constantly turn on and off, or vary in strength as clouds pass before it. Also, it doesn't change color according to the time of day and season. These are all aspects of light that are difficult to capture in a painting, but we have seen ways of relaying them through the manipulation of color and contrast, and through a variety of brushwork and painting techniques. Conveying this constant— and some would say stark and deadpan—quality of artificial light can be done through hard-edged, stylized painting with a smooth, unpainterly application of paint.

Greenish Tinge Finally, the color that encapsulates our idea of artificial light is a greenish tinge, most often experienced with strip lighting. It does occur in nature occasionally before a heavy storm,

Kaleidoscope of Sails
BARBARA HOLDER
The artist has abandoned any attempt at a naturalistic light, in order to express the sense of excitement, speed, and moving light evident in the vivid colors of these racing yachts.

Waiting *DOUG LEW*
A wistful painting with its own sense of atmosphere is summed up almost entirely in the straightbacked figure clasping her hands, who conveys a sense of nervous expectancy. The romantic setting with the figure, *contre jour*, at the muslined windows further fuels the imagination.

making the countryside look unnaturally green and lush. So our conditioned response is to associate it with the drama of a storm, adding to the dramatic possibilities of such a gambit.

Natural light in an interior

Natural light coming in through a window or doorway can be equally dramatic. In this case, we have the order and evidence of control that an interior conveys: a complex portrait of the occupant with his or her interests on show. This comparative, non-organic order is illuminated by light from outside, which, as described above, informs you of another less ordered, uncontrollable world. It brings movement into the stillness of the interior. But how can you put this across?

A tried and tested way of showing nature encroaching on our order is through the fluttering motion of curtains. Diaphanous drapes will allow the light to pass through and will be affected by the slightest breeze. Specific treatment of the path of light can also help to give it a sense of movement by using broken paint techniques, such as stippling or dry brushing, over the initial washes. Now paint the rest of the room in a flatter style, to contrast the unlit stillness with the activity of the light-filled area.

School Playground *BRYN CRAIG*

A stark view that nonetheless provokes a reaction, this abandoned playground has an eerie feel to it. The sense of unease is intensified by the unnaturally colored, strong, cool light, suggesting stage lighting, that brutally cuts the space in two. So we wait for the players to come on.

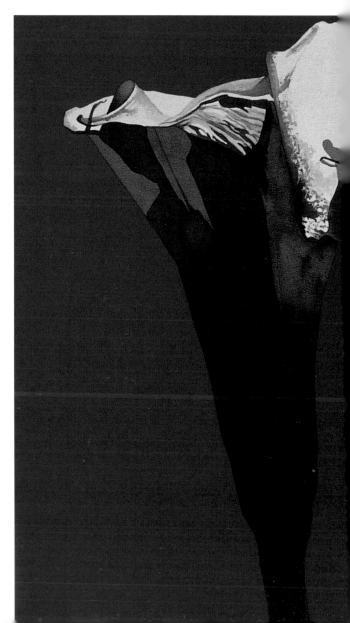

Scarlet Ladies *SUSANNA SPANN*

Such a depth of red plays optical tricks on us, pushing these lilies forward so that they appear to burst out of the picture space in an amazing feat of three-dimensionality. The red is so luminous and high in value that it is tonally insubordinate, as the monochrome version shows you; play with it at your peril.

Upper Tweed Valley II
MARY ANN ROGERS

This precious river valley, running through the border country between England and Scotland, is one of soft greens and heather blushes and, looking at the black-and-white version, you can imagine it thus. Refreshingly, the artist chooses to cast a new light on the scene—literally. It confirms the old adage that if you get the values right, the colors look after themselves.

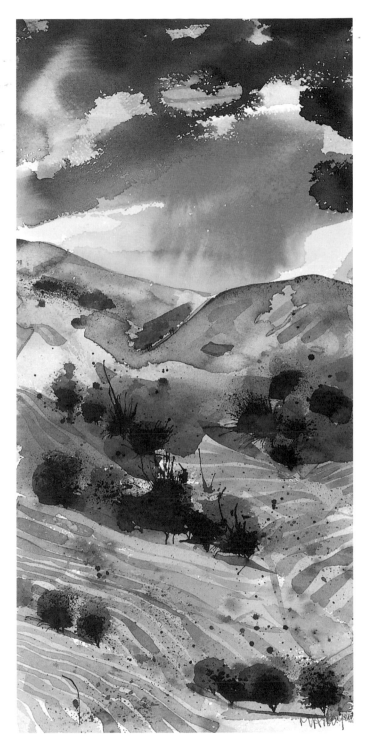

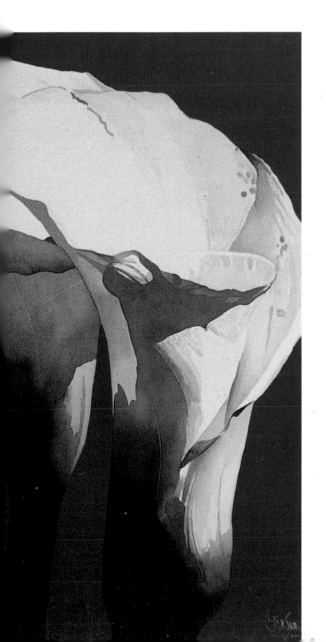

Colored spatters
Opaque white highlights
Textural scumbles
Dancing white lights

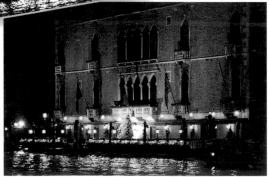 The drawing first maps out the outline of the scene–the building, with its architectural flourishes, the pier and awning, the flags, and the globe lamps. It also carefully plots the reflections on the water, not leaving them to chance.

Demonstration:
Venice by night

by *NICK HEBDITCH*

2 First, paint an underpainting of Raw Sienna and Burnt Sienna. Mix a decent quantity and then lay it on with a large brush. Here a one-inch decorator's brush is used. Don't wet the paper first, as you want the color to be intense.

Even before any atmospheric paintwork is performed, the evocative nature of the subject is obvious–a scene on a Venice canal at night, looking toward a floodlit palazzo. The method of painting starts with some drama, too, with a startling underpainting, which creates the glowing light that shines out from the finished painting. Over this go layers of textural washes for the main façade, and we find that there is an alternative to masking fluid.

3 Then, with a large round brush with a prehensile tip, paint in the windows with a mixture of Ultramarine Blue and Raw Umber. Aim to make some of the windows darker than others and do not be afraid of irregularities in their shape either.

PALETTE
Naples Yellow, Raw Sienna, Burnt Sienna, Winsor Red, Dioxazine Violet, Cerulean Blue, Ultramarine Blue, Burnt Umber, Chrome Lemon, White Gouache

4 Marching on with the same mixture, add a shadow wash to the building on the left, which is set back and at an angle, taking the wash over the darkened windows. Next add the vertical divisions of the main façade with a pale broken line and the structure of the awning. Then with a more intense mix, paint in the void on the right and the dark band above the canal.

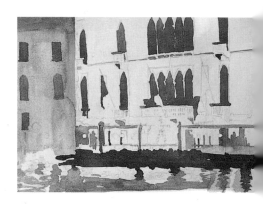

PREPARATORY WORK
A black-and-white photocopy of the painting helps you gauge the tonal distribution in the photograph.

5 THE FIRST STAGE
The structure of the painting and the tonal distribution have been mapped out. The next stage will build on these foundations.

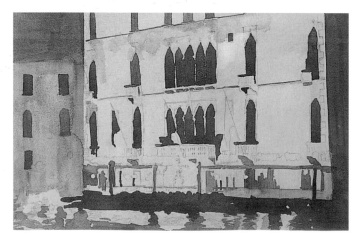

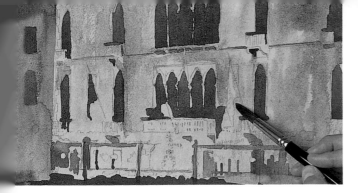

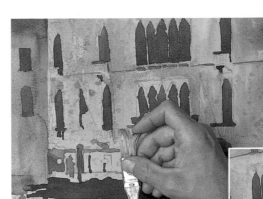

6 Having allowed the paint to dry, the shadows and texture of the main façade is built up by first spraying the area with a spray mist of water, and feeding in the shadow color. Build up the area so that it combines hard-edged parts where the paint has gone in wet-on-dry, and softer-edged areas where the paper is damp and the paint has spread.

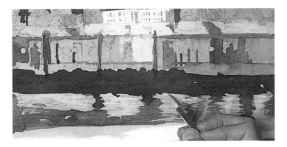

7 Now, while still damp, spatter the area with Winsor Red and the shadow color for the mottled texture of the building. It will look garish at first, but will dry much paler and softer. Now do the same with green (inset). A smaller brush is used for this so that the spatter is finer.

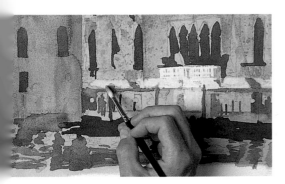

8 Now add the highlights—which are not conserved this time in any way, but replaced with the help of white gouache. Use it dilute to start with, so that it qualifies the paint beneath. Build it up more in the center, where the light is brightest.

9 Adding a little yellow to the white, map out the highlights in the water using the side of the brush to get a soft, broad horizontal stroke. Take it over the shadow color so that it is qualified by it.

10 Now articulate the façade with various dilutions of white gouache and yellow. Don't allow it to get too strong, or it will take over.

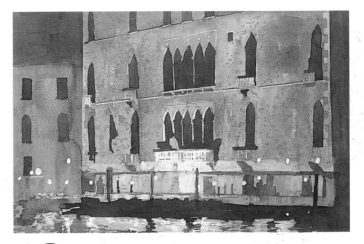

11 The focus of light at the water's edge is built up with overlapping opaque washes of yellow and white, and the globe lights are painted in white, dancing along the edge of the canal. Now add Dioxazine Violet to the white and touch in the purple cast of the lights at the water's edge, which can be seen clearly in the photograph. These are also reflected in the water, and are captured with a light squiggle.

12 THE SECOND STAGE
The artist brings forward the whole painting at the same rate so that he can judge its color values. Notice how the white lights across its center bring a sense of movement to the painting.

13 Now add a green wash to the main façade to qualify the shadows—Cerulean Blue with a touch of Lemon Yellow. Use a dry brush and scrub and scumble it on.

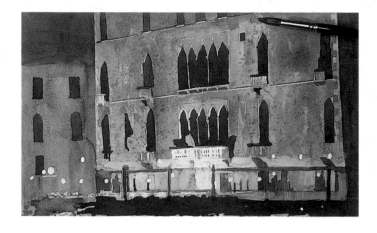

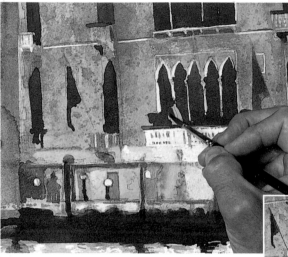

14 The bright red of the flags in the center of the painting helps to draw the eye in. Take the red across the painting, in a horizontal line across the façade, and around the globe lamps as a complementary red aura to their greenish light (inset).

15 THE THIRD STAGE
There has been success in building up the focus of light in the center. Now, to bump up the contrasts, the next stage will be to increase the darks to match.

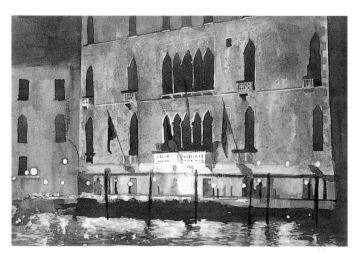

16 With a more intense mix of the shadow color, add another wash to the windows and darkest shadow areas. Do not cover the whole window area, just part of it. It will add to the sense of depth.

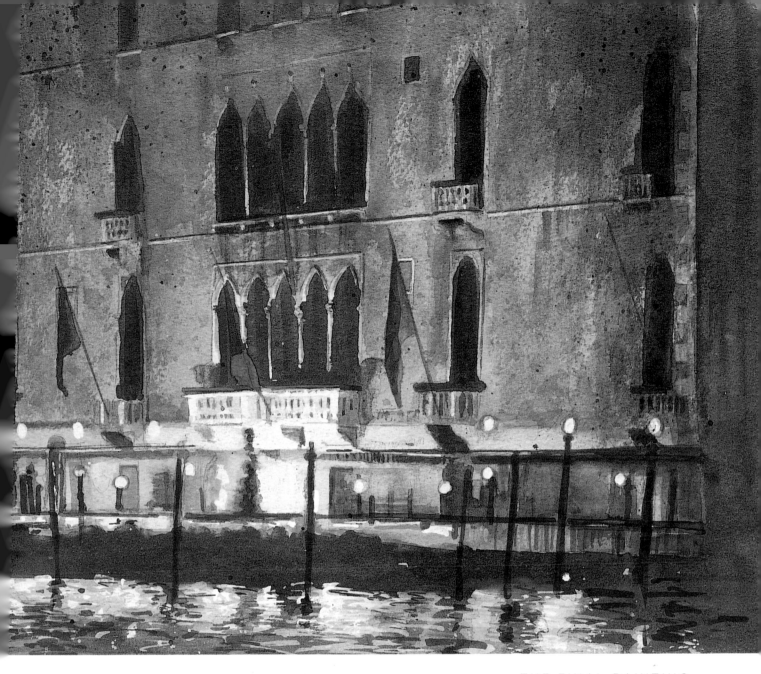

THE FINAL PAINTING

The final painting doesn't just shine with light, you can swear you can hear music and see people dancing. Its burning light comes from the original underpainting, combined with the deep contrasts. The main façade, which takes up so much of the painting, could have become a "boring bit," but has been given a life of its own through the application of a host of textural techniques.

17 Now mix plenty of Burnt Sienna and Ultramarine Blue for a shadow wash over the building on the left-hand side. This will balance the temperature in the painting with a warm and cool side. It will also have the effect of bringing out the light from the globe lamps.

18 Further build up the texture and darken the top of the façade with a scumble of Ultramarine Blue and Dioxazine Violet. Add the final touch to the façade with a spatter of the same mix (inset).

Getting technical

The technical side of light and cast shadows is not for everyone but it can help to understand it. Sometimes, the artist has to work without a visual reminder, such as a photograph or sketch; then an idea of the theory of light and cast shadows can be useful. Cast shadows are particularly important, and even if they do not have to be technically correct in that artistic license will prevail, they do need to make sense. The information below will enable you to work these out.

Natural light
The sun—and the moon—give out light which changes constantly depending on the time of day, the season, and the weather.

COLOR OF LIGHT
The color of the light cast by the sun changes according to the time of day and the weather. At noon, direct sunlight contains a relatively even distribution of the colors of the visible spectrum. It is therefore possible to see the widest variety of subject colors. At dawn or dusk, there are fewer blue wavelengths present than at noon, so the color of light tends toward pink, yellow, and orange. The color of light is also affected by weather conditions such as rain, mist, cloud, snow, and wind. For example, water particles in the air tend to absorb blue wavelengths, making the sky look whiter than it would at noon on a clear day.

Morning and Evening Morning and evening light is biased toward the pinks and yellows, and is usually cooler in the morning than the evening.

Noon Noon light includes the full spectrum of colors, energizing the full range of colors it shines upon.

LIGHT STRENGTH
The strength of the light will differ, depending on the weather, the season, and where you are in the world.

▲ **Hard Light** If the sun is in an open blue sky in summer—on a summer beach or on a sunlit, snowy winter's day—the light is hard. The rays in this case are roughly parallel and the shadows cast are dark and hard-edged.

▼ **Diffuse Light** With the sun behind clouds, the rays are scattered and the shadow cast is soft. Coming from behind a cloud or through a mist, the light is diffuse.

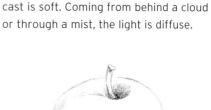
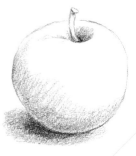

◀ **Soft Light** Sometimes in winter, with a clear sky, the sunlight can be much weaker and diffuse, casting softer, less dark shadows with less defined edges. The same effect comes from the sun shining through an overcast sky. You will notice the darker "center" of the shadow. Artists talk of the shadow "sticking" to the object casting it.

LIGHT DIRECTION

The position of the sun—whether it is high or low—and the direction from which it shines on a scene—from the side, back, or front—will have a great effect on the perception and mood of that scene.

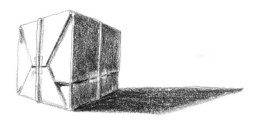

Frontal Lighting Lighting from the front flattens modulations in form. Shadows are often hidden behind the objects casting them, or stretch out beyond, which can be used positively. As you can see above, the wrapping, string, and tape on the package are clear, but there are no shadows to differentiate between the two sides of the parcel, nor a cast shadow to place it on a surface. In this context, you must rely on the outline to understand the form.

Side Lighting Side-lighting presents a variation of highlights and shadows that can be manipulated to make an interesting composition. Side-lighting is good for showing off textures too. Hard side-lighting creates strong contrasts between light and dark areas. Strong side-lighting can add interest to a scene with a network of cast shadows, but take care as it can also add confusion if the scene is complicated enough already. Softer side-lighting has the effect of reducing extremes of light and dark, while retaining good subject detail.

Back Lighting Lighting from the back of the scene you are painting can produce dramatic effects, with the shadows coming forward and objects appearing in dark silhouette against the light. Colors are much weaker, and objects often appear very distinct from their background, emphasizing shape at the expense of detail and form.

Valle de San Martino II
CLAIRE SCHROEVEN VERBIEST
A warm evening summer sun casts a golden light on this village street, permeating every corner of the scene. This is laid down as an early pale wash of transparent yellow which qualifies superimposed hues.

Rim Lighting Rim lighting occurs when the back lighting is so bright it burns into the shape set against it, giving figures a halo. This effect emphasizes the figure's shape and is particularly dramatic when the background is dark.

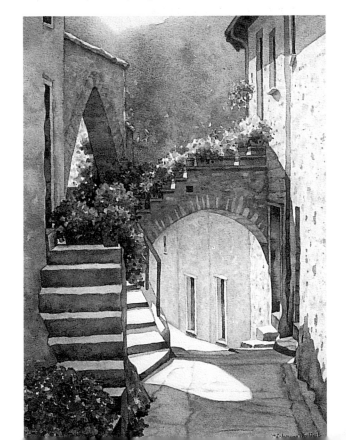

CAST SHADOWS

Shadows not only give depth to a painting by giving clues about subjects' shape and structure, they can also be fascinating subjects in their own right.

The shape of a cast shadow can be calculated from two factors: the height of the sun, which affects the length of the shadow; and the direction from which the sun's rays hit the object, which affects the direction of the shadow (eg, to the left, right, front, or back of the object). The simplest way to calculate the position of a shadow is to think of the object casting the shadow as a stick, and to imagine a triangle composed of the sun's rays, the object, and the ground plane (see below).

The strength of a cast shadow is affected by the strength of light. Outdoors in sunshine, the shadows are darker around noon, and softer in the early and later parts of the day.

▲ If the sun is low in the sky, to the right of the object as it faces you, the rays come down at a lower angle, and the shadows toward the left are longer.

The sun sits lower in the sky in the early morning and late afternoon, when shadows are long and less intense, and reaches its zenith around noon, when shadows are short and at their darkest.

Summer Bouquet with Cherri⸱
WILLIAM C. WRIGHT
With strong light coming from behind the still life, the shadows are cast forward toward the viewer and are hard-edged. The shape of the shadow can be calculated by dropping verticals to the tabl⸱ surface from the flowers in the vase, taking into account the viewpoint, which would foreshorten the result.

▲ **Side Lighting** This is probably the most common directional lighting used in painting and it is the simplest to work out. So, for example, if the sun is high up in the sky, to the right of the object as it faces you, the sun's rays come steeply down, creating short shadows to the left of the object.

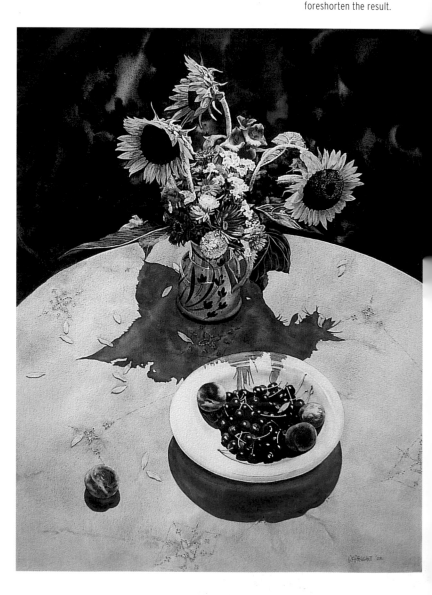

Back Lighting With the sunlight coming from behind the scene you are painting, the shadows will come forward toward you. Here, above, the sun is low in the sky, casting long shadows toward the viewer, obeying the laws of perspective.

Frontal Lighting Again, shadows obey the laws of perspective and, therefore, with the light behind the viewer, they will stretch out from the object toward the horizon (HL), to a point at which they appear to vanish—the vanishing point (VP).

More Complicated Shapes The same rules apply to more complicated shapes. Keep your nerve and drop down the same ray lines to form the shape of the shadow.

Shadows Up a Vertical Shadows become more complicated when there are two or more objects in close proximity to each other. Here the sun, in the picture plane, is shining down at an angle to the ground plane, so the lamppost's shadow continues up the side of a building until the sun's rays cut it off.

Artificial light

Lamps, candles, night lights, and fires all produce different lighting effects. Lamps can differ in the quality—the strength, color, and nature—of the light they produce, and also in the width of their beam. Lamps can be combined with each other or with natural light for interesting effects.

Most of the effects of natural light can be reproduced with artificial light. However artificial light affords you more control in terms of the direction, quality, and strength of the light that you shine on your chosen subject.

Single-Source Light With a single source of artificial light, such as the light from a lamp in a studio setting, you can set up fairly natural lighting conditions, akin to those created by the bright light of the sun on a summer's day. By contrast, the soft light of a candle creates a gentle, subdued glow, which generates equally subdued shadows.

Multiple-Source Light Using several artificial lamps to light an interior scene can produce fascinating effects and counter-effects. Try combining two light sources from different directions, so that there are two shadows radiating from the object. You could also try varying the strength of the lamps, making one strong and the other weak. It is up to you to decide which aspects of your subject you wish to emphasize (shape, form, texture, color, and so on), and the mood you want to create. All this can be manipulated through light.

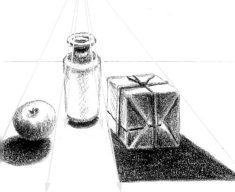

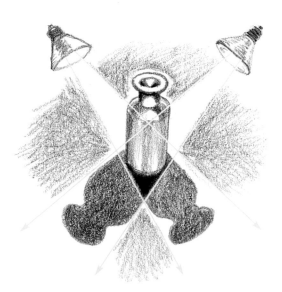

Index

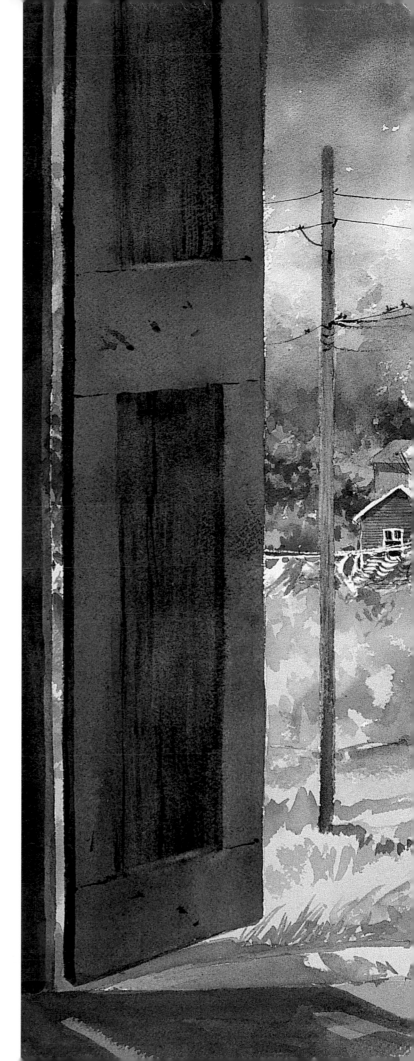

Credits

Quarto would like to thank all the artists who supplied pictures reproduced in this book. Quarto would also like to thank those artists who carried out the demonstrations–Glynis Barnes-Mellish, Moira Clinch, Marjorie Collins, Adelene Fletcher, Margaret Heath, Nick Hebditch, Geoff Kersey, Hazel Lale, Audrey MacLeod, Julia Rowntree, and Mark Topham .

All other photographs and illustrations are the copyright of Quarto Publishing plc. While every effort has been made by Quarto to credit contributors, we apologize in advance for any omissions or errors, and would be pleased to make the appropriate correction for future editions of this book.

Pages 127 and 128
details from **Savannah Sound**
RUTH BADERIAN